NATIONAL MUSEUM OF WOMEN IN THE ARTS

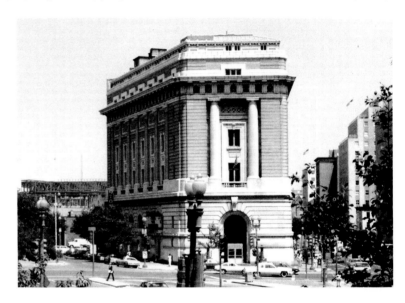

NATIONAL MUSEUM

OF WOMEN IN THE ARTS

HARRY N. ABRAMS, INC. | PUBLISHERS | NEW YORK

TO WILHELMINA AND WALLACE HOLLADAY,
WHOSE VISION BECAME THE MUSEUM

PROJECT MANAGER: *Leta Bostelman*
EDITOR: *Margaret B. Rennolds*
DESIGNER: *Judith Michael*

ON PAGE ONE: The National Museum of Women in the Arts, Washington, D.C.

LIBRARY OF CONGRESS CATALOGING-IN-PUBLICATION DATA

The National Museum of Women in the Arts.

Bibliography: p. 249
Includes index.
1. Art—Washington (D.C.)—Catalogs. 2. National Museum of Women in the Arts (U.S.)—Catalogs.
N858.N36A56 1987 704'.042'0740153 86–28672
ISBN 0–8109–1373–9 (Abrams)
ISBN 0–940979–00–4 (pbk.)

Published in 1987 by Harry N. Abrams, Incorporated, New York

TIMES MIRROR BOOKS

Printed and bound in Japan

CONTENTS

SPONSOR'S STATEMENT | 6
by Hamish Maxwell, Chairman and Chief Executive Officer, Philip Morris Companies Inc.

PREFACE AND ACKNOWLEDGMENTS | 7
by Anne-Imelda Marino Radice, Director, National Museum of Women in the Arts

INTRODUCTION:
WHY A NATIONAL MUSEUM OF WOMEN IN THE ARTS? | 8
by Alessandra Comini, University Distinguished Professor of Art History, Southern Methodist University

FOUNDERS' STATEMENT | 14
by Wallace and Wilhelmina Holladay

SELECTIONS FROM THE PERMANENT COLLECTION | 15
Seventeenth Century
ITALIAN: Lavinia Fontana, 16; Elisabetta Sirani, 19
FLEMISH: Clara Peeters, 20
GERMAN: Anna Maria Van Schurman, 23; Maria Sibylla Merian, 25

Eighteenth Century
DUTCH: Rachel Ruysch, 27
FRENCH: Marie Anne Loir, 28; Marie-Geneviève Navarre, 31; Adélaïde Labille-Guiard, 33;
 Marie Louise Elizabeth Vigée-Lebrun, 34; Marguerite Gérard, 37;
 Antoinette Cecile Hortense Haudebourt-Lescot, 39
SWISS: Angelica Kauffman, 40

Nineteenth Century
AMERICAN: Anna Claypoole Peale, 42; Lilly Martin Spencer, 45;
 Elizabeth Gardner Bouguereau, 46; Mary Cassatt, 48; Lilla Cabot Perry, 51;
 Jennie Augusta Brownscombe, 52; Ellen Day Hale, 54; Cecilia Beaux, 57;
 Evelyn Beatrice Longman, 58; Bessie Potter Vonnoh, 59;
 Anna Vaughn Hyatt Huntington, 60; Malvina Hoffman, 60
FRENCH: Rosa Bonheur, 63; Berthe Morisot, 64; Camille Claudel, 67;
 Suzanne Valadon, 68; Marie Laurencin, 70

Twentieth Century
AMERICAN: Gertrude Käsebier, 73; Louise Dahl-Wolfe, 74; Berenice Abbott, 77;
 Marguerite Thompson Zorach, 79; Georgia O'Keeffe, 80;
 Beatrice Whitney Van Ness, 83; Alma Thomas, 84;
 Charmion von Wiegand, 87; Alice Neel, 88; Isabel Bishop, 90;
 Lee Krasner, 93; Dorothea Tanning, 94; Elaine Fried de Kooning, 97;
 Joan Mitchell, 98; Georgia Mills Jessup, 101; Helen Frankenthaler, 102;
 Audrey Flack, 105; Eva Hesse, 106; Dotty Attie, 109; Nancy Graves, 110;
 Alice Aycock, 113; Maria Montoya Martinez, 114; Lucy Lewis, 114;
 Margaret Tafoya, 115
BRITISH: Gwendolen John, 116; Barbara Hepworth, 118; Leonora Carrington, 120;
 Bridget Riley, 123
CANADIAN: Dorothea Rockburne, 125
GERMAN: Käthe Kollwitz, 127; Paula Modersohn-Becker, 128;
 Gabriele Münter, 131
PORTUGUESE: Maria Elena Vieira da Silva, 133
RUSSIAN: Natalia Goncharova, 134; Alexandra Exter, 137;
 Sonia Terk Delaunay, 138
SCOTTISH: Anne Redpath, 141
SWISS: Alice Bailly, 142; Sophie Taeuber-Arp, 145

BLACK-AND-WHITE PLATES | 146

BOOKS FOR FURTHER READING | 249

INDEX TO ARTISTS AND WORKS | 250

PHOTOGRAPH CREDITS | 254

SPONSOR'S STATEMENT

IT HAS BEEN an article of faith that a work of art is judged on its own merits. Yet this ideal has rarely been applied equally to the works of men and women. For centuries the mere designation "woman artist" has stood between innumerable pieces of art and their appreciation and accessibility.

To thrive, art demands visibility—a public place where it can be viewed, experienced, and absorbed into the mainstream of society. As part of its commitment to artistic excellence, Philip Morris has sought to assure the widest possible audience for artists who may previously have been denied the opportunities to exhibit their work. In supporting the publication of this catalogue, Philip Morris continues its tradition of equal opportunity in the arts as well as in industry.

It has been less than a century since Edgar Degas marveled that a woman—Mary Cassatt—could produce canvases of such great power and beauty. Since that time women have successfully worked to counter the biases of conventional thought. The National Museum of Women in the Arts is taking another significant step by recognizing the role of women in their rightful place in the world of art. We are proud to play a part in the publication of its first catalogue.

Hamish Maxwell
Chairman and Chief Executive Officer, Philip Morris Companies Inc.

PREFACE AND ACKNOWLEDGMENTS

Founded to herald the creativity of women, the National Museum of Women in the Arts seeks to highlight the work of women artists in all media and to educate the public about their achievements. The permanent collection now contains approximately five hundred works of art, and it will continue to grow as the Museum acquires representative works of women artists of centuries past as well as works that portend the future of art. The core of the Museum's holdings, which inspires the fulfillment of its great challenge, is the Holladay Collection. The prints, oils, photographs, pottery, pastels, and sculptures are the generous donations of the Museum's founders, Wilhelmina and Wallace Holladay. Their collection offers arresting, tangible proof of what women artists have accomplished from the Renaissance to the present day.

National Museum of Women in the Arts is a survey of some of the finest pieces acquired by the Museum prior to June 1, 1986. Of the 239 works included, 69 are illustrated in color and the remainder in black-and-white.

As with all projects associated with the establishment of this Museum, the book has truly been a labor of dedication and love. We are especially grateful to the National Endowment for the Arts and to Philip Morris Companies Inc., which generously underwrote the research and writing of the catalogue.

We thank Alessandra Comini for her introduction; Martha McWilliams (M.B.M.), who served as the project director and as an author; Mary Louise Wood (M.L.W.), Curator of Education, who was a major contributing writer; and Eric Denker (E.D.), who supplied additional entries to the publication. Steven Sloman produced brilliant color photography and Steve Payne contributed black-and-white photographs. Louise Lavenstein researched the photo representations of the artists and Elizabeth Churchill Cattan coordinated the photographic sessions and artists' entries. We thank all our colleagues at Philip Morris Companies Inc., who were so helpful, especially Stephanie French. We are grateful for the expertise and encouragement of those at Harry N. Abrams, Inc., notably Paul Gottlieb, President; Leta Bostelman, Managing Editor; Margaret Rennolds, Editor; and Judith Michael, Designer. The Museum also wishes to thank its librarian Krystyna Wasserman, and Mary Sullivan, Al Abrams, Margaret Humphreys, and Linda Lightbourn. We appreciate the work of Jill Meredith, who did the first research on the permanent collection.

Finally, we extend appreciation to those who serve on the Board of Directors of the Museum for their enthusiasm and support, and to Wilhelmina Cole Holladay, whose vision and drive have made the National Museum of Women in the Arts a reality.

Anne-Imelda Marino Radice
Director, National Museum of Women in the Arts

INTRODUCTION

WHY A NATIONAL MUSEUM OF WOMEN IN THE ARTS?

She remained amused and a little irritated when critics continued to speak of her as a woman portraitist, a woman painter. "They don't write about *men* painters," she said.

Catherine Drinker Bowen on her aunt, Cecilia Beaux (*Family Portrait*, Boston, 1970, p. 169)

CECILIA BEAUX'S bemused vexation at being categorized always as a woman painter not only responds to a cumbersome practice still in use today with many writers on art but also suggests that some artists, perhaps most artists, do not care to have a modifier specifying their sex precede the noun denoting their professional identity. Female artists through the ages have had to contend with this linguistic, hence cultural, subdivision; male artists have not usually had to cope with such gratuitous information. In earlier centuries the designation "woman" before the word "artist" was meant as a compliment, hailing a presumed pheromenon, as when the sixteenth-century painter Albrecht Dürer, marveling at the work of miniaturist Susanne Horebout in Antwerp, exclaimed to his diary how astonishing it was that a *woman* could do so well. Giorgio Vasari's *Lives of the Artists* (1555; second, expanded edition, 1568) documents with wondering if cloying admiration the accomplishments of the sculptor Properzia de' Rossi and the six Anguissola painter sisters. But as time passed, the number of professional female artists increased: Artemisia Gentileschi, Elisabetta Sirani, Clara Peeters, Judith Leyster, Louise Moillon, Mary Beale in the seventeenth century; Rosalba Carriera, Maria Sibylla Merian, Rachel Ruysch, Adélaïde Labille-Guiard, Angelica Kauffman, Elizabeth Vigée-Lebrun in the eighteenth century; Anna and Sarah Peale, Harriet Hosmer, Edmonia Lewis, Elizabeth Thompson, Louise Seidler, Elisabet Ney, Cecilia Beaux, Mary Cassatt, Berthe Morisot, and Eva Gonzalès in the nineteenth century. And so the designation "woman" came, imperceptibly, to incorporate a qualifying nuance in the term "artist." The continued, almost fixated use of the circumscribing adjective in twentieth-century writing and casual speech—for example, "Georgia O'Keeffe was unquestionably the greatest woman artist America has yet produced" or "Who do you think is the best woman artist alive today?"—would certainly frustrate Cecilia Beaux and has indeed moved feminist art critics like Rozsika Parker and Griselda Pollock of England to conclude: "The phrase 'woman artist' does not describe an artist of the female sex, but a kind of artist that is distinct and clearly different from the great [i.e., male] artist" (Rozsika Parker and Griselda Pollock, *Old Mistresses: Women, Art and Ideology*, New York: Pantheon Books, 1981, p. 114).

Why, then, a National Museum of Women in the Arts? Attractive as is the notion of another "national" museum, is not the proscriptive "of women" a setback, an unwitting reinforcement of society's apartheid attitude toward male and female artists? Is it not a confirmation of traditional value systems inherent in the paradigm of a male artistic tradition against which women's work must be measured and from which it can be subtracted? Could a museum such as this, well-intentioned as its founders' motives might be, fall innocent victim to that time-tested artifice for affirming art done by women in such a manner as to attest, at the same time, to male prominence? By celebrating a national heritage in this way are we not separating a part from the whole? "Will Washington's new museum focus long-overdue attention on women artists of the past and present or will it segregate them in a female ghetto?" asked a nervous article in a national magazine (*ARTnews*, Summer, 1986, p. 111).

Some impish answers come to mind (out of impertinence comes pertinence). We

have never seemed to fret much about the acreages of male "ghettos" walled in for the art-loving public by so many major museums around the world. Contrasting men artists with other men artists does not appear to be a dangerous abridgment of the human experience. "That's because most artists have been male," comes the ready rejoinder. Old masters are one thing; old mistresses quite another. (And yet the 1972 exhibition of women artists of the past staged by Ann Gabhart and Elizabeth Broun at The Walters Art Gallery in Baltimore entitled "Old Mistresses" nicely agitated the murky waters of this semantic swamp.)

Another way to put it might be that, until recently, most acknowledged artists have been male. The activity of women "in the arts"—the concluding words of the title of this new National Museum—is, nevertheless, as old as society itself. How this activity has been perceived charts a history of taste, priorities, personalities, and values— all shaped primarily by male articulators of the collective consciousness. The unknown women weavers of Navajo blankets would have no place in this schema. *Anonymous Was a Woman* is the mordant title given by filmmaker Mirra Bank to her 1979 book on eighteenth- and nineteenth-century American needlework art, and it points out the secondary status conventionally accorded to work done by women in the home as compared to work ("art") done by men outside the home. A familiar example is the shift in status from cook (female) to chef (male). From the structural anthropologist's point of view, the hierarchical division between craft and art not only parallels an ascending ranking from Nature (raw material) to Culture (civilizing artifact) but also corresponds to the domestic versus public areas of creativity. What makes the National Museum of Women in the Arts different, even radical, is that craft and "high" art are not viewed as mutually exclusive. An earthenware vase made by the nonagenarian Acoma potter Lucy Lewis in 1983 (page 115)—and signed by her, despite tribal constraint to remain anonymous—is one of the original pieces in the Holladay Collection.

The strategy broadcast in the Museum's full name—National Museum of Women in the Arts—cannot be ignored. It draws attention to the fact that the word "arts," unadorned by modifiers, is still generally taken to imply male activity. This new institution is, in the words of its founder Wilhelmina Holladay, "the first museum in the world dedicated to the contributions of women to the cultural life of their society." To this we might add that, as an ever-growing depository of past and present expressions by women in the visual arts, the Museum commits itself to illuminating the history of women in art and not just women's art history—the latter either neglected by hoary mainstream history texts or in danger of crystallizing into a separate and subservient story through the compensatory spate of laudable surveys devoted exclusively to female artists.

The National Museum of Women in the Arts is indeed—unashamedly and unabashedly—a museum of special purpose. It provides, in the words of Virginia Woolf, "a room of one's own." This room is intended not to cloister the work of women from the world but rather to single it out and highlight it in relation to the world. This "room"— actually seven floors of a former Masonic temple (oh, irony!)—can be a beacon sweeping its powerful beam across the country and abroad, encouraging, by featuring women in the arts, past and present, the efforts of women artists to come.

In this the current goals of the National Museum of Women in the Arts are not so different from those set down by the National Association of Women Artists in a 1942 catalogue marking its fiftieth year of annual exhibitions:

The question is often asked: "Why do you exhibit as *women artists*—is it necessary in this day of equal opportunity for men and women in the world of art?" No, it is not necessary, nor do the Women Painters and Sculptors appeal for chivalry or wish to emphasize sex distinctions. They stand squarely as artists, ready to submit to a universal measure of quality. The reason for maintaining their identity as a women's organization lies in a pride in a record of fifty-two years of women working together, not selfishly to further their own ends, but to extend the field of opportunity for women and to encourage artists in out-of-the-way places in maintaining a high standard in their output.

(National Association of Women Artists, Inc., *50th Exhibition Catalogue*, New York, 1942, p. 19)

Despite "this day of equal opportunity for men and women in the world of art," it is everywhere patent that there are still, almost half a century later, frequent inequities in the extent to which women in the world of art are exhibited, reviewed, researched, collected, and named recipients of grant monies. By its very existence, the National Museum of Women in the Arts challenges the unequal representation of female artists in other museums, in galleries, and in major shows and offers an important and national alternative space.

Notwithstanding apparent "advancements" concerning the integration of women artists into a central cultural scene, the need for this museum of special purpose is conspicuous: at best to serve as a catalyst, at the very least to function as a gadfly, provoking other museums to document and display the reserves of women's work in their—all too often basement storage—collections. The role of women as part of culture, and not apart from culture, has only begun to be fully identified by historians.

A comparison of the situation of present-day women composers with that of women artists is instructive. In 1978 the New England Women's Symphony was founded by four musicians, whose stated ambitions seem very similar to the objectives of all those who wish women in the arts well: "to promote the composition, performance and public appreciation of music written and performed by women." The statement of purpose continues: "In researching programs of major professional and semi-professional orchestras we noted growth of female personnel listings [see the long enumeration of female staff members under the leadership of, often, a single male director at most American museums] but little if any programming of women's compositions [substitute "little if any scheduling of exhibitions of women's art"] and virtually no evidence of women conducting with any regularity [note the paltry showing of women critics on the rosters of our major American newspapers and national magazines]." The next step taken by the New England Women's Symphony paralleled measures introduced by supporters of women artists some fifteen years earlier, when the Women's Caucus for Art was established: "[We] set out to correct this imbalance by providing 1) a performance vehicle for large-scale compositions by women, 2) a podium for women conductors, and 3) an organization to educate the public and performing organizations as to the existence of women's orchestral literature and to the existence of female conductors." Here we see how far ahead of their musical sisters women artists are: it is no longer necessary to announce the very existence of female artists to the general public. This is now an accepted fact, in America at least, thanks to the corrective histories and television documentaries that have appeared over the past decade and a half. Before that, in 1964, the modern-day Vasari, John Canaday, in his four-volume *Lives of the Painters* included a grand total of eleven women in his list of five hundred artists. (Progress!) Nowadays most lay persons can come up with the names of women artists; universally, they are Georgia O'Keeffe and Mary Cassatt. *Two* women artists—are we really so far ahead of the women composers? The final chapter in the history of the New England Women's Symphony draws attention to another, and crucial, aspect pertinent to the success of activism in behalf of women in the arts: "Each program was designed to showcase works by 'established' living composers, 'new' composers, and composers from our women's musical heritage. [Could the ordinary concert-goer name Clara Schumann or Lili Boulanger?] Unfortunately, after our sixth concert (November 1979), we were forced to suspend operations indefinitely in order to raise funds" (from the liner notes for *Women's Orchestral Works*, Galaxia Records, Woburn, Maine).

This sad demise in childbirth from financial malnutrition is a poignant reminder of the other component cited by Virginia Woolf as necessary to the creative life: "A woman must have money and a room of her own." Woolf warmed to her subject with wistful indignation: "What had our mothers been doing then that they had no wealth to leave us? . . . If only Mrs. Seton and her mother and her mother before her had learnt the great art of making money and had left their money, like their fathers and their grandfathers before them, to found fellowships and lectureships and prizes and scholarships appropriated to the use of their own sex . . ." (Virginia Woolf, *A Room of One's Own*, New York, 1929, p. 21).

Realistic as well as revisionist, the National Museum of Women in the Arts depended from its inception upon mounting a national subscription to its cause. Around

the country, financial support was enthusiastic and forthcoming, in both individual memberships and corporate sponsorships, for several years prior to the opening of the Museum doors in 1987. Woolf would have approved. She would also have howled had she applied, at the Library of Congress, the tactics she employed in the British Museum, where she went to look up the topic "women" and discovered so many learned tomes on the subject written exclusively by "professors, schoolmasters, sociologists, clergymen, novelists, essayists, journalists, men who had no qualification save that they were not women" (*Ibid*, p. 28). Were she consulting guides to American museums to ascertain how many institutions were listed under "women" and how many under "men," she would initially have found an equally uninspiring distribution: one entry in *The Official Museum Directory* of 1985 calls our attention to, for "women," the *Women's City Club of Boston* (two adjoining historic houses with marble mantels and original French wallpapers), while a lone entry under "men" proclaims a repository soberly entitled *Man Full of Trouble Tavern* in Philadelphia. Turning to the heading "museums" she would have discovered a second entry for "man"—the *Museum of Man* at Wake Forest University in Winston-Salem, North Carolina. How about looking under the term "national"? Peering over Woolf's shoulder we seem to have hit the jackpot. There it is, in all its consciousness-raising brilliance, the heartening entry,

National Women's Hall of Fame

in Seneca Falls, New York—of course! where the first women's rights convention was held in 1848. (When was the *Hall of Fame* founded, by the way, *in* 1848 or shortly thereafter? Oh! As recently as 1969. One hundred twenty-one years later! Well, let's be grateful for small miracles.) And what else, the insatiable Woolf might have wondered, appears under the impressive "national" category? A patriarchal glut. And one that takes the polish right off our resplendent discovery of latecomer (1969) *National Women's Hall of Fame*. Here is a sampler:

National Baseball Hall of Fame and Museum Inc., Cooperstown, New York (founded 1936)
National Bowling Hall of Fame and Museum, St. Louis, Missouri (1977)
National Cowboy Hall of Fame and Western Heritage Center, Oklahoma City, Oklahoma (1954)
National Football Foundation's College Football Hall of Fame, Kings Island, Ohio (1978)
National Football Museum, Inc., Canton, Ohio (1963)
National Fresh Water Fishing Hall of Fame, Hayward, Wisconsin (1960)
National Ski Hall of Fame and Museum, Ishpeming, Michigan (1954)
National Softball Hall of Fame, Oklahoma City, Oklahoma (1957)
National Wrestling Hall of Fame, Stillwater, Oklahoma (1976)

Perhaps it is not such an esoteric special-interest group that in the year 1987 created a *National Museum of Women in the Arts* as a contender to be added to this sinewy slate. To point out that a *National Museum of The Boy Scouts of America* (1959) is listed in the robust register but that no corresponding *National Museum of The Girl Scouts of America* exists would be to descry Woolfism, no doubt.

Nevertheless, it is interesting, apropos of special-interest museums appealing to a national constituency, that among twentieth-century museums instituted prior to the 1987 founding of the National Museum of Women in the Arts, the following accredited institutions devoted to specific subjects came into being: in Washington, D.C.— the National Building Museum (1980), the National Museum of African Art (1964), the National Portrait Gallery (1962), and the National Air and Space Museum (1946); and in New York City—The Studio Museum in Harlem (1967), China House Gallery (1966), Museum of American Folk Art (1961), The Asia Society (1960), Museum of the American Indian (1916), Japan House Gallery (1971), The Hispanic Society of America (1904), and The Jewish Museum (1904). If special-interest museums can be criticized as responding only to minority groups within society at large, this charge cannot appropriately be leveled against a National Museum of Women in the Arts. Aside from the fact that women constitute a majority in the population nationally, statistics reveal that for the past decade, between 60 and 75 percent of artists enrolled in art programs across the country are women. There are many more exhibiting women

artists in the art world than the ratio of reviews in national journals would lead us to believe (in 1984, for example, fewer than one-third of the reviews in *ARTnews* and *Artforum* dealt with female artists). The optimistic words of American sculptor Harriet Hosmer, penned over a hundred years ago, have yet to come true: "But in a few years it will not be thought strange that women should be preachers and sculptors, and every one who comes after us will have to bear fewer and fewer blows" (letter of 1868 to Reverend Phebe A. Hanaford, quoted by the author in Phebe A. Hanaford, *Daughters of America*, New Jersey, 1882, p. 302).

It is in response to the mandate of a cultural imperative, then, that the National Museum of Women in the Arts comes into being. Two dynamic factors have converged: the acute need for a national museum focusing on women in the visual arts, and the felicitous circumstance of an existing private collection—the Wallace and Wilhelmina Holladay Collection of Washington, D.C. Again, there are vigorous and imposing precedents in twentieth-century America for the conversion of a formidable private collection into a museum for public enjoyment and edification. One thinks easily of the Isabella Stewart Gardner Museum (Boston, 1900), The Phillips Collection (Washington, D.C., 1918), The Frick Collection (New York City, 1920), The Pierpont Morgan Library (New York City, 1924), the Norton Simon Museum (Pasadena, 1924), The John and Mable Ringling Museum of Art (Sarasota, 1930), the Whitney Museum of American Art (New York City, 1930), The Solomon R. Guggenheim Museum (New York City, 1937), The J. Paul Getty Museum (Malibu, 1953), the Hirshhorn Museum and Sculpture Garden (Washington, D.C., 1966), and the Kimbell Art Museum (Fort Worth, 1972). Along with the Menil Collection (Houston, 1987), the National Museum of Women in the Arts is simply the latest in a proud and democratic tradition of bringing important collections to the public.

T HE CORE collection of some three hundred items of the National Museum of Women in the Arts has the advantage not only of depth—immersion in multiple aspects of female creativity—but of breadth—of medium, period, style, and even of definition concerning what constitutes art. To have concentrated upon a specialty field such as art created by women is partisan yet unbiased, exclusive yet ecumenical. Baudelaire's exhortation that the art of criticism be partial, passionate, and political can apply with equal verve to the art of collecting. A true collector is propelled by a magnificent obsession, a tunnel-visioned, exclusionary prejudice that nevertheless exposes an infinity of vistas. Such has been the case with Wallace and Wilhelmina Holladay.

The Holladay Collection that now makes up the nucleus of the holdings of the National Museum of Women in the Arts can be examined and appreciated in several ways. It is, upon first encounter, and remains, upon subsequent encounters, a select and high-quality survey of major periods and styles of art of the last five centuries. It begins with a superb portrait of a noblewoman, poised and serene, executed with jewel-like precision in the late sixteenth century by the Bolognese artist Lavinia Fontana (page 17). The Collection enters the 1980s with a very different but equally pristine and hard-edged portrait of a young, expectant-looking woman by the Photorealist New York painter Audrey Flack, entitled *Who She Is* (page 104). Who she is, is Hannah, the artist's daughter, and the emphasis on identity common to the Fontana and Flack portrayals (the twentieth-century portrait contains a double emphasis, with the frontal image reinforced by painted-in lines from a descriptive poem) indicates another dimension in which the collection of the National Museum of Women in the Arts can potentially be apprehended. And that is the particularity of the female experience as encoded in the art objects themselves.

"*Is* there such a thing?" one might ask. We are invited to entertain that possibility by the inescapable singularity of the Collection's organizing principle—women's work only. We may return to the "norm" for guidance—men's work. Until very recently, those delegates from the visual arts have been presented and accepted as cogently representative of their epoch and nation, with their individual expressions signifying universal principles. Is the particularity of the male experience not also imbedded in those works, however? Do not a Bolognese Guido Reni portrait of a cardinal and a New

York Larry Rivers portrait of his son Joseph have something to communicate other than period and national origin? We could answer: yes, biographical uniqueness— the individuality of one artist's experience, inflected in the male gender. Not neuter, i.e., "universal," gender, but male or female gender. These do constitute two modes of seeing. Whether they are *different*—substantially or marginally, always or occasionally—will be decided for each generation by the viewer's own sensitivity to and interpretation of history, psychology, socialization, biology, and biographical particulars. There may be as many different answers as there are onlookers or as there are art makers.

If there is such a thing as the particularity of the female experience implicit at various times in art (separate from the frequently fondly debated idea of an intrinsic difference between a "man's" touch and a "woman's" touch), then the National Museum of Women in the Arts collection hints at a tremendous variety. Different categories might experimentally be proposed for the following works:

blatant: Alice Neel, *T.B., Harlem,* page 89
recondite: Maria Montoya Martinez, *Collings Pot,* page 115
narrative: Marguerite Gérard, *Prelude to a Concert,* page 36; Jennie Augusta Brownscombe,
 Love's Young Dream, page 53
metamorphosed: Barbara Hepworth, *Figure (Merryn),* page 119
isolating: Gwen John, *Seated Woman,* page 117; Eva Hesse, *Accession,* page 107
jesting: Alice Aycock, *The Great God Pan,* page 112
suspended or *androgynous:* Sophie Taeuber-Arp, *Composition of Circles and Semicircles,*
 page 144; Bridget Riley, *Red, Turquoise, Grey and Black Bands,* page 122
empathetic: Elisabetta Sirani, *Virgin and Child,* page 18; Gertrude Käsebier, *The Manger,*
 page 72
symbolic: Berthe Morisot, *The Cage,* page 65; Alice Bailly, *Self-Portrait,* page 143
ambiguous in the dated Freudian sense: Georgia O'Keeffe, *Alligator Pears in a Basket,* page 81
familiar: Mary Cassatt, *The Bath,* page 49; Ellen Day Hale, *June,* page 55
emblematic: Leonora Carrington, *The Magic Witch,* page 121
enigmatic: Dorothea Tanning, *To Max Ernst,* page 95; Nancy Graves, *Rheo,* page 111
compassionate: Käthe Kollwitz, *The Downtrodden,* page 126
evocative: Georgia Jessup, *Downtown,* page 100
programmatic: Sonia Terk Delaunay, *Study for Portugal,* pages 138–39

But these designations are not exclusive to the female experience, even if we allow their applicability here. And that is the point. These same qualities are usually credited to the male experience of reality, and hence, are regarded as generically representative for the whole species. Encountering the same "universal" categories in our all-female museum merely demonstrates that they are not variants or dilutions but unalloyed constants. Whether some of these classifications are, at times, more likely to be expressed within a female or a male psyche can only be postulated—if at all—by the perceived play of cultural forces as filtered through the temperament of the interpreter, who is subject to the same forces.

A litmus test of our own preconceptions and stereotypes might be to determine how many works in the National Museum of Women in the Arts collection would tempt one to declare: "Now *that,* only a woman could have done that!" and then to repeat the procedure at the nearest museum of "mainstream" art without looking at the labels. Perhaps we would discover that, like death and taxes, art knows no sex. Perhaps not. Museum collections around the world are loaded in favor of the generic (male) artist— few mistakes in judgment of gender are likely.

Another, less quixotic, dimension in which the National Museum of Women in the Arts permanent collection can be viewed is the obvious one of high example. If role models are sought by present and future women (and men) practitioners of the arts, here, under one roof, is an inspiring treasure house. Aside from the practical fact that, if we are in search of the heritage of women artists past and present, the National Museum of Women in the Arts saves a lot of walking, there is a cumulative impact, the force of which cannot be denied. Physically and psychologically, the sheer density of so much art—so many items, styles, media, periods, and genres—is overwhelming. And heartening, if we are still in pursuit of paradigms. Ultimately, however, we con-

centrate on the art, not the sex, of the maker. And is that not one of the primary purposes of a museum?

The permanent collection of the National Museum of Women in the Arts serves a revisionist—and coincidentally feminist—cause, ensuring that the whole story of art be told, and insisting that the definition of art be broadened to include the "Anonymous Was a Woman" arenas of human endeavor. It presents not a footnote to the history of art, but a supplement; not a ghetto, but an extension. Just as Judy Chicago's extraordinary ensemble *The Dinner Party* gave the nation a beautiful and palpable catechism of women's history, so the National Museum of Women in the Arts offers its visitors a national trust, one which, it is hoped, will grow over the decades not only by means of changing exhibitions, symposia, and judicious, high-quality acquisitions but also through legacies and bequests intended to preserve, return, and introduce the achievements of women in the arts to a public that will in turn look for and ask to see the work of women in the arts in their local museums. For integration still proceeds at a snail's pace and out of tempo with that acceleration of history so characteristic of the twentieth century.

Here, in one museum, is a permanent collection of works by artists who happened to be women. "Happened to" should be incidental and not an organizing principle. But history and past practices have deemed differently. The National Museum of Women in the Arts is a historical corrective and much more. It initiates a new era determined to give more than lip service to the happy phenomenon that for five thousand years art and creativity have been the province of both sexes. If Adam could depict Eve, Eve could and did depict Adam. Together or apart they illuminate each other. Here it is, then, this "room of one's own," this museum of special purpose. Depending on our point of view, we may welcome it, quarrel with it, applaud it. But from now on, like Mount Everest, it exists. And we should like to believe that, as with Mount Everest, people will climb the steps to it, simply and especially "because it's there."

Alessandra Comini
University Distinguished Professor of Art History, Southern Methodist University

FOUNDERS' STATEMENT

THE NATIONAL MUSEUM OF WOMEN IN THE ARTS is more than a collection. It is a beautiful building, exhibition halls, a library and resource center, a large auditorium, a knowledgeable Board of Trustees, energetic volunteers, and a hardworking staff dedicated to presenting art by women in all media to the public. The Museum is also the fulfillment of a dream, a dream made possible by the generous financial and emotional support of individuals, institutions, and corporations throughout the United States and abroad.

The collection has been given as a seed from which the Museum's own holdings might grow. The works pictured in this book, therefore, have great personal significance for us. We have lived with the paintings and sculpture for years; they are old friends. Many of the acquisitions for the collection marked special occasions, such as Christmas or a particular birthday. Some were happy discoveries made while traveling and bring back memories of other years and other countries.

It pleases us greatly that the Museum collection, now in book form, can be more widely shared. We hope that this catalogue will provide continued enjoyment to those who come to the Museum and will induce others to visit.

Wallace and Wilhelmina Holladay

SELECTIONS FROM THE PERMANENT COLLECTION

LAVINIA FONTANA

ITALIAN | 1552-1614

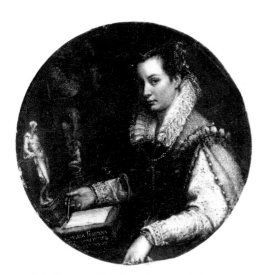

Lavinia Fontana. *Self-Portrait*. 1579. Oil on canvas. Uffizi Gallery, Florence

OPPOSITE:
Lavinia Fontana. *Portrait of a Noblewoman*. c. 1580. Oil on canvas, 45¼ × 35¼". The Holladay Collection

THE FERMENT of change associated with the Italian Renaissance and its aftermath affected many aspects of culture and society, including the status of women as artists. The atmosphere of the city of Bologna, where women had been admitted to the university since the thirteenth century, was one of the most conducive in Italy to the development of the artistic talent of women. In the sixteenth and seventeenth centuries, twenty-three women painters are recorded as having worked in Bologna. Two of these, Lavinia Fontana and Elisabetta Sirani, are represented in the Holladay Collection.

Lavinia Fontana is considered to be the first woman painter to have achieved a successful artistic career, supporting herself and her family by her work, which included major commissions from public and private patrons. Fontana was encouraged to develop her artistic potential by her father, Prospero, a well-known artist and teacher, with whom she also studied. Among his other pupils were Ludovico Carracci (elder cousin of Agostino and Annibale Carracci) and Gian Paolo Zappi, whom Fontana married in 1577. Her husband appears to have given up his own artistic career to assist his wife in her studio, handle her finances, and help care for their growing family.

Fontana achieved her initial success as a portrait painter in her native Bologna. *Portrait of a Noblewoman*, shown here, is characteristic of her many depictions of women. The unidentified young woman is standing in a three-quarter-length pose, her gaze modestly averted from the viewer. One hand caresses a small lap dog and the other holds a marten skin, which is adorned with an exquisitely jeweled head. Marten skins can often be found in portraits of upper-class women, who used them to draw fleas away from their bodies and clothes. Fontana has skillfully depicted the contrasting textures of the gauzy silk underdress and heavily embroidered velvet overdress and carefully rendered each detail of the gold, pearl, and ruby jewelry. As in many of her portraits of women, the background is uniformly dark and flat.

Fontana also painted large public altarpieces, a rare distinction for a woman artist. Women were generally not commissioned to do altarpieces, since these works often required the composition of scenes involving many figures, including male and female nudes, which women were not encouraged to study. Her first altarpieces were for churches in Bologna and Cento and date from 1589. After moving to Rome around 1603, she created the best known of her public commissions, *The Stoning of St. Stephen*. This altarpiece, painted for the church of San Paolo fuori le Mura, one of the seven pilgrimage churches of Rome, was unfortunately destroyed by fire in 1823.

As with other successful artists of the period, Fontana was also commissioned to execute small-scale, private religious works. The Holladay Collection possesses an early work, *Holy Family with St. John* (see page 180), which is sketchily painted on copper and was probably intended for use in a personal chapel.

Although fewer than half of the 135 recorded works by Lavinia Fontana can be identified today, this number still represents the largest surviving body of work by a major woman artist before the eighteenth century.

M.L.W.

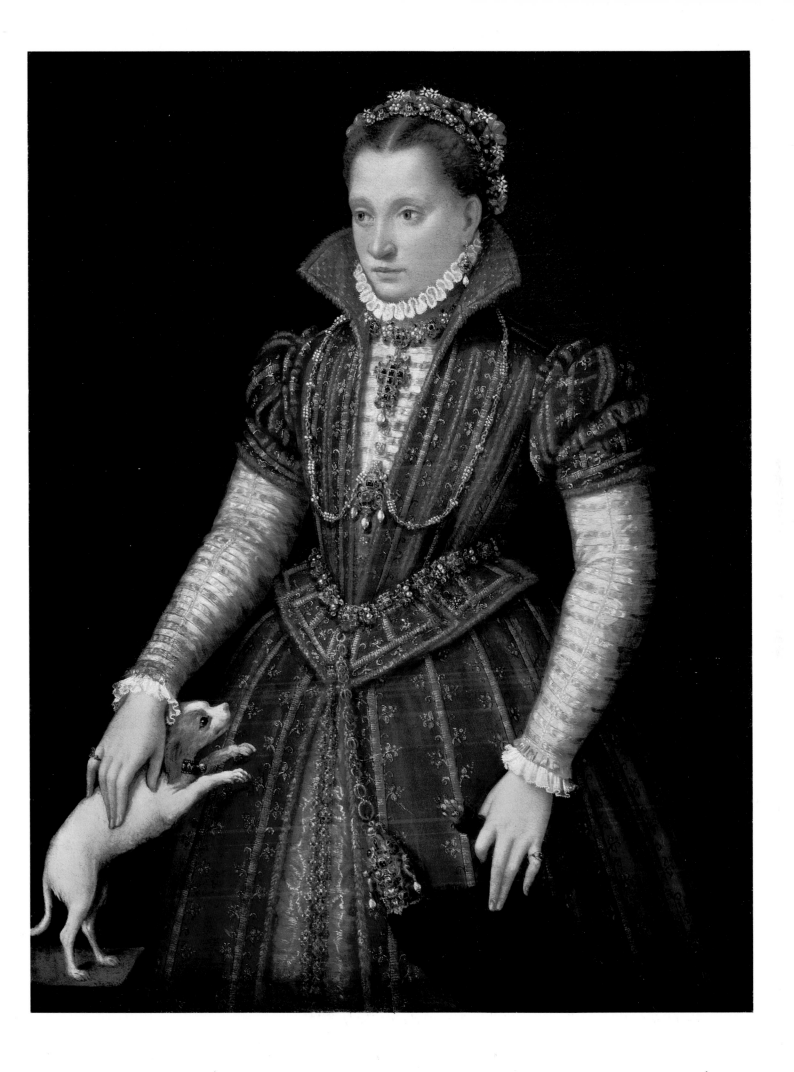

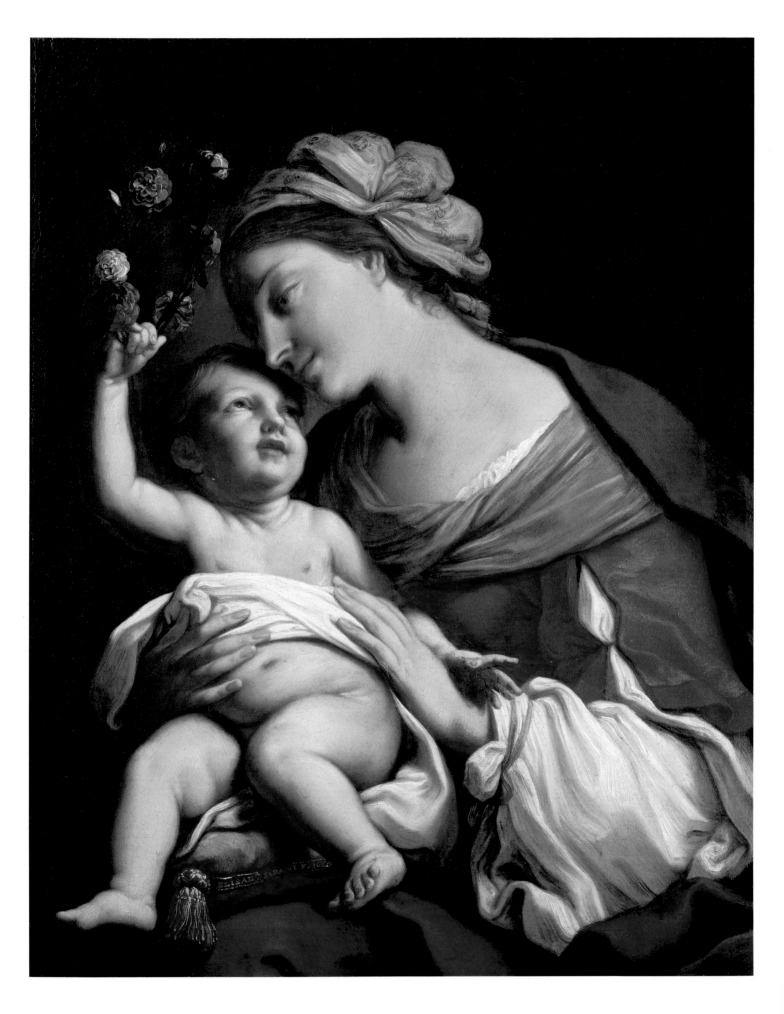

EVEN IN seventeenth-century Bologna, which was well known for its intellectual and artistic women, the talent of Elisabetta Sirani was considered unusual. Her international fame and prodigious output helped to make her a living legend, while the mysterious circumstances surrounding her death at the young age of twenty-seven only added to her renown in her native city.

Sirani learned to paint in the workshop of her father, a local artist, Gian Andrea (1610–1670), where she studied the style of Guido Reni, the most influential seventeenth-century Bolognese painter. Early in her career, she opened her own studio and a school for women painters, an avant-garde institution in this period, thus earning enough money to support her family and allow her crippled father to retire. Many anecdotes of her life and career have been noted by Count Carlo Cesare Malvasia, biographer of Bolognese artists and a family friend.

Malvasia also published a list of Sirani's works, which she herself compiled as proof against contemporary forgeries. In the ten years during which she worked, about 190 pieces are recorded, the great majority executed for private patrons. Several stories noted in Malvasia's chronicle testify to her rapid working procedures, such as the account of the visit of Cosimo of Tuscany in 1664. After the Crown Prince watched her work on a portrait of his uncle Prince Leopold, he ordered a Madonna for himself, which she executed quickly so that it could dry and be taken home with him. These and other bravura performances made her studio internationally famous.

Sirani's sudden death in the summer of 1665 has never been satisfactorily explained—both poisoning and ulcers have been suggested as causes for her demise. The entire city of Bologna went into mourning and arranged a magnificent funeral, at which the oration was delivered by the Prior of the Lawyers of the university. As a final tribute, she was buried next to Guido Reni.

By the time she died, Sirani's work already showed an impressive knowledge of the major Renaissance styles current in centers outside Bologna. Her drawings, etchings, and paintings of religious themes and unusual mythological subjects indicate that she was also familiar with the Bible, lives of the saints, and Greek and Roman mythology, subjects considered necessary elements of the education of a contemporary artist.

The Holladay Collection contains three examples of Sirani's work which illustrate different facets of her art. The signed and dated painting *Virgin and Child* was executed two years before she died. In her list of works it is described as "a Blessed Virgin half figure with the Child in her arms, and said Child lifts a fistful of roses with his right hand, and with the left caresses his Mother, for Signor Paolo Poggi." As an example of her mature style, the scene is sweet and intimate, fully in keeping with the spirit of the times. The child turns to playfully crown his mother with a garland of roses in a completely naturalistic rendering of an oft-depicted theme. Sirani's technique is quite accomplished, especially in the subtle differentiation of the child's soft pink skin from his mother's more olive coloring. The broad, fluid brushstrokes used to delineate the mother's bodice and sleeves contrast with the refined patterns of her headdress and loose curls of coarse brown hair. Sirani has effectively used a limited palette of different tones of white, red, and blue to set off the mother and child against the dark background.

The two etchings in the Collection (both, see page 231) illustrate Sirani's early interest in this medium. *Madonna and Child with St. John the Baptist*, after a composition by Raphael, is indicative of her study of High Renaissance artists. *Holy Family with St. Elizabeth and St. John the Baptist*, her own interpretation of a similar subject, places the family in a contemporary setting.

Sirani's considerable talent and fresh approach to old themes made her works sought after and highly praised by her contemporaries. Even in her short lifetime, Elisabetta Sirani developed an individual style that stands out in the context of seventeenth-century Bolognese art.

M.L.W.

OPPOSITE:
Elisabetta Sirani. *Virgin and Child*. 1663. Oil on canvas, 34 × 27½". The Holladay Collection

Portrait of Elisabetta Sirani

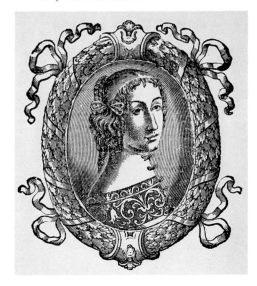

CLARA PEETERS

FLEMISH | 1594–AFTER 1657

STILL-LIFE paintings, which became important in late-sixteenth-century Flanders and The Netherlands, evolved from simple anecdotal elements such as vases of flowers or groups of household objects found in late medieval and early Renaissance portraits and religious works. Clara Peeters of Antwerp was one of several women who pioneered the development of still-life painting. Little is known of her life except the record of the registry of her baptism (1594) and marriage (1639) in the same church in Antwerp. Over thirty-one signed works, of which nine are dated, were painted in the years 1608 to 1657 and illustrate several important still-life categories. Four works are pure flower paintings, and five are compositions that contain vases of flowers balanced by groups of different kinds of food, expensive vessels, and costly gold chains and coins. Her remaining still lifes can be categorized as fish pieces, breakfast pieces (depicting food for a light meal at any time of day), and banquet pieces. Peeters is generally credited with the development of the latter two categories of still lifes.

This unsigned work in the Holladay Collection, *Still Life of Fish and Cat*, is typical in subject matter, composition, and style of Peeters's late work. The theme of a fish stalked by a cat is found in at least four signed works. Peeters often combined perch, shrimp, and oysters in groupings that contrasted their colors, shapes, and textured surfaces. While her earlier works were extravagant displays of sumptuous vases and luxurious foods, known appropriately enough as banquet pieces, her later works, such as this one, depict commonplace foodstuffs and vessels of humble materials. Peeters has, as in other paintings, created an asymmetrical composition, with the few objects neatly grouped on a narrow ledge. The slightly off-center earthenware strainer, laden with eels and fish, is balanced by the forms of the crouching cat on one side and the shallow metal plate of oysters and shrimp on the other. The use of a slanting object to establish depth beyond the picture plane, in this case the figure of the small fish being guarded by the cat, is a convention used in many of her works.

Clara Peeters is particularly important to the National Museum of Women in the Arts because of her profound influence upon Wilhelmina and Wallace Holladay in the formative years of their collecting. When they first saw her paintings in Vienna and Madrid in the early 1960s, they were particularly struck by their beauty and, upon returning to the United States, tried to learn more about the artist. They found that the standard art history text by H. W. Janson did not at that time contain reference to Peeters—or to any other woman artist—and decided to focus their collecting upon works by women, thus forming the nucleus of the National Museum of Women in the Arts.

M.L.W.

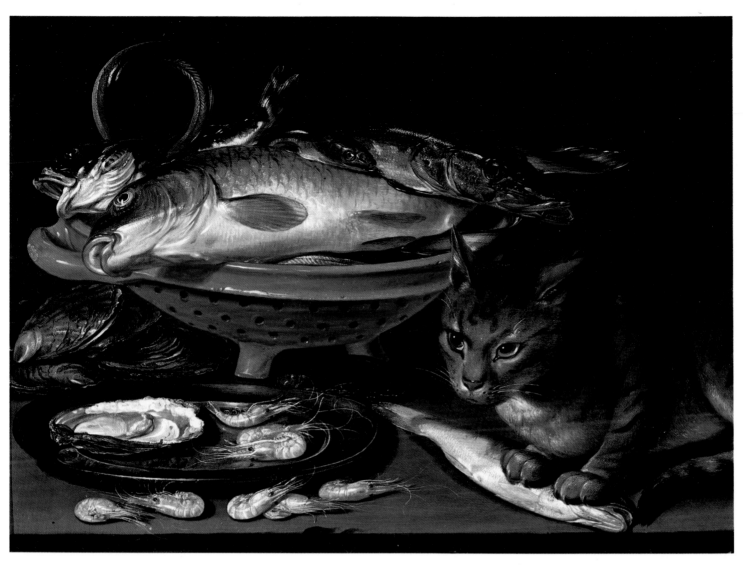

Clara Peeters. *Still Life of Fish and Cat.* Oil on
panel, 13½ × 18½". The Holladay Collection

Clara Peeters. *Self-Portrait with Still Life.* Present
location unknown

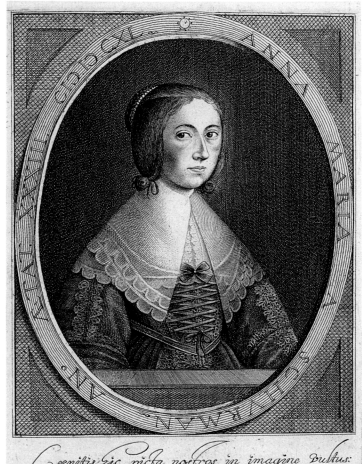

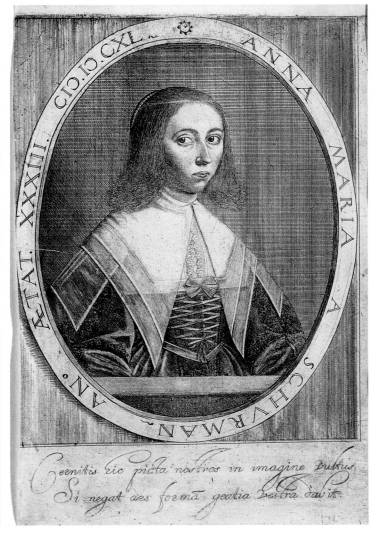

ANNA MARIA VAN SCHURMAN was a noted scholar, linguist, poet, and artist—an unusual combination in the seventeenth century. The record of Van Schurman's intellectual accomplishments, for which she is best known, is impressive. At the age of seven she had mastered Latin, at ten was easily translating from Latin into French and Flemish, and at eleven was reading Homer and the Bible in the original Greek and Hebrew. In total, she knew fifteen languages. When she was an adult, Van Schurman was invited to participate in discussions at the University of Utrecht. At the University of Leyden, she was honored by the professors, who allowed her to attend lectures behind a specially constructed screen that shielded her from the gaze of an inquisitive audience. She corresponded widely with noted theologians, philosophers, and scholars.

As an artist Van Schurman specialized in portraiture, leaving more than twenty-one engraved or painted likenesses in collections in Europe and America. The two self-portraits in the Holladay Collection, dating from 1640, depict Van Schurman at the age of thirty-three. They are probably two versions of the same design, each showing the artist in a three-quarter position but in different costume and different hairstyle. The inscription appearing below both images can be translated as follows:

You describe our countenances in the image depicted here:
If art denies form, your grace will furnish it.

The writer is probably Antonio Maria à Sancta Trinitate.

The self-portraits have been executed in two different techniques. The image on the right, done in drypoint, has a softer, more spontaneous quality, visible in the features of the face, the long hair, the shading of the sleeves, and the transparency of the large collar. In the drypoint process a design is cut into a metal plate with a fine steel needle; the burr raised on either side of the incision produces a soft, feathery line.

The self-portrait on the left is an engraving with etched details. The engraving process is similar to drypoint, except that the design is cut into the plate with a pointed steel tool, and the burr raised on either side of the groove is wiped away to give a sharper line, evident in the eyebrows, pearl hair ornament, and detailed embroidery of the dress. Interesting effects were added to this image by the process of etching, in which the plate is coated with resin, the details are traced through the resin to the metal, and the plate is submerged in an acid bath to dissolve the exposed metal. The plate is heated to remove the resin, then inked and printed on paper.

M.L.W.

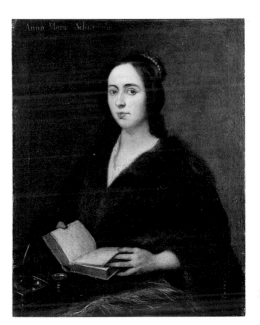

Jan Lievens the Elder (Dutch, 1607–1674).
Portrait of Anna Maria Van Schurman. 1649.
34¼ × 27″. The National Gallery, London

OPPOSITE. LEFT:
Anna Maria Van Schurman. *Self-Portrait.* 1640.
Drypoint, 8 × 5⅞″. The Holladay Collection

OPPOSITE. RIGHT:
Anna Maria Van Schurman. *Self-Portrait.* 1640.
Engraving with etching, 8 × 5⅞″. The Holladay Collection

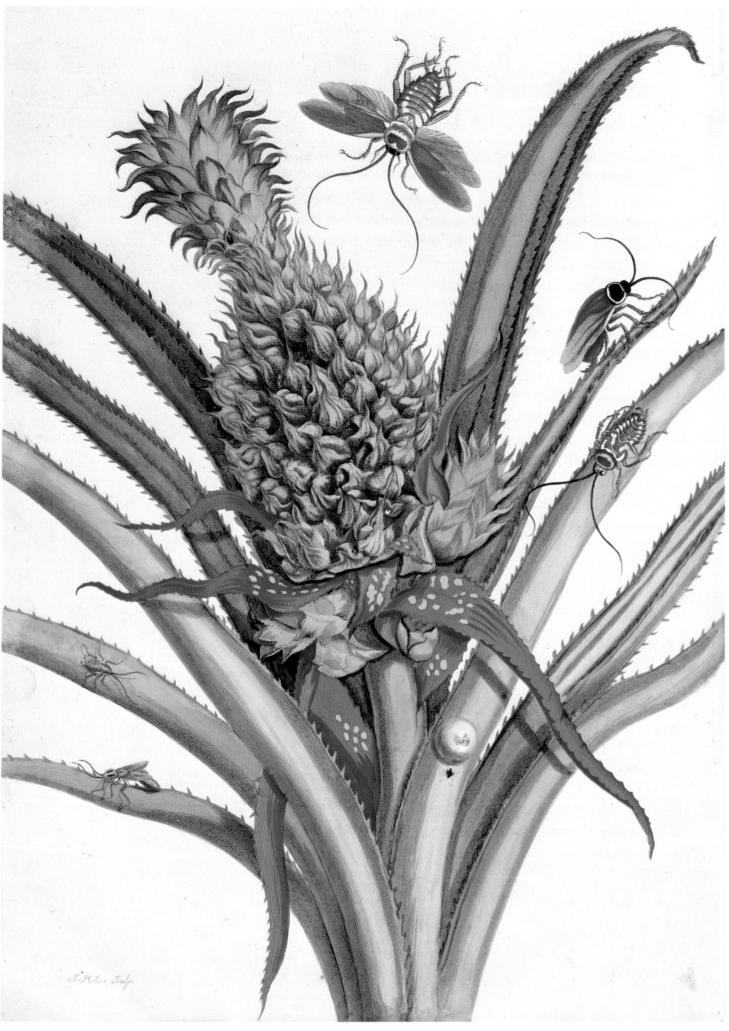

MARIA SIBYLLA MERIAN
GERMAN | 1647–1717

Maria Sibylla Merian's life and work are as important to the history of the natural sciences as they are to the history of art. Merian was born in 1647 in Frankfurt to Matthäus Merian the Elder (1593–1650), a Swiss engraver and publisher who specialized in city views and landscapes, and Johanna Catharina Hein, a Dutch woman. After her father's death in 1650, Merian's mother married the Flemish flower painter Jacob Marrel (1614–1681), who had been trained by one of the greatest seventeenth-century Dutch flower painters, Jan Davidsz. de Heem, and who arranged for Merian's early training. She married the painter Johann Andreas Graff (1637–1701) in 1665, and they moved in 1670 to Nuremberg. Merian was visited there in 1675 by the German biographer Joachim von Sandrart, who reported that by then she was making oil and watercolor paintings of flowers, fruit, birds, worms, flies, mosquitoes, spiders, "and other filth."

During this early period of her life, Merian was conducting her own scientific research on the life cycles of insects, as well as producing flower paintings and drawings for private patrons. She collected insect eggs, caterpillars, cocoons, chrysalises, and adults of each species and studied their eating habits and evolution. Her discoveries confounded the popular belief of her day that most insects emerged spontaneously from dirt and mud. She published her research, her first completely original publication (she published a largely derivative book of flower illustrations beginning in 1675), in 1679 and 1683 as *The Wonderful Transformation of Caterpillars and [Their] Singular Plant Nourishment*. A third volume was published posthumously in 1717. The book catalogues 186 European moths, butterflies, and other insects based on her own investigations and drawings. The format was revolutionary, showing on a single page each creature in all stages of metamorphosis, on or near the plant she had learned was its favorite. Her design has subsequently become a model for zoological and botanical illustration.

In 1690 Merian moved to Amsterdam and soon became part of the scientific and artistic community there, counting among her acquaintances such scientific collectors as Frederick Ruysch, father of the flower painter Rachel Ruysch. Following an interest sparked by collectors' specimens of Surinam insects, Merian acquired the support of the city of Amsterdam in 1699 for a two-year voyage to the South American Dutch colony. During her two years in Surinam she collected and raised insects in cages and vessels, made extensive notes and drawings, and interviewed the native population concerning local customs, especially in the uses of plants. After her return to Amsterdam she prepared and published in 1705 the *Metamorphosis of Insects of Surinam*. The Holladay Collection possesses a second edition (1719) of this volume, entitled *Dissertation in Insect Generations and Metamorphosis in Surinam*, from which an engraving is illustrated here.

Merian's last years were spent preparing a Dutch-language version of her European insect study. She died in 1717.

M.B.M.

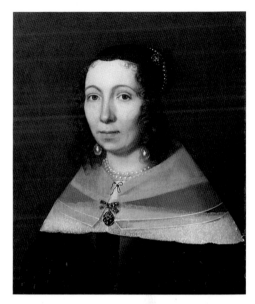

Netherlandish (?) Master of 1679. *Portrait of Maria Sibylla Merian*. 1679. Oil on canvas. Offentliche Kunstsammlung, Basel

OPPOSITE:
Maria Sibylla Merian. Illustration from *Dissertation in Insect Generations and Metamorphosis in Surinam*. Bound volume of 72 hand-colored engravings, 2nd edition. 1719. The Holladay Collection

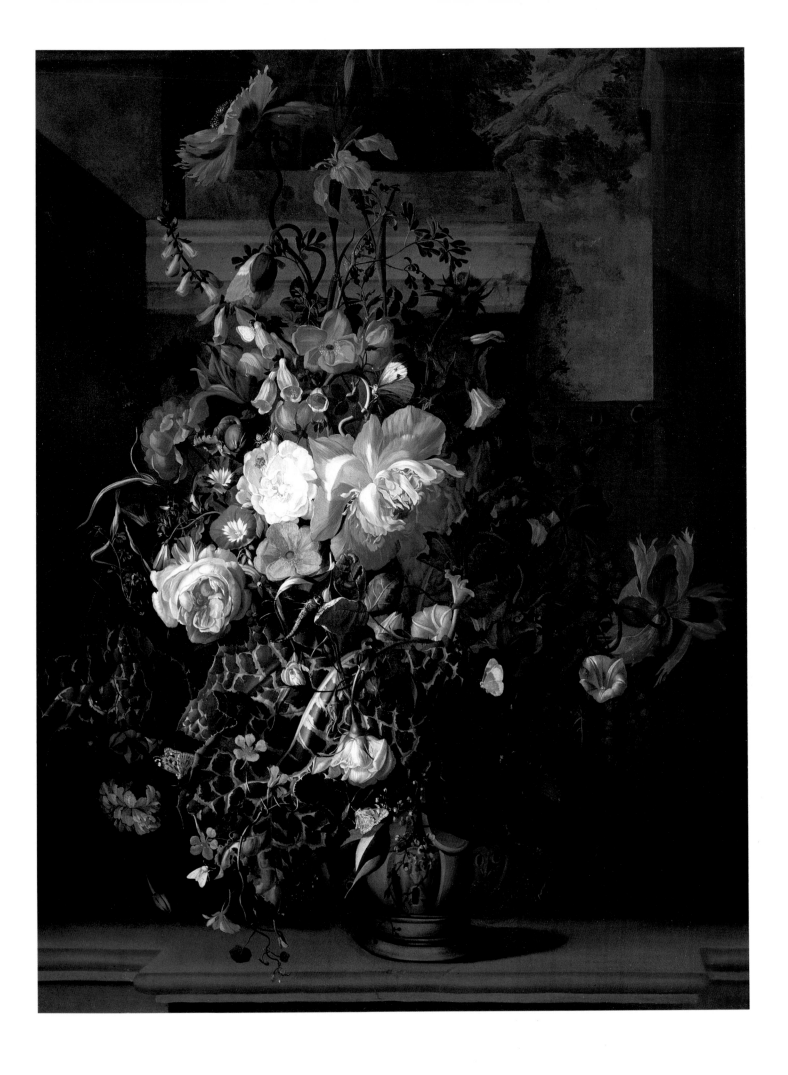

RACHEL RUYSCH

DUTCH | 1664–1750

IN SEVENTEENTH-CENTURY Holland, flower pieces were one of the most popular still-life types, often depicting tulips, a fashionable and expensive flower of the period. In the next century, although still lifes in general became unpopular, flower paintings continued to have widespread appeal. The premier flower painters of this century were Rachel Ruysch and Jan van Huysum. Ruysch's production of over one hundred paintings brought her fame and wealth during her lifetime and continued her reputation after her death.

Rachel Ruysch's family encouraged her interest in both art and flowers: her father was an amateur painter and a noted professor of anatomy and botany, and her mother was the daughter of the celebrated architect Pieter Post. Ruysch studied with the flower painter Willem van Aelst and, in 1693, at the age of twenty-nine, married the portrait painter Juriaen Pool. The couple were appointed court painters to the Elector Palatine and lived in Düsseldorf from 1708 until the Prince's death in 1716, when they returned to Amsterdam; during this period Ruysch painted exclusively for the Elector and also bore and reared ten children.

Both paintings in the Holladay Collection, *Flowers in a Vase* (see page 228) and *Roses, Convolvulus, Poppies and Other Flowers in an Urn on a Stone Ledge*, reproduced here, are excellent examples of Ruysch's distinctive style. The flowers are arranged asymmetrically to form an S-curve, a device Ruysch adapted from her teacher van Aelst and used to such advantage that it became a cliché with later eighteenth-century flower painters. The flowers are painted in a precise, delicate style, each detail carefully and naturalistically rendered. In both pictures, the vase holding the flowers is placed on a ledge parallel to the picture plane and centered in the foreground of the composition. The large flower piece illustrated here is set against a three-dimensional architectural framework that adds depth to the composition. In the upper right corner, an opening into the distance gives a glimpse of a forest, one of Ruysch's favorite settings.

Some artists created flower paintings as examples of *vanitas* pieces, in which the transience of the brilliantly colored blooms symbolized the brevity of life itself. Ruysch was more interested in producing a faithful depiction of nature, and she worked slowly and carefully—she once spent seven years finishing three canvases for a daughter's dowry. As with most other flower painters, Ruysch probably worked from studies of flowers rather than from the actual blooms themselves. This method had several advantages. An artist could include in one work flowers that bloomed at various times of the year. In the case of this particular Ruysch painting, the flowers are all spring blooms, but using sketches meant that Ruysch could work slowly and not be concerned about the flowers fading and dying before she had finished the picture.

The high esteem in which the artist was held is indicated by the prices that her works commanded: while her predecessor Rembrandt rarely received more than 500 guilders for a work, Rachel Ruysch routinely earned from 750 to 1,250 guilders per painting.

M.L.W.

Constantijn Netscher (Dutch, 1668–1723). *Rachel Ruysch (1664–1750) in Her Studio.* c. 1710. Oil on canvas, 44¹⁵⁄₁₆ × 35⅞″. The North Carolina Museum of Art, Raleigh

OPPOSITE:
Rachel Ruysch. *Roses, Convolvulus, Poppies and Other Flowers in an Urn on a Stone Ledge.* c. 1745. Oil on canvas, 42½ × 33″. The Holladay Collection

MARIE ANNE LOIR

FRENCH | c. 1715–1769

Since the late Middle Ages, the social and intellectual position of artists had been ill-defined, as painters, sculptors, and architects attempted to free themselves from association with artisans and craftsmen and to establish their position as professionals. To facilitate this process, academies were founded by some cities, such as Rome, Florence, and Toulouse, as well as by national governments, such as those of France and England, and patronized by the ruling royal families. This prevailing academy system did provide status and support to some artists, but since membership in the academy was essential to obtain commissions, the development of those artists who did not conform to the official style was limited. Quite often, the number of members was also restricted and only a token number of women, if any, were admitted.

In France, the Académie Royale de Peinture et de Sculpture, founded in 1648 under the patronage of Louis XIV, sponsored the annual Salons that exhibited the best work of the approved artists and administered the Ecole des Beaux-Arts, which trained artists in the official style. While a few women artists were admitted to the Academy during the seventeenth and eighteenth centuries, in 1770 the number was officially limited to four. After the Revolution, when the Academy was reopened, the position of women artists improved, and more women submitted paintings for exhibition at the annual Salons. More limiting for the development of their artistic careers, however, was the prohibition against women attending the Ecole des Beaux-Arts or working from a nude model.

Without such training, women artists had difficulty learning to execute the large-scale figural compositions that were usually integral to the history and religious works considered to be the most important kind of painting. Women were thus restricted to practicing the so-called minor forms of painting: portraiture, still life, floral and animal pieces, and intimate genre scenes. They were also not allowed to compete for the prestigious Prix de Rome. Since only Prix de Rome winners received Church or State commissions to paint the large historical, allegorical, and religious canvases considered the most legitimate form of painting, women were prevented from achieving influential positions in the artistic world.

The earliest French woman artist in the collection of the National Museum of Women in the Arts is Marie Anne Loir, who came from an artistic family resident in Paris since the seventeenth century. She studied with Jean-François de Troy (1679–1752) in the French capital and probably joined him in Rome when he became Director of the Académie de France there in 1738. She was elected to the Academy of Marseilles in 1762 and is recorded as having painted the portraits of several wealthy patrons from Pau in the 1760s.

This portrait, *Madame Geoffrin*, in the Holladay Collection is characteristic of Loir's work. Of ten known dated portraits by Loir, all are of wealthy members of the aristocracy or upper bourgeoisie, such as Madame Marie Thérèse Geoffrin (1699–1777), who, for more than twenty years, held a weekly salon where celebrated artists and writers gathered.

The portrait of Madame Geoffrin illustrates Loir's technical mastery of and improvement upon the popular portrait style of Jean-Marc Nattier (1685–1766) and his son-in-law Louis Tocqué (1696–1772), which, at the expense of an accurate portrayal of the sitter's personality, emphasized the costly details of the dress.

Loir, on the other hand, succeeded in making the painting a penetrating character study of an intelligent and influential woman, as well as accurately recording the details of her jewels, laces, and velvet overdress. Instead of idealizing her sitters' features, she stressed their personalities, thereby providing later generations with realistic depictions of the women who helped to shape the history of France in the years before the Revolution.

M.L.W.

OPPOSITE:
Marie Anne Loir. *Madame Geoffrin*. Oil on canvas, 39½ × 32¼". The Holladay Collection

28

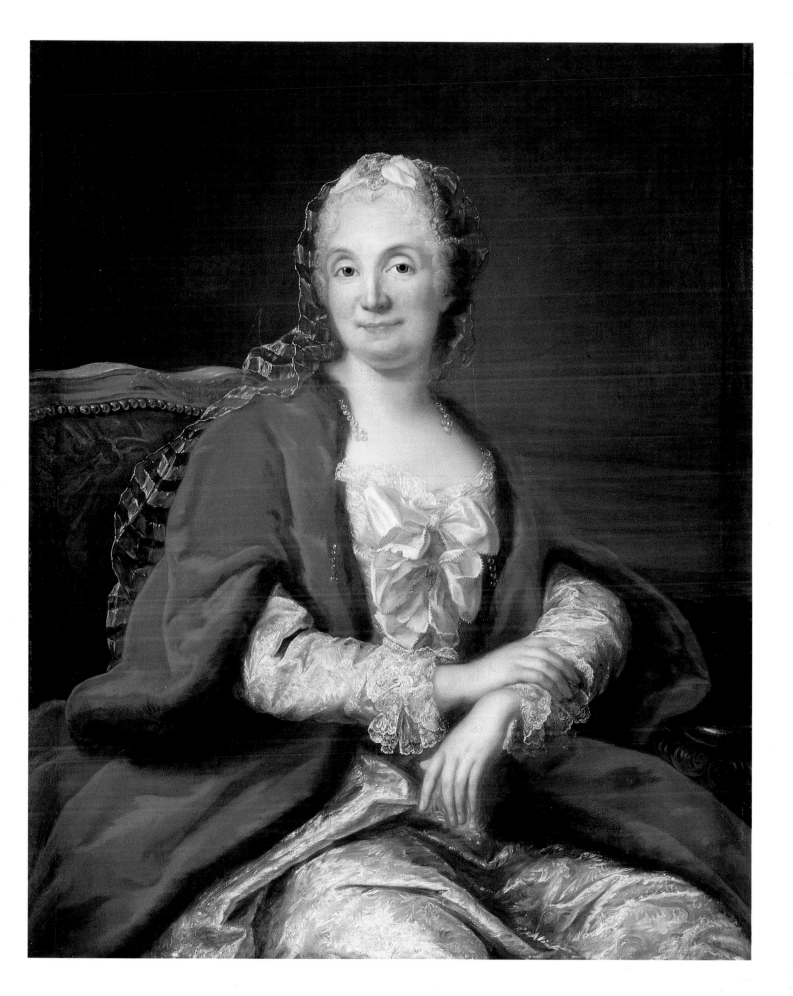

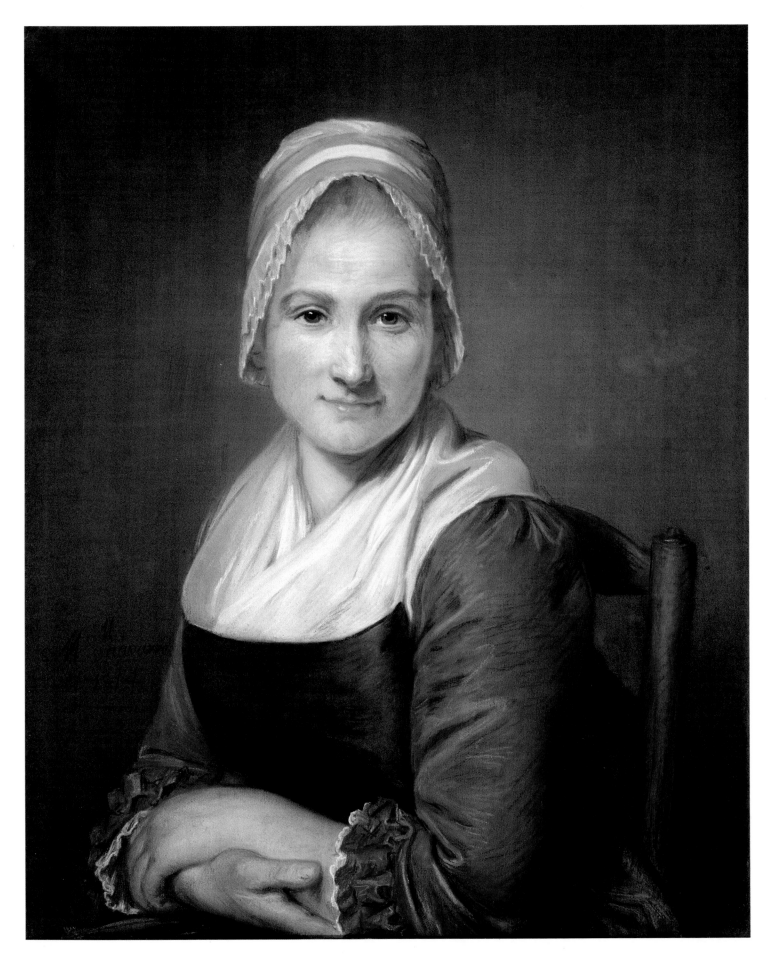

T HE USE OF pastels for portraits in France became widespread after the visit of the Venetian artist Rosalba Carriera (1675–1757) to Paris in 1720–21. By exploiting the unique properties of pastel crayons to produce a wide range of tonal nuances and unusual textural effects, Carriera executed portraits in a dazzlingly brilliant technique that helped to bring the Rococo style to Italy and France.

Carriera's influence in France was spread by Maurice Quentin de La Tour (1704–1788), who, as a painter to the royal family of France and member of the Academy, is credited with developing the pastel portrait in eighteenth-century France. The many students trained in his style include the finest women pastelists of the day, Adélaïde Labille-Guiard and Madame Roslin. Another pupil of La Tour's was Marie-Geneviève Navarre, about whom little is known. The only painting attributed to her is the signed and dated portrait in the Holladay Collection, the work of a mature artist in the exacting medium of pastel.

This pastel portrait depicts a young woman seated on a plain, straight-backed chair. She is dressed in a red-brown garment whose sleeves end above the wrists and are edged with ruching of the same material and white lace. A large shawl of white batiste is crisscrossed over her chest and folded into her black apron. Her gray-blonde hair is scarcely visible, tucked into a white linen bonnet decorated with a double band of orange ribbon. Her delicate peach-colored skin, rosy cheeks, and brown eyes are set off against the cool greenish-gray background.

The identity and even the class of the woman are unknown. She could be a peasant woman in her Sunday finery, a servant of a middle-class family, a daughter of a prosperous bourgeois family, or even an upper-class woman masquerading as a member of the lower class, often a fashion in this period.

The one reference to Navarre's personal life is the record of a brief marriage that ended in legal separation in 1779. The only mention of her professional career is found in documents of the Académie de Saint-Luc, the one alternate group open to artists who were not admitted to the Académie Royale. This ancient institution, which traced its origins to medieval painters' and sculptors' guilds, trained and licensed artists and held occasional exhibitions until its abolition in 1777. About three percent of its membership of 4,500 were women, all admitted in the eighteenth century. Of these, most were portraitists working in oil, pastel, and miniature. The first record of Navarre's exhibiting was in 1762, when she was twenty-five. Two years later she submitted two portraits and, in 1774, several pastel portraits and portrait miniatures. The portrait in the Holladay Collection was probably shown at this time. Navarre is also recorded as having shown works at the Hôtel d'Aligre in 1762 and 1764.

No other signed works by Marie-Geneviève Navarre are known. Unfortunately, the possibility exists that her name was removed (an easy enough job in the medium of pastel) and replaced with the signature of another, better-known artist.

M.L.W.

OPPOSITE:
Marie-Geneviève Navarre. *Portrait of a Young Woman.* 1774. Pastel, 24 × 19¾". The Holladay Collection

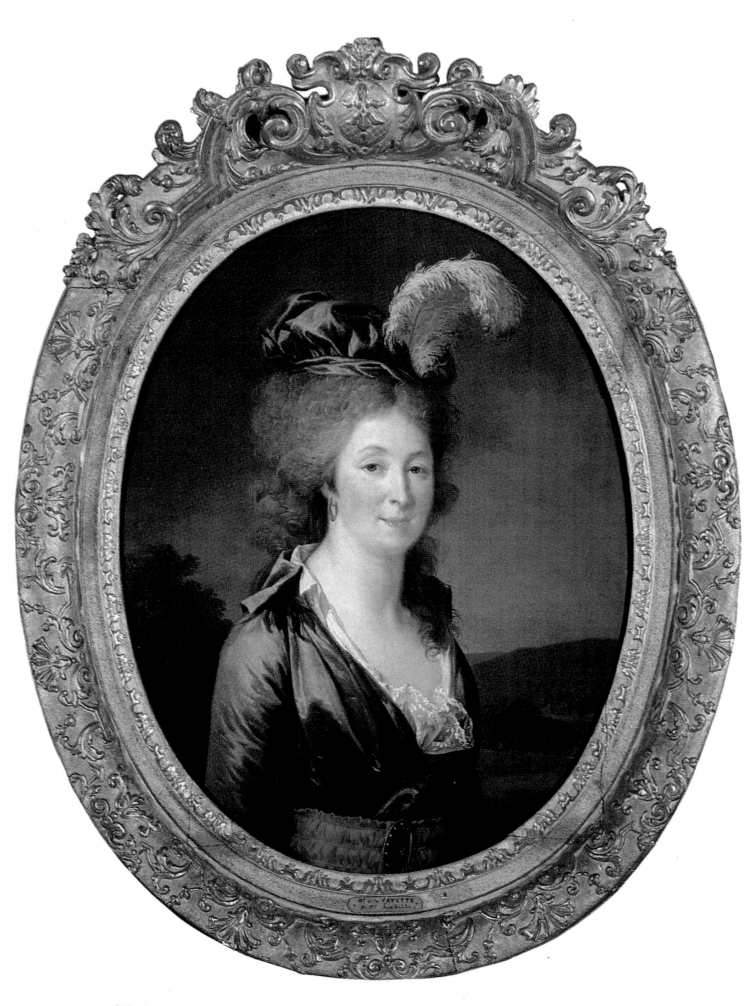

32

ADELAIDE LABILLE-GUIARD

FRENCH | 1749–1803

Adelaide Labille-Guiard was a noted and successful painter who also worked actively during the French Revolution to further the cause of women and of women artists.

Her first formal training was with the miniaturist François Elie Vincent (1703–1790). From 1769 to 1774 she studied with Maurice Quentin de La Tour, the foremost French pastel painter and an acclaimed portraitist. Aspiring to be more than just a portrait painter, Labille-Guiard then studied oil painting with François André Vincent (1746–1816), an important history painter, son of her first teacher, and a close childhood friend whom she married in 1800.

The young artist exhibited to the public for the first time in 1774 at an exposition of the Académie de Saint-Luc, the only alternative to the official Académie Royale. Her next public notice came in 1782 at the newly created Salon de la Correspondance, successor to the now abolished Académie de Saint-Luc as focal point for nonofficial artists.

Entrance into the official Academy was particularly difficult for women, since membership had been restricted in 1770 to four women: To gain admittance and to counter rumors that her works were executed by Vincent, Labille-Guiard painted a series of pastel portraits of prominent Academicians. She was elected by a majority vote on May 31, 1783, the same day that the famous portraitist Elizabeth Vigée-Lebrun was admitted—but by decree of the Queen, Marie Antoinette.

During the 1780s, Labille-Guiard was a sought-after teacher and portraitist, counting among her high-born clients the maiden aunts of King Louis XVI. She was also much in favor of the ideals of the Revolution, hoping that, among other reforms, the change in government would advance the cause of women artists. During the 1790s, she gradually built up a new clientele composed of members of the ruling revolutionary elite, both former nobility and prominent bourgeoisie. *The Portrait of the Marquise de la Fayette (?)*, shown here, is an oil painting presumed to be a portrait of the wife of Lafayette, hero of the American Revolution. It was probably painted in 1790–91, when the general, a member of the Constituent Assembly, was also head of the Parisian National Guard. Later he and his wife were both imprisoned for their royalist connections.

The half-length figure of the Marquise is turned slightly toward the viewer, a pose the artist favored for many of her subjects. The panoramic landscape background, suggestive of influence from the eighteenth-century English portraitist Thomas Gainsborough, was employed sporadically by Labille-Guiard throughout her career. The Marquise is dressed in the simple costume worn by women during the early years of the Revolution. Both dress and landscape are executed in the cooler tones and simpler decor Labille-Guiard used in the 1790s. In spite of the trend toward simplicity in dress favored by the Revolutionary leaders, Labille-Guiard has faithfully depicted the differing textures of the Marquise's costume, contrasting the feathery plume with the rich satin of the bonnet and dress and the delicate bit of lace at her bosom. Never one to unnecessarily flatter her sitters, Labille-Guiard has portrayed the Marquise as a slightly older woman with puffy cheeks and graying hair, staring uncompromisingly at the viewer.

The Portrait of the Marquise de la Fayette (?) illustrates the artistic skill and forthright approach that made Labille-Guiard a successful painter before and during the Revolution.

M.L.W.

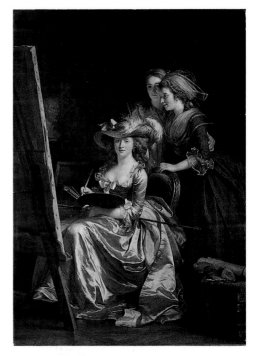

Adélaïde Labille-Guiard. *Self-Portrait with Two Pupils, Mademoiselle Marie Gabrielle Capet (1761–1818) and Mademoiselle Carreaux de Rosemond (died 1788)*. 1785. Oil on canvas, 83 × 59½". The Metropolitan Museum of Art. Gift of Julia A. Berwind, 1953

OPPOSITE:
Adélaïde Labille-Guiard. *Portrait of the Marquise de la Fayette (?)*. Oil on canvas, 30¾ × 24¾". The Holladay Collection

MARIE LOUISE ELIZABETH VIGEE-LEBRUN

FRENCH | 1755–1842

ARIE LOUISE ELIZABETH VIGEE-LEBRUN, one of the most famous and most highly paid portrait painters of the 1780s and '90s in France, included among her sitters the royalty and nobility of much of Europe. She excelled at choosing the most appropriate pose, the most flattering costume, and the most creative setting to present a client at his or her best.

Vigée-Lebrun, the daughter of a minor portrait painter and a hairdresser, was not well connected herself. She learned her craft from her father and his friends and from studying nature and the old masters. By the time she was twelve, when her father died, she was able to support her family by painting. Even though well established at a young age, she was strongly urged by her mother to marry the respected connoisseur, art dealer, and painter Jean Baptiste Pierre Lebrun, twelve years her senior. Although her husband proceeded to squander her considerable earnings, he promoted both her artistic career and her social life.

The Holladay Collection contains five works by the artist that illustrate different periods, media, and themes of her career. A portrait of Madame d'Espineuil in pastel (see page 242), the first medium in which Vigée-Lebrun became proficient, dates from around 1776 and exemplifies the artist's graceful, elegant style.

In 1778, Vigée-Lebrun was commissioned to paint a portrait of Marie Antoinette, which assured her career as a society portraitist; the Collection contains one of twenty to thirty likenesses she executed of the Queen. The painter's close personal relationship with Marie Antoinette was a factor in obtaining her admission to the Academy in 1783, even though, as the wife of an art dealer, formal rules barred her from applying. Vigée-Lebrun, ambitious and talented, wanted to be admitted as a history painter, the most prestigious category of painting, and not as a portrait or a pastel painter, the fields most acceptable for women. Although the category in which she was admitted was not stipulated, the painting she submitted as her acceptance piece was a history painting, indicating that the Academy tacitly agreed with her wish. *Innocence Taking Refuge in the Arms of Justice* (see page 243) is an engraving after that painting. Between 1783 and 1789 Vigée-Lebrun exhibited more than forty portraits and historical compositions in the biennial Salons.

As the political situation in France worsened, the friendship of the Queen became a liability. When the Parisian crowds invaded Versailles on October 6, 1789, Vigée-Lebrun escaped to Italy with her daughter and governess. During the twelve years of exile that followed, Vigée-Lebrun capitalized upon her international reputation as an artist and a member of the court of Versailles to obtain lucrative commissions and to be admitted to the Academies in the countries where she visited. Her longest stay was six years in Russia, where she produced many portraits of the aristocracy and filled at least four notebooks—one of which is in the Holladay Collection—with sketches of members of the cosmopolitan St. Petersburg society (see page 243).

Vigée-Lebrun received permission to return to France in 1802 and eventually settled in Paris. With her reputation secure and her income assured by wise investments, she painted few portraits in the last years of her life. The oil painting *Portrait of a Young Boy,* shown here, dates from 1817 and depicts one of her favorite themes—that of innocent, carefree children. The portrait is illustrative of Vigée-Lebrun's individual technique, in which she gives a sense of life to the eyes—the most compelling feature of this and many other portraits by the artist. The power of the face is further enhanced by the simple execution of the remainder of the painting: the child's dark outfit and the somber monochromatic background highlight the face, while the white collar and long gun help to focus the viewer's attention upon the features.

The considerable production of Vigée-Lebrun leaves an important and reliable record of the talent of a most remarkable woman painter and of the taste of her time.

M.L.W.

OPPOSITE:
Elizabeth Vigée-Lebrun. *Portrait of a Young Boy.* 1817. Oil on canvas, 21¾ × 18¼". The Holladay Collection

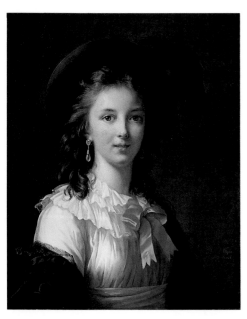

Elizabeth Vigée-Lebrun. *Self-Portrait.* c. 1781. Oil on canvas, 25½ × 21¼". Kimbell Art Museum, Fort Worth, Texas

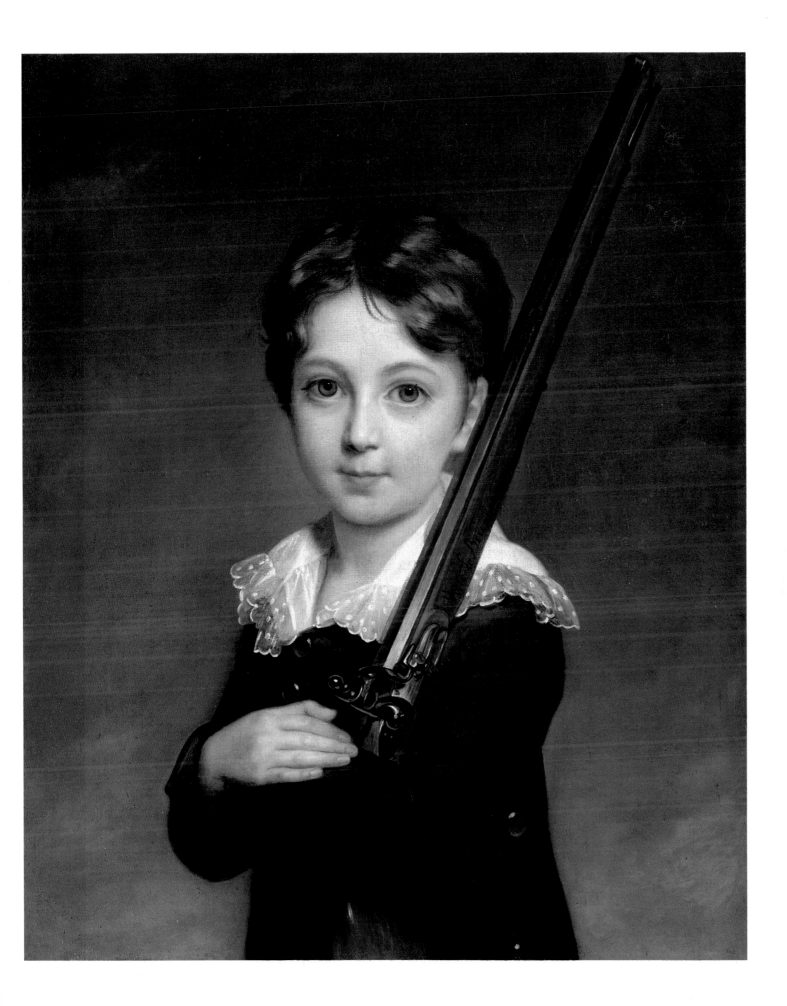

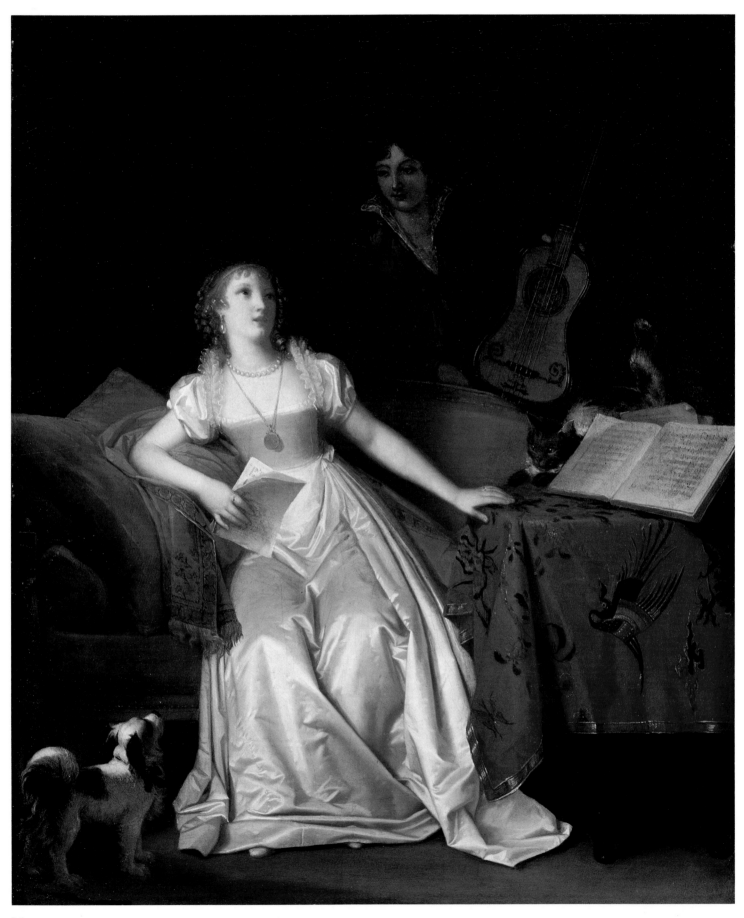

MARGUERITE GERARD

FRENCH | 1761–1837

MARGUERITE GERARD was one of the first French woman painters to achieve professional success, in spite of the fact that, as a woman, she did not have access to the traditional methods of artistic advancement in France—attendance at the Ecole des Beaux-Arts and the study of nude models. However, as the sister-in-law of the celebrated Rococo painter Jean-Honoré Fragonard (1732–1806), she had other important advantages.

Gérard came to Paris from her hometown of Grasse to live with the Fragonard family in the 1780s and immediately became Fragonard's informal apprentice; this provided her with an avenue of advancement usually closed to women. Through her teacher she was in touch with the major artists of the day and could easily visit private art collections and libraries to study paintings and volumes of engravings. Living with Fragonard and his family also eliminated financial worries and allowed her to devote herself full-time to her career without pressure to marry.

By her mid-twenties, Marguerite Gérard had identified the subject matter she would paint for the remainder of her career: genre scenes of Enlightenment women engaged in domestic activities, such as making music, enjoying their children, or reading love letters. She painted these canvases in her own characteristic style, a meticulous, painstaking manner that was reminiscent in both theme and style of seventeenth-century Dutch genre painters, the so-called *petits maîtres hollandais*. Her revival of this vogue coincided with a renewed popular interest in the work of Dutch genre painters of the preceding century and anticipated similar developments in post-Revolutionary French literature and theater. Gérard's popular and financial success was assured by the emergence of a wealthy, educated bourgeoisie who appreciated representations of the traditional values of home and family, promoted by the Dutch in the preceding century, and who desired intimate canvases of these subjects to hang in the smaller, more lavish town houses popular in the mid-century.

Prelude to a Concert, shown here, is dated c. 1810 and illustrates aspects of the characteristic themes and style that Gérard developed in the 1780s and continued for five decades with considerable success. While the theme of motherhood predominates in her work, there are more than a dozen paintings, such as this one, that portray glamorous women playing musical instruments or reading letters, typical pastimes of upper-class women. The emphasis, as in all her canvases, is on the chaste, puritanical comportment of her heroines. Where a masculine figure appears, he is in a subordinate role, as in this painting—a shadowy figure who seems as much a studio prop as the guitar he holds. The fluffy cat and faithful spaniel seen here appear often in her works and sometimes seem to have more personality than her male genre figures.

The classical profiles of the two figures and the meticulous depiction of the details of the heroine's dress are characteristic of Gérard's style. To achieve the luminous, buttery softness of the satin gown, she developed a particular glaze medium and mastered the technique of painstakingly applying layers of translucent colors. She also utilized mannequins as models to experiment with the placement of the carefully arranged folds of fashionable gowns.

When the Salon was opened to women in the 1790s, Marguerite Gérard exhibited regularly until 1824, when she seems to have retired from professional activity. She was a great commercial success, selling paintings to Napoleon and Louis XVIII and amassing a large personal fortune.

M.L.W.

François Dumont (French, 1751–1831). *Portrait of Marguerite Gérard*. 1793. Watercolor on ivory, 6⅜ × 4⅝″. The Wallace Collection, London

OPPOSITE:
Marguerite Gérard. *Prelude to a Concert*. c. 1810. Oil on canvas, 22¼ × 18¾″. The Holladay Collection

ANTOINETTE CECILE HORTENSE HAUDEBOURT-LESCOT

FRENCH | 1784–1845

I N THE early nineteenth century, several women artists in France followed the lead of Marguerite Gérard and developed distinct specialties within the traditionally male preserve of genre painting. Antoinette Haudebourt-Lescot has been credited with creating Italian genre painting, as well as winning acclaim as a portrait painter. The esteem in which she was held by her male counterparts is indicated by the fact that, in a contemporary painting of King Charles X distributing awards to artists after the Salon of 1824, she is the only woman depicted, although she was not the only woman who exhibited.

Haudebourt-Lescot found the inspiration for her most well known works, Italian genre painting, when she worked from 1807 to 1816 with her teacher Guillaume Guillon, Director of the Académie de France in Rome. Although a trip to Italy was mandatory for male artists at this time, it was unheard of for females to leave the protection of their families and travel abroad to study—especially to Italy, which had a rather lawless reputation in those years.

Inspired by the customs and costumes of the peasants in and around Rome, Haudebourt-Lescot painted both scenes with exotic themes and tableaux of ordinary Italian peasant women performing everyday chores. While her interest in women as subject matter was not uncommon for a French female artist at the beginning of the century, her picturesque portrayals of Italian life were unusual at this time and were widely imitated.

Official recognition for Haudebourt-Lescot came early and often, beginning with a second-class medal awarded at her first Salon appearance in 1810. In the course of her career, she exhibited over one hundred paintings, both genre scenes and portraits. Her works were popular with the newly prosperous middle class, who enjoyed her small-scale paintings of contemporary life. Engravings of her canvases spread her fame even to America, where there is evidence that the father of Anna Claypoole Peale copied one of her paintings.

Later in her career, in the 1830s, Haudebourt-Lescot concentrated upon portraits, where her talent in depicting personalities and details of costume and surroundings was readily apparent. Two of her portraits had been acclaimed in the 1827/28 Salon, and she had been commissioned in 1830 to portray various historical personages for inclusion in collections at Versailles. The portrait in the Holladay Collection dates from this period and shows a young woman, dressed in white, dramatically highlighted against a brilliantly executed landscape. Pink roses and red geraniums frame the sitter, a rippling stream flows past her feet, and a purple-pink sky is reflected in a mountain lake in the distance. Her pensive expression is accentuated by her upswept hairstyle and simple gold jewelry.

Haudebourt-Lescot's technical skill and sensitivity to her subjects, whether upper-class female sitters or Italian peasant women, were major factors in the development of her reputation as one of the most highly regarded women artists of her time.

M.L.W.

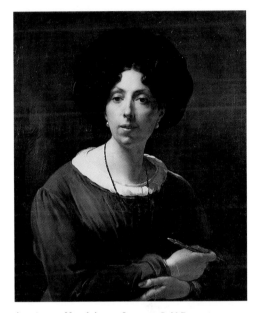

Antoinette Haudebourt-Lescot. *Self-Portrait.* 1825. Oil on canvas, 29¼ × 23⅝″. Musée National du Louvre, Paris

OPPOSITE:
Antoinette Haudebourt-Lescot. *Young Woman Seated in the Shade of a Tree.* Oil on canvas, 67 × 45½″. The Holladay Collection

ANGELICA KAUFFMAN

SWISS | 1741–1807

Angelica Kauffman. *Self-Portrait*. c. 1762–63. Oil on canvas. Galleria dell'Accademia di San Luca, Rome

OPPOSITE:
Angelica Kauffman. *The Family of the Earl of Gower*. 1772. Oil on canvas, 59¼ × 82″. The Holladay Collection

Angelica Kauffman was one of the most acclaimed women artists of the eighteenth century. Her skill in painting flattering portraits of her many aristocratic patrons assured her popular and financial success. She was also an accomplished history painter and is credited with introducing this genre to England.

Early in her career, Kauffman's father, Joseph Johann Kauffmann (1707–1782), an itinerant Swiss painter, recognized and promoted his daughter's talent. At the age of twelve she painted a portrait of the Bishop of Como and by sixteen, living in Milan, she had attracted the notice of the Duke of Modena and had obtained many portrait commissions from the court. Always traveling with her father, she moved to Florence and then to Rome. Here she met J. J. Winckelmann, the German art historian, and other artists who were developing the style of Neoclassicism. In June of 1765, at the age of twenty-three, she was elected to the prestigious Accademia di San Luca in Rome.

The wife of the British diplomatic representative in Venice sponsored Kauffman's debut in London in 1766, where the artistic climate favored the ideas she had learned in Rome. Her circle of friends included Sir Joshua Reynolds, one of the main proponents of classical ideas in art and the first president of the Royal Academy of Art in London. When the Academy was established in 1768, there were only two women among the thirty-six founding members—Angelica Kauffman and Mary Moser (1744–1819). It was almost two hundred years until Laura Knight became the next woman elected to full membership in the Academy in 1936.

At the first exhibition of the Academy, Kauffman and Benjamin West were the sole exhibitors to submit only history pictures. However, although Kauffman preferred to paint subjects from English history, literature, Greek mythology, and the Bible, she was not able to elevate history painting in England to the prominence it enjoyed on the Continent and was forced to rely on portrait commissions for most of her income. She often portrayed her sitters, many of whom were female members of the nobility and wealthy bourgeoisie, as allegorical figures, thus raising these portraits closer to the status of history painting.

An excellent example of Kauffman's distinctive type of portraiture is the signed and dated (1772) family portrait in the Holladay Collection, *The Family of the Earl of Gower*, depicting the Earl and Countess with their six children in an outdoor setting. Kauffman has introduced a classical feeling into this otherwise straightforward rendering of a noble family by using several devices: the sculpted portrait bust of the husband of the older daughter, the lyre held by the Countess, the antique-inspired clothes of both male and female members, and the flower garlands twirled by the daughters. Even some of the poses would have been familiar to contemporary viewers as stock attitudes borrowed from traditional history paintings.

Kauffman often designed large paintings for use as insets in the interior decoration of Adam-style Neoclassical houses. Her works inspired small designs for Wedgwood and Meissen china and medallion inserts on contemporary furniture. Book engravings of her paintings and portrait etchings, two of which are in the Holladay Collection, also spread her reputation to a wider audience than could have been reached by the original paintings themselves.

After a disastrous first marriage, Kauffman married, in 1781, a fellow artist and decorator, Antonio Zucchi (1726–1795), who became her business manager, taking the place her elderly father had occupied for so many years. They returned to Italy the next year and settled in Rome, where Angelica Kauffman became a central figure in society, counting both intellectuals and nobility as her friends and clients. At her death in 1807, the artistic community of Rome went into mourning and arranged a funeral similar to that of Raphael to honor her memory. She was buried next to her husband in the church of San Andrea delle Fratte, and a portrait bust of her was placed in the Pantheon, resting place of Raphael, as a final gesture of respect.

M.L.W.

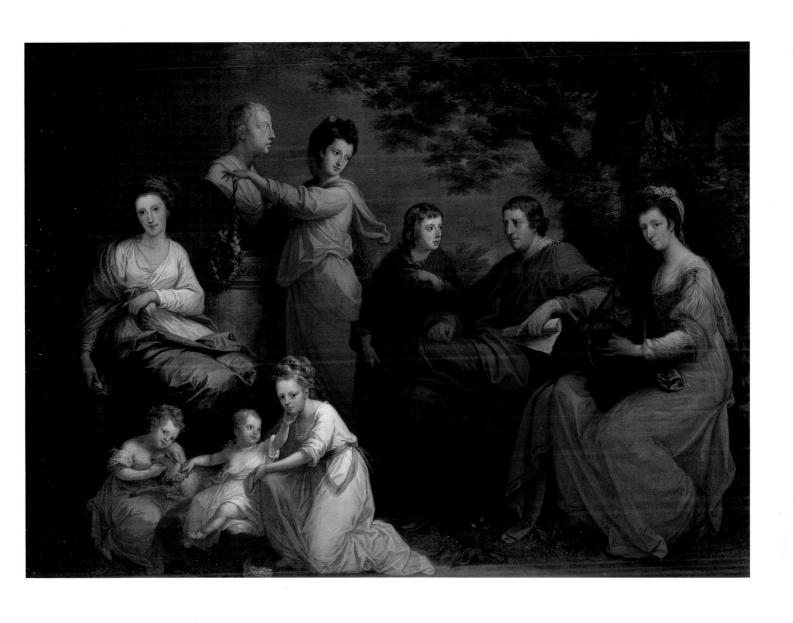

ANNA CLAYPOOLE PEALE

AMERICAN | 1791–1878

James Peale (American, 1749–1831). *Anna Claypoole Peale*. c. 1808–10. Oil on canvas, 35½ × 28". Collection Jeffrey R. Brown, Boston

OPPOSITE:
Anna Claypoole Peale. *Nancy Aertsen*. Watercolor on ivory, 3½ × 2¹³⁄₁₆". The Holladay Collection

AS A MEMBER of the famous Peale family of painters, Anna Claypoole Peale had access to artistic training from her father, James Peale (1749–1831), a noted miniaturist and portrait painter, and her uncle Charles Willson Peale (1741–1827), portrait painter of the major figures of the American Revolution. Anna was fortunate to receive her artistic education from her own family, as professional training was difficult for women artists to obtain. Until the mid-nineteenth century, women were prohibited from attending the professional art academies, where students studied anatomy and drew from a nude model, both important steps in an artist's training.

The Pennsylvania Academy of the Fine Arts, founded in 1805, admitted women in 1844, allowed them to attend anatomy lectures in 1860, began a segregated life class for women in 1868, and added a male model in 1877. Beginning in 1811 the Pennsylvania Academy held exhibitions that regularly included women's works; in 1824, Anna Claypoole Peale and her younger sister Sarah (1800–1885) were elected the first women Academicians.

The National Academy of Design, founded in New York City in 1825, formally admitted women in 1831 but did not allow them to attend classes until 1846. A Life School was instituted in 1871, women were admitted to anatomy lectures in 1914, and coeducational life classes instituted in 1930. Although membership in the National Academy of Design was considered essential in establishing an artist's reputation, before 1900 only one woman was a full member, eleven were associates, and four were honorary members.

Anna, the fourth child in a family of six, learned from her father both the art of painting miniatures, executed in watercolor on ivory, and of painting in oil on canvas. She often assisted her father in his studio, and when his eyesight began to fail around 1812, she took over his miniature commissions. Until her sister Sarah took up a brush, Anna was the only woman artist in Philadelphia. Eventually, her reputation as a miniature painter extended beyond her native Philadelphia to Baltimore, New York, Boston, and Washington.

In 1819, Anna was invited by Charles Willson Peale to share a studio in Washington. During that winter their sitters included President James Monroe, Andrew Jackson, and Henry Clay, the most prominent and influential statesmen of the day.

The portrait miniature of Nancy Aertsen, illustrated here, is executed in watercolor on ivory. The medium illustrates the characteristic technique that developed when, in the early 1700s, ivory replaced card or vellum as the support for the miniature painting. The surface of the ivory was lightly sanded and then degreased to permit the color to adhere. Pigments were applied in a combination of stippling and hatching to model the forms and indicate details. Thin washes of color allowed the natural surface of the ivory to show through. Peale has utilized the technique to great advantage, delineating the dress and hair in minute detail. The sitter's pursed smile, formed by slight, dark marks at the corners of the mouth, is a characteristic feature of Peale's portrait miniatures. While miniatures had originally been fashioned to be worn as private mementos of loved ones, by the time of this portrait they had become larger in size and were meant to be displayed in a drawing room. To portray a heavily curtained background in the miniature—intended to blend with the decor of the parlor where it was exhibited—was fashionable during this period.

Until the advent of portrait photography in the 1830s and '40s, miniature painters were much in demand. Often a sitter would commission both a miniature and a large-scale oil portrait; Anna and her sister Sarah often shared such commissions, with Anna executing the miniatures and Sarah the oils.

M.L.W.

Lilly Martin Spencer, the best-known American genre painter of the mid-nineteenth century, successfully combined the demands of an artistic career with those of a large family. Her husband supported her choice, became her business manager, and assisted in raising the seven children that survived from thirteen pregnancies. Although Spencer seems to have enjoyed the roles of artist and of mother, her art was always a means to an end, namely, supporting her family.

Spencer's unusual attitude toward home and family was probably a product of her upbringing. Her French parents, followers of the French social critic Charles Fourier, had emigrated to America from England in 1830 to establish a utopian cooperative community. Although her parents did not seem to involve Spencer in their lifelong passionate interest in such issues as temperance, abolitionism, and women's suffrage, they encouraged her to develop her artistic talent. Her father even moved with her, in 1841, from their home outside Marietta, Ohio, to Cincinnati to enable her to pursue painting as a career. She refused the offer of a local patron to assist with her studies in Boston or Europe, and, in 1844, married Benjamin Rush Spencer, an English tailor and painter of stereopticon slides.

The contemporary reputation of Lilly Martin Spencer rested upon her choice of subject matter and the wide distribution of her work through engravings. As her family grew, her interest turned from the historical themes she had favored in her youth to intimate genre scenes of domestic dramas, of children and pets at play, of families enjoying quiet times together. Canvases depicting such scenes of everyday life were in demand by the middle class, which, as in England and Europe, was becoming a major market for art. This new taste was fostered by organizations called art unions, based on similar groups in Europe. Subscribers paid an annual fee of five dollars, which entitled them to an engraving of an oil painting by an American artist and a chance to win an original oil in a lottery drawing. As a commercial enterprise, the art union concept reached a wide audience, generated many sales, and supported American art. Spencer showed at the Western Art Union in Cincinnati at its opening exhibition in 1847 and was enthusiastic about its business and artistic possibilities.

Spencer moved to New York in 1848 with hopes of earning more money to support her family. However, she found that competition from European-trained artists and the scrutiny of a more sophisticated audience necessitated constant work and laborious study to improve her technique. In 1854 the Cosmopolitan Art Association began to promote her work, declaring that it bore favorable comparison with the work of seventeenth-century Flemish artists. The *Still Life with Watermelon, Pears, and Grapes*, illustrated here, is an example of Spencer's style in a type of painting favored by these masters. The lush colors, simple but effective composition, and skillful rendering of different textures are all illustrative of her ability in this field. Although Spencer is known to have painted other still lifes, this painting is one of the few examples existing today. Her mastery of the genre can be studied in her domestic scenes, in which she often used still-life groupings within the compositions.

M.L.W.

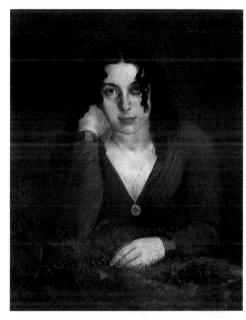

Lilly Martin Spencer. *Self-Portrait*. c. 1842. Oil on canvas, 30⅛ × 25¼". The Ohio Historical Society

OPPOSITE:
Lilly Martin Spencer. *Still Life with Watermelon, Pears, and Grapes*. Oil on canvas, 13⅛ × 17¼". The Holladay Collection

ELIZABETH JANE GARDNER BOUGUEREAU

AMERICAN | 1837–1922

Photograph of Elizabeth Gardner Bouguereau taken on the occasion of her winning a silver medal, Exposition Universelle, Paris, 1878

OPPOSITE:
Elizabeth Gardner Bouguereau. *The Shepherd David Triumphant*. c. 1895. Oil on canvas, 61½ × 42½". The Holladay Collection

For many Americans, both male and female, a career in the art world at the end of the nineteenth century required study in Paris, the center of the Western art world. For women, professional study with officially recognized and commercially successful artists was extremely difficult. Elizabeth Jane Gardner, later married to the highly acclaimed Academic artist William Adolphe Bouguereau (1825–1905), was instrumental in reversing this state of affairs.

Gardner is credited with opening Parisian art academies to women students. When she left her native New England in 1864, all the art schools in Paris, public and private, were closed to women. In 1873, following the example of Rosa Bonheur, Gardner requested permission from the police to dress in male clothes and, thus garbed, attended drawing classes at the Gobelins Tapestry Factory. Inspired by her pluck and daring, Adolphe Julian, head of the prestigious Académie Julian, admitted Gardner and three other women that year.

Since both women and foreigners were excluded from the official art school, the Ecole des Beaux-Arts (women were finally admitted in 1897), the Académie Julian offered an important alternative education for many serious students during these years. Julian's carefully planned curriculum included life classes for all students and critiques by an illustrious group of well-known artists.

One of Gardner's instructors at Julian's was William Adolphe Bouguereau, a leading Academic painter. The term "Academic" indicates a style based on the teachings espoused in the conservative academies such as the Ecole des Beaux-Arts. Academic paintings depicted historical, biblical, Near Eastern, and classical subjects, rendered in a meticulously detailed, smooth-surfaced technique. Careful attention was paid to accurate portrayal of costumes, furniture, and background details. The paintings were often idealized or sentimental allegories with moral or religious overtones. By the turn of the century, Academic painting had been overshadowed by Impressionism and Post-Impressionism.

Gardner and Bouguereau became engaged in 1879, when he was fifty-four and she was forty-two. Bouguereau's elderly mother opposed the match for several reasons, including that she thought it would have been impossible for the two artists to sustain separate, successful painting careers in one marriage. Consequently, the engagement lasted seventeen years; they did not marry until Bouguereau's mother died in 1896. Gardner gave up her career to care for Bouguereau until his death in 1905 and then resumed painting.

The painting in the Holladay Collection entitled *The Shepherd David Triumphant* was exhibited in the 1895 Paris Salon and was among the last group of canvases Gardner finished before her marriage. In both subject matter and style it is representative of her best work. This Old Testament theme is one of several that she exhibited. The scene of a young person triumphing over evil was typical of the scenes preferred by Victorian audiences. The contrast in textures of the lamb's woolly coat, the lion's luxuriant mane, and David's simple garment are all carefully rendered. While the shepherd's pose seems exaggerated and melodramatic today, it was a thoroughly accepted convention that displayed Gardner's draftsmanship and technical mastery to advantage.

During her life Gardner received many official awards. In 1866 she was the first American woman ever to exhibit at a Paris Salon. The Salon of 1879 awarded her an honorable mention and the right to exhibit without first passing the jury selection. In 1889 she became the first American to win a gold medal at a Salon.

M.L.W.

MARY CASSATT
AMERICAN | 1844–1926

Edgar Degas (French, 1834–1917). *Mary Cassatt.*
c. 1880–84. Oil on canvas, 28⅛ × 23⅛". National
Portrait Gallery, Smithsonian Institution,
Washington, D.C. Gift of the Morris and
Gwendolyn Cafritz Foundation and the Regents
Major Acquisitions Fund

OPPOSITE:
Mary Cassatt. *The Bath* (also called *The Tub*).
1891. Color print with drypoint, soft-ground
etching, and aquatint, 14⅜ × 10⅝". The Holladay
Collection

Mary Cassatt was born into an upper-middle-class family in western Pennsylvania in 1844. She was enrolled at the Pennsylvania Academy of the Fine Arts from 1861 to 1865 and later studied in Paris at the studios of Gérôme and Couture. In 1874 she settled permanently in Paris, where she regularly submitted works to the yearly Salon exhibitions. Edgar Degas saw Cassatt's work at the Salon, and in 1877 he invited her to join the Impressionists; Cassatt was the only American ever to exhibit in the group's shows. Degas was a powerful influence on Cassatt, and, with his encouragement, she began to make prints in 1879, producing over 220 in the course of her career. Cassatt's first solo exhibition took place at Galerie Durand-Ruel in 1891 and included a set of ten color aquatints. Failing eyesight prevented Cassatt from working after 1911. Fifteen years later she died, at the age of eighty-two.

In 1890 Cassatt and Degas visited a comprehensive exhibition of Japanese woodblock prints held at the Ecole des Beaux-Arts. Oriental art had begun to influence French painting by this time, and Japanese woodcuts had been popularly admired in Paris as early as 1860. The Ecole exhibition had a profound effect on Cassatt, who had already displayed an awareness of Oriental art in her canvases and drypoints. This renewed exposure to the work of Utamaro, Toyokuni, and others inspired Cassatt's set of ten color aquatint plates produced in 1891. This series of prints is one of the major achievements of her career and a milestone in the history of printmaking. In these works Cassatt combines her devotion to simple, domestic European subjects with the decorative novelty and grace of Oriental art.

The Bath (shown here), Cassatt's initial work in the series, was her first attempt at color printmaking. She later wrote, "The set was done with the intention of attempting an imitation of Japanese methods." Cassatt simulated the effect of the color woodblock by using several etching plates for each print. The linework was done in soft-ground etching and drypoint. The color area of each plate was prepared with aquatint, a tonal process associated with the etching technique. The color was applied by hand to each of the plates, which were then successively impressed upon paper. The procedure was both intricate and time-consuming, requiring one entire day of preparation to ink and reprint the plates for each of the eight or nine impressions.

A woman bathing a child is a common theme in Japanese art, and Cassatt may have known Utamaro's color woodcut of a similar subject and composition. Cassatt rendered the figures and the tub as two-dimensional shapes, almost completely eliminating the traditional shading and tonal variations that create the illusion of depth. The space that the mother and child occupy is only barely suggested by the line that separates the wall and the floor behind them. The artist also exploited the bright colors and decorative quality characteristic of Japanese prints. Although the facial features of the figures are Occidental, the delicate linework and the flattened shapes demonstrate Cassatt's absorption of Oriental principles.

Mary Cassatt was one of the major painters and printmakers of the nineteenth century. In addition to *The Bath*, she is represented in the collection of the National Museum of Women in the Arts by four other works (see pages 166–67).

E.D.

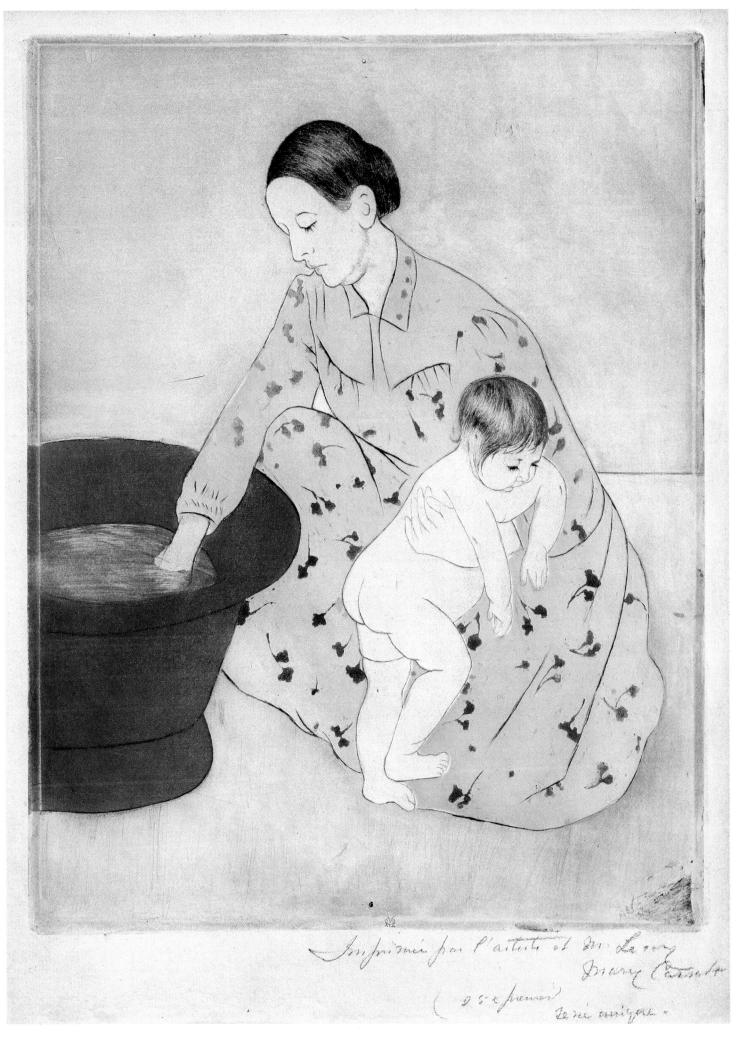

Imprimée par l'artiste et M. Leroy

Mary Cassatt

(25. e.preuve)

se ni essaye.

49

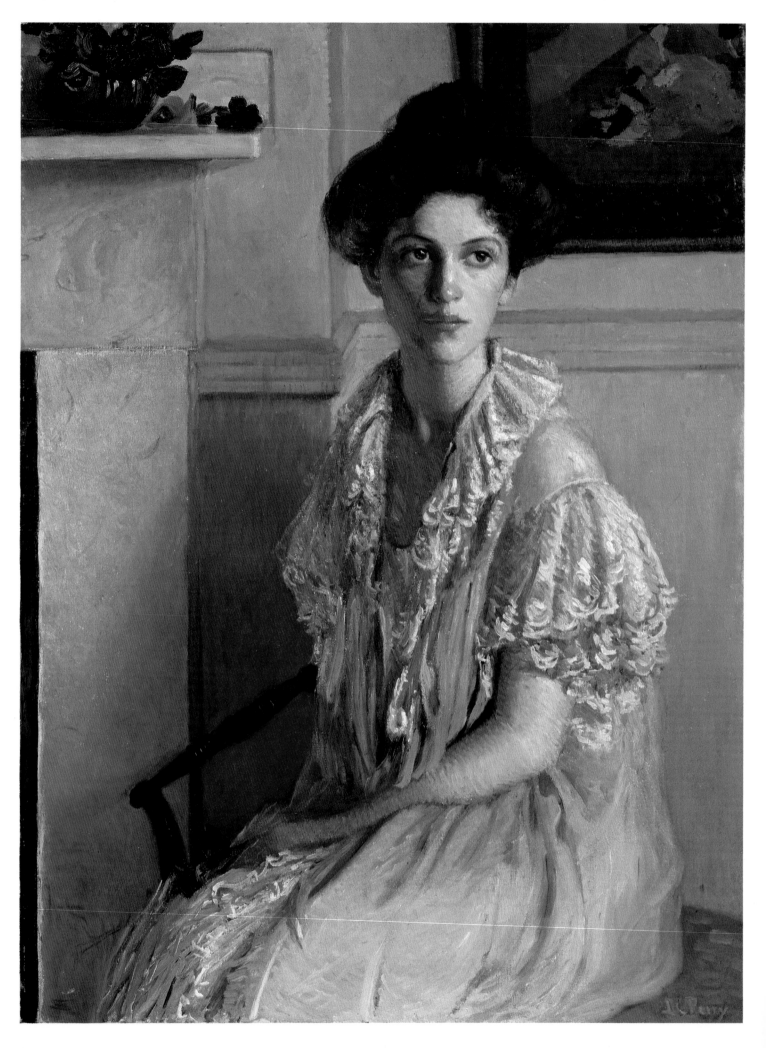

LILLA CABOT PERRY

AMERICAN | 1848–1933

THE INTRODUCTION of French Impressionism to America is just one of Lilla Cabot Perry's major accomplishments. She was also an esteemed painter, a poet, and a founder and first secretary of the Guild of Boston Artists.

Perry's professional training began in the 1880s in Boston at the Cowles School, where she studied under Robert Vonnoh and Dennis Bunker. In Paris, she was admitted to the Julian and Colarossi academies and also worked privately with Alfred Stevens (1828–1906), the Belgian-born portrait and genre painter.

In 1889, Lilla Cabot Perry met Claude Monet, one of the founders of Impressionism, thus beginning an association that transformed her professional life. Although Monet did not accept students on a formal basis, he reviewed her work and offered valuable suggestions to improve her technique. To be near Monet, Perry spent the next ten summers with her husband and daughters in Giverny and became a close personal friend of the "Grand Old Man of Impressionism."

When Perry returned to America after her initial meeting with Monet, she brought one of his paintings of Etretat, a small town on the windswept eastern coast of Normandy. Most of her friends, having never before seen an Impressionist painting, were not yet enthusiastic about the unusual technique and subject matter. However, Perry used her immense influence in the Boston social world to promote the new art form.

Another important step in the development of Perry's own artistic style was her stay in Japan from 1898 to 1901 with her husband, Thomas Sergeant Perry, grandnephew of Commodore Matthew C. Perry, who opened Japan to the West in 1857. She was thus exposed firsthand to the Oriental art that had been instrumental in the late nineteenth century in shaping Western art and that had had a profound effect upon her own painting. After her summers in France and several years in Japan, Perry spent most of her time in Boston and at her summer home in Hancock, New Hampshire, where she made many of the flowing, Impressionist-like landscapes of her later years.

In the portraiture that formed a considerable part of her oeuvre Perry exhibited her impressive ability to merge the lessons of Impressionism with her own vision of painting to produce sparkling likenesses of lovely young women, her own daughters, and other upper-class sitters. The portraits in the Collection are examples of the three-quarter and full-length poses she favored (see opposite and page 222). *Lady with a Bowl of Violets* reveals the influence of Monet in the short, spontaneous brushwork of the sitter's filmy negligee and in the luminous quality of her face. The effects of ever-changing light, an Impressionist concern, are apparent in the glow of a fire ingeniously placed just beyond the left picture plane and softly reflected on the shining marble mantelpiece. The wall behind the sitter is composed of flat planes of color, broken by the horizontal bands of the wainscoting and the mantel and the vertical lines of the corner and of the fireplace. Perry's Academic training is evident in the well-balanced composition, the clearly structured form of the figure, and the interest in detail and volume—qualities that differentiate her portraits from Impressionist paintings. The compositional simplicity, the Japanese-inspired print in the upper right corner, and the flowers in the upper left indicate Oriental influences.

Perry successfully combined an interest in the personality of her sitters with an exploration of the effects of light and color on form and substance. Her utilization of these lessons of Monet in her many portraits is a lasting contribution to the development of the American portrait genre.

M.L.W.

Photograph of Lilla Cabot Perry

OPPOSITE:
Lilla Cabot Perry. *Lady with a Bowl of Violets*. Oil on canvas, 40 × 30″. The Holladay Collection

JENNIE AUGUSTA BROWNSCOMBE

AMERICAN | 1850–1936

Photograph of Jennie Augusta Brownscombe, early 1930s

OPPOSITE:

Jennie Augusta Brownscombe. *Love's Young Dream.* 1887. Oil on canvas, 21¼ × 32⅛". The Holladay Collection

DURING THE latter half of the nineteenth century in America, the artworks best known and appreciated by the majority of the populace were the sentimental history and genre paintings of the Academic artists. Jennie Augusta Brownscombe was a well-known and respected painter of genre, history, and portrait canvases. Her career was typical of that of many Academic artists whose work in genre painting fell out of fashion in the nineteenth century but who are now being reevaluated as having been important interpreters of the taste of their time.

Born in a log cabin on a farm in Wayne County, Pennsylvania, Brownscombe went to New York to study at the School of Design for Women of The Cooper Union for the Advancement of Science and Art (later Cooper Union). From 1871 to 1875 she was enrolled in the Antique and Life Schools of the National Academy of Design and helped to found the Art Students League in 1875. She made a trip to Paris in 1882 and studied with the American genre painter Henry Mosler (1841–1920), who had recently been honored as the first American to have a painting purchased by the French government for exhibition in the Luxembourg Museum. More important for Brownscombe was the fact that Mosler was one of the very few painters to accept women painters in his studio at this time.

Brownscombe's fame was assured when, beginning in 1882, her work began to be engraved, appeared on calendars and in magazines, and was sold by commercial print companies. Over one hundred of her paintings were copyrighted and circulated in this fashion in thousands of American homes at the turn of the century.

The work reproduced here, *Love's Young Dream,* signed and dated 1887, was one of the most popular of these illustrations. A young woman, apparently in love, is gazing off into the rural landscape. Her beauty and naïveté contrast with the self-absorption and isolation of the older couple, who pay no attention to each other. Brownscombe's nostalgic portrayal of a contemporary farm family is characteristic of a type of genre painting popular at the end of the nineteenth century, in which the title is an integral part of the composition and helps to invoke the sentimental feeling that the painter intended to convey. Story paintings, as they were called, were as much literary as artistic productions and, as such, contained a strong didactic vein.

During the 1890s, Brownscombe became more interested in American Colonial and Revolutionary themes and executed an extensive series of paintings on topics of American history. Her own ancestry, dating back to the *Mayflower,* may have been partly responsible for this fascination with the beginnings of the nation. Many of her depictions of these scenes, which concerned both real and imagined subjects in American history, were engraved and hung in classrooms across the nation, thus influencing the taste and historical sense of another generation.

M.L.W.

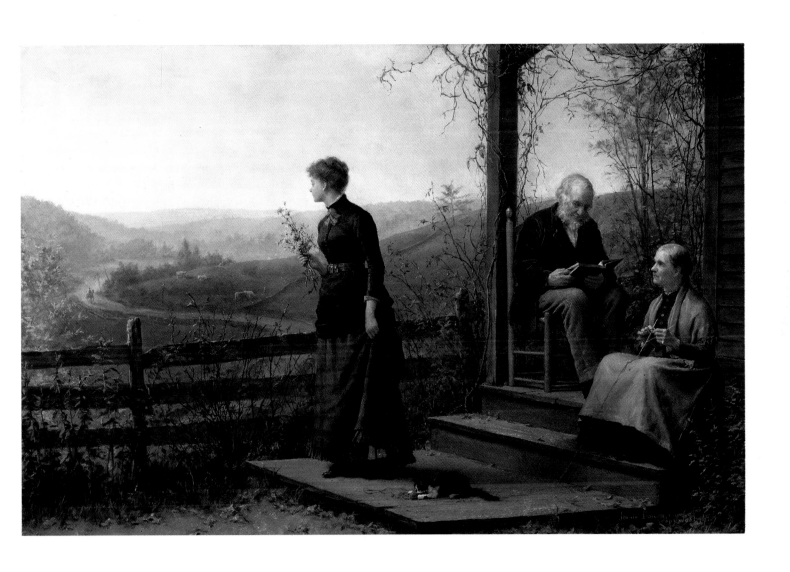

ELLEN DAY HALE

AMERICAN | 1855–1940

Margaret Lesley Bush-Brown (American, 1857–1944). *Ellen Day Hale.* 1910. Oil on canvas, 30¼ × 25⅛″. National Museum of American Art, Smithsonian Institution. Gift of Arthur Hale

OPPOSITE:
Ellen Day Hale. *June.* c. 1905. Oil on canvas, 24 × 18⅛″. The Holladay Collection

ELLEN DAY HALE, an accomplished American painter and printmaker, established her reputation as a portraitist in the late nineteenth century and maintained an active artistic production that included altarpieces, genre paintings, still lifes, landscapes, and graphic media into her eightieth year.

Hale was born in 1855 in Worcester, Massachusetts, into a prominent Boston family that encouraged her artistic inclination and provided for her early education. One of her six brothers, Philip Leslie Hale, also became a successful painter. Hale began her artistic studies with the sculptor William Rimmer and later worked with the painter William Morris Hunt, who encouraged his students to travel to Europe to continue their training. Hale made several trips to Paris between 1881 and 1885, attending the Académie Colarossi and studying with the fashionable portrait painter Charles Emile Carolus-Duran after 1882. Later she worked with William Adolphe Bouguereau and Jean Jacques Henner at the Académie Julian.

In 1885 Hale exhibited a work at the Paris Salon for the first time, a self-portrait entitled *Lady with a Fan.* At the same time she began to make etchings under the guidance of Baltimore artist Gabrielle de Veaux Clements (1858–1948). After her return to the United States in 1885, Hale became increasingly absorbed with printmaking, exhibiting in an enormous show of American women etchers in Boston in 1887 and in New York in 1888. In 1890 her etching *Dolce far Niente* was included in the Paris Salon. During the following two decades she experimented with drypoint, aquatint, soft-ground and color etchings, experiments that continued through the rest of her long life. In 1902 Hale moved to Washington, D.C., and thereafter exhibited occasionally in museums and galleries in eastern cities. In 1907, 1924, 1926, and 1935, she showed works at the Corcoran Gallery.

The National Museum of Women in the Arts possesses one of the major collections of Ellen Day Hale's work. In addition to two oil paintings, *June,* reproduced here, and the c. 1930 portrait, *Gabrielle de Veaux Clements* (see page 189), the Museum's holdings include many preparatory painted sketches, drawings, and etched plates. The Museum's comprehensive collection of one hundred etchings spanning Hale's career includes her *Portrait of a Girl in a Cap* of c. 1889 (see page 189). Ranging from European landscapes to portraits, the group demonstrates the full range of Ellen Day Hale's achievements.

June depicts a woman engaged in a simple domestic task, a popular subject in Hale's oeuvre. The theme of a figure seated in a light-filled interior had been popularized by French Impressionist painters, whom Hale would have encountered during her years in France. Hale's adaptation of their style is evident in the broken brushstrokes and bright colors that define the intense sunlight as it plays over the scene, producing white highlights on the windowpane, the chair back, the sitter's hair and dress. The solid pose and confident composition combined with the impression of bright sunlight in the painting eloquently express a mood of domestic intimacy and solitude.

E.D.

I N THE HISTORY of American art, Cecilia Beaux stands out as a portrait painter of great sensitivity and originality. She not only captured penetrating likenesses of the social and intellectual elite who shaped America at the turn of the century, but also created intimate and perceptive portrayals of women and children that remain outstanding examples of the genre.

Beaux was raised in Philadelphia by her grandmother and two aunts. Her early artistic training was sporadic, beginning with classes taught by her cousin Katherine Drinker, a history and biblical painter and the first woman instructor at the Pennsylvania Academy of the Fine Arts. This training was followed by lessons at the Van der Whelan Art School and, more important, by twice-monthly reviews of her work by a New York painter, William Sartrain, who had introduced her to painting from live models.

Ethel Page (Mrs. James Large) was painted early in Beaux's career and was her first portrait from life not evaluated by her teacher. The photograph (reproduced on this page) of the artist finishing the painting shows the sitter, Beaux's good friend Ethel Page, coquettishly cocking her head to one side, a pose deftly captured by the young artist. Beaux's insistence on getting to know a sitter before painting a portrait helped her to incorporate basic character traits into her portrayals of physical likenesses. We can see the beginnings of her masterly use of color in her placement of a subdued red bow on the hat directly above the sitter's highlighted face. The rest of the composition is executed in somber tones of greenish-gray and brown, characteristic of her early palette before her study in France in 1888. Beaux had already begun to demonstrate her ability to distinguish subtle differences in texture, evident in her treatment of the satin capelet, curly hair, and gauzy bow.

Realizing the necessity for European study, she sailed to Paris in 1888 and enrolled in the Académie Julian. A summer spent painting in Brittany set the stage for a radical change in her style: her colors became more radiant, her brushwork looser, and her approach to her sitters more expressive. Although Beaux has often been compared with John Singer Sargent and the Impressionists in her strong brushwork, rich palette, and painterly technique, she was very conscious of not imitating any particular movement, determined to blaze her own path.

This path led her to New York, where, by 1900, she was a well-established portraitist—among her sitters were Mrs. Theodore Roosevelt and Mrs. Andrew Carnegie—and a recipient of many national and international honors, such as the Mary Smith Prize from the Pennsylvania Academy of the Fine Arts, an award for the best woman artist in residence, in 1885, 1887, 1891, and 1892, and a gold medal in 1898. Her first international triumph came in 1896 with her exhibition of six portraits at the Paris Salon and her election as an Associate of the Société Nationale des Beaux-Arts, a rare honor. Another major acknowledgment of her talent was the commission in 1919 to paint portraits of three World War I heroes: Cardinal Mercier, Archbishop of Malines, Belgium; Admiral Lord Beatty of the British Navy; and Georges Clemenceau, Premier of France. In 1925, she was the first American woman to be asked to paint a self-portrait for the Uffizi's gallery of artists.

M.L.W.

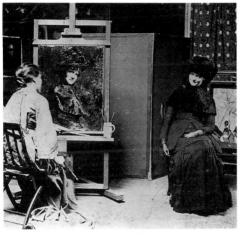

Photograph of Cecilia Beaux painting the portrait *Ethel Page (Mrs. James Large)*, 1884

OPPOSITE:
Cecilia Beaux. *Ethel Page (Mrs. James Large)*. 1884. Oil on canvas, 30 × 25⅛". The Holladay Collection

AMERICAN WOMEN SCULPTORS
OF THE EARLY TWENTIETH CENTURY

THE ORIGINS of the art of sculpture in America can be traced to the production of utilitarian items such as ships' figureheads and mantelpieces. It was not until the end of the eighteenth century, with the visit of the French sculptor Jean Antoine Houdon (1741–1828), that sculpture was acknowledged and promoted as a separate art form. Since the roots of the Neoclassical style practiced by Houdon were to be found in Italy, many young American sculptors traveled to Rome beginning in the 1820s.

In the mid-nineteenth century, American women joined their male counterparts in Rome in such numbers that they were dubbed "the white marmorean flock" by their fellow expatriate Henry James. These women, among them Harriet Hosmer, Edmonia Lewis, and Emma Stebbins, executed both monumental sculptures and smaller, more intimate works, becoming well known on both sides of the Atlantic.

New currents in American sculpture were discernible after the Civil War, as bronze began to replace marble for statuary. Bronze was lighter and more durable than marble for outdoor monuments and was thus employed for many equestrian memorials commissioned to honor war heroes. The metal also afforded greater detail in modeling and more freedom in composition, since it was fashioned first in pliable clay or wax and then cast in metal. Finally, especially important for small sculptures that were becoming so popular for placement in homes, bronzes could be easily replicated in various editions.

The second generation of American sculptors drew inspiration from events in Paris, not Rome. American women abroad studied at the privately owned Julian and Colarossi academies, since women were excluded from the prestigious Ecole des Beaux-Arts until the end of the century. Practical training for women could be obtained in the studios of American sculptors both in France and in the States. Augustus Saint-Gaudens apprenticed Helen Mears; Frederick W. MacMonnies accepted Janet Scudder to his Paris studio; and Daniel Chester French chose Evelyn Longman as his only female student.

Women were also allowed significant opportunities for training and for exhibition at the Chicago World's Columbian Exposition of 1893. Lorado Taft (1860–1936), an instructor at the Art Institute of Chicago and a former student at the Ecole des Beaux-Arts, employed many women as assistants in executing sculptures for different buildings of the Exposition.

The practice of using small bronze figurines as decorative items in the home offered more opportunities for sculptors, both men and women. This new fashion was actively promoted by the National Sculpture Society, founded in 1893 after the Chicago Exposition, by the Exposition itself, and by commercial galleries. The bronze figurines were particularly popular among the middle class, which enjoyed scenes showing daily life in realistic, informal groupings.

EVELYN BEATRICE LONGMAN | 1874–1954

Evelyn Beatrice Longman was considered the most successful woman sculptor of her time. She began her career as the only woman assistant of Daniel Chester French, working in his studio from 1901 to 1904. *Bacchante Head*, inscribed "Peggy" on the back, is actually a portrait of French's daughter, Margaret French Cresson (1899–1973), executed around the time Longman was associated with the sculptor. The bust is still mounted on its original marble and bronze pedestal, which allows the viewer to imagine how small bronzes were displayed in the home. The head was cast at the Roman Bronze Works in New York, which, along with Gorham, specialized in the production of these small figurines. Longman's reputation, however, was made by such monumental commissions as the bronze doors of the chapel of the United States

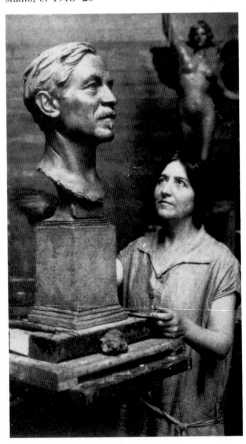

Photograph of Evelyn Beatrice Longman in her studio, c. 1918–20

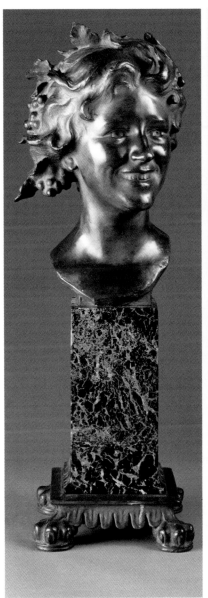

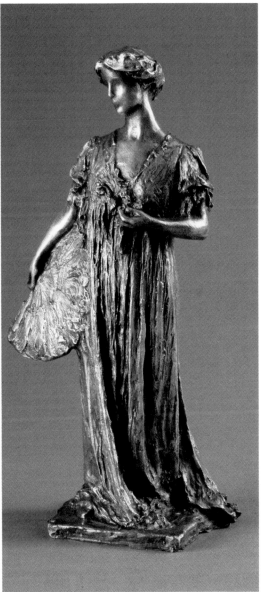

Naval Academy in Annapolis, completed in 1906. Her best-known work is *Genius of Electricity,* her entry in a contest sponsored by AT&T in 1914 to design a corporate image. "Golden Boy," as it is affectionately called, was restored in 1980 and moved indoors to the lobby of the new AT&T building on Madison Avenue in New York City. Longman was the first woman elected to the National Academy of Design, only one of many professional honors in her long and productive career.

BESSIE POTTER VONNOH | 1872–1955

Bessie Potter Vonnoh, who worked with Lorado Taft at the Columbian Exposition of 1893, was trained in the tradition of monumental sculpture but is best known for her exquisite statuettes of intimate genre subjects, which she became interested in producing after viewing an exhibition devoted to small bronzes at the Exposition. Vonnoh began making these statuettes after a trip to Paris in 1895, where she was impressed by the domestic subject matter of works by the sculptor Rodin and the painter Mary Cassatt. The silvered-bronze *Fan* (c. 1910) is the only casting known of this particular piece. The small, elegant sculpture of a woman holding a fan is typical of both Vonnoh's subject matter and style. She specialized in creating groups and single figures of young mothers with babies and elegant young women in flowing, classically inspired draperies, waving their fans or dancing. The silvered facets of the details of the woman's gown and fan reflect the play of light in an Impressionist fashion. In the 1920s and '30s Vonnoh created larger sculptures, including portrait commissions, but she remains best known for her genre pieces.

Marion Boyd Allen (American, 1862–1941). *Portrait of Anna Vaughn Hyatt*. 1915. Oil on canvas, 65 × 40″. Maier Museum of Art, Randolph-Macon Woman's College, Lynchburg, Virginia

ANNA VAUGHN HYATT HUNTINGTON | 1876–1973

The Collection's small bronze *Yawning Panther* by Anna Vaughn Hyatt Huntington is illustrative of the oeuvre of America's best-known animal sculptress. Huntington's father, a prominent paleontologist, encouraged her early interest in animals, which developed into a lifelong study of animal anatomy and behavior. *Yawning Panther* portrays the animal stretched full-length, tail arched, head thrown up and back, mouth wide open as he yawns, relaxed but still tensed to respond to the slightest untoward sound. Huntington also combined her love of animals with studies of historical subjects to create large-scale commissions. One famous example is *Joan of Arc*, which earned an honorable mention in the Paris Salon of 1910 and was erected on Riverside Drive, New York City; additional casts were placed in Blois, France; Gloucester, Massachusetts; and San Francisco. Her marriage in 1923 to the philanthropist and Spanish-language scholar Archer Milton Huntington provided the inspiration for other renowned large-scale sculptures, among them *El Cid* and *Don Quixote*. The Huntingtons have left an enduring monument, among many, in Brookgreen Gardens, South Carolina, which they bought in 1932. Their original intention of designing a sculpture garden for Anna's works was expanded to include pieces by other sculptors, so that today the garden is the largest collection of its kind in the world.

MALVINA HOFFMAN | 1887–1966

The bronze bust of *Anna Pavlova* in the Holladay Collection is a lasting tribute to the friendship and collaboration of two eminent women artists: the ballerina Pavlova and the sculptor Malvina Hoffman. As a student and friend of Rodin's during her early days in Paris, 1910–14, Hoffman was exposed to the incredible intellectual and artistic turmoil of the years immediately preceding World War I. Although she met many important persons of the day, including Gertrude Stein, the personality most crucial to her development as an artist was the Russian ballerina Anna Pavlova. Their

Photograph of Malvina Hoffman in the mid-1940s

intense and rewarding friendship began in 1914 and continued until Pavlova's death in 1931. During World War I, Hoffman worked on the design and modeling of many ballet sculptures, including a frieze that depicted the entire ballet *Bacchanale* in twenty-five bas-relief scenes. *Bacchanale* had been choreographed expressly for Pavlova and her current partner in 1909 and had become a favorite with audiences the world over as one of her signature pieces. The portrait bust of the ballerina, shown here, was executed in 1926 and is one of three lifetime casts. In the sculpture, the ballerina strikes a thoughtful pose, hands folded demurely before her, an introspective attitude quite at variance with the usual depictions of the high-spirited performer. Hoffman's most challenging commission was a request by the Field Museum of Natural History in Chicago for over one hundred lifesize sculptures representing the "Living Races of Man," which required that she travel around the world to study her subjects. The project was finished in time to be a central feature of the Chicago World's Fair in 1933.

The women sculptors of the early twentieth century, of which those represented in the Collection provide just a tantalizing glimpse, opened new vistas in both monumental and small-scale sculpture. Their command of the practical aspects of bronze casting, their unending quest for truth in the depiction of their subjects, and their talent and dedication to their art produced works at once intensely personal and also illustrative of the age in which they lived.

M. L. W.

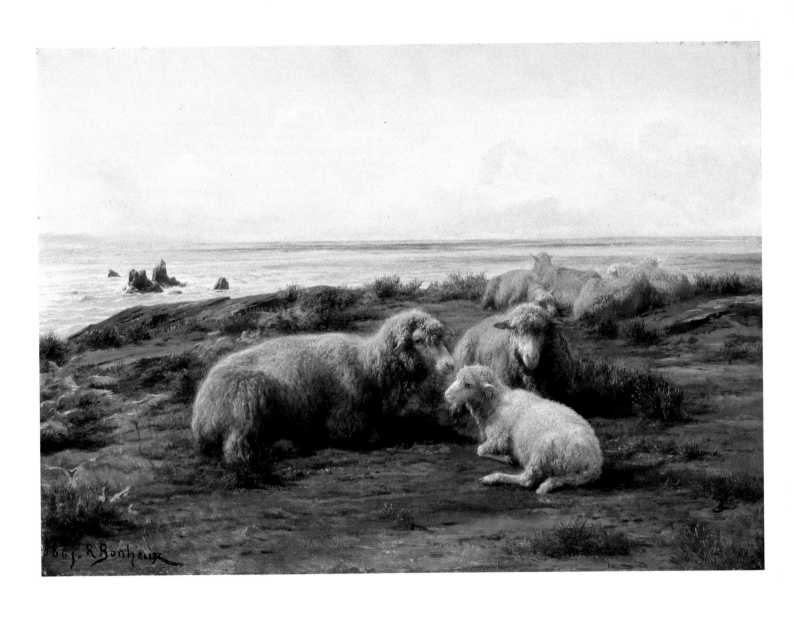

ROSA BONHEUR
FRENCH | 1822–1899

THE FRENCH animal painter and sculptor Rosa Bonheur made an important contribution to the development of nineteenth-century art. Her father, a painter and follower of the radical Saint-Simonian sect, encouraged her interest in art in general and in animals as her exclusive subject and allowed her to keep a veritable menagerie in their sixth-floor Parisian apartment—including a sheep that lived on the balcony. Out of financial necessity, her father became her art teacher and, to widen her horizons, sent her off to the Louvre to copy the old masters.

Bonheur exhibited her animal paintings and sculptures at the Paris Salon every year from 1840 to 1855. Participation in the Salon was decided by a jury that was usually dominated by older, established artists. Even though the Salons tended to support only conservative, traditional styles and values, most artists still sought to exhibit at the annual shows, as it was the only way for their work to be seen by the public. In 1845 Bonheur won a third prize and in 1848 a gold medal and was subsequently awarded a commission from the French government to produce a painting on the subject of plowing. *Plowing in Nivernais*, painted the next year, launched her career in France.

Bonheur won international acclaim with her lifesize painting *The Horse Fair* exhibited at the 1853 Salon. The raw energy and power of the wild animals and her accurate anatomical rendering of them demonstrate a debt to the painter Théodore Géricault (1791–1824). The superb modeling of the horses, which are seen from many angles, dominates the painting; the human figures are incidental to the scene and rarely appear in Bonheur's work.

Bonheur's popular success paralleled the rise of the middle class in France from 1850 to 1870. The newly rich bourgeoisie spurned great history paintings and were anxious to buy small, picturesque renderings of landscapes and animals with which they could more easily identify. Her popularity in England was assured after *The Horse Fair* was exhibited there, and Queen Victoria ordered a private showing at Buckingham Palace. In fact, the artist's chief source of revenue in the 1860s and '70s came from sales in England, a nation devoted to animals, rather than from her native France.

Sheep by the Sea (1869), shown here, illustrates Bonheur's lifelong interest in portraying farm animals in a straightforward, unromantic manner. She has captured the essence of a flock of domestic sheep—calm, undisturbed, and complacent—settled in a meadow on the edge of a body of water. Even the engraving *Sheep in a Mountain Landscape* (see page 161), a subject that would normally have been romanticized in the nineteenth century, is presented in this same realistic manner.

Bonheur's unconventional life-style contributed to the myth that surrounded her during her lifetime. She smoked cigarettes in public, rode astride, and wore her hair short. From her teens, she favored men's attire for working and obtained a special permit from the police to dress in her usual trousers and smock. She also wore men's clothes when she visited the slaughterhouse and butcher shops of Paris to study the anatomy of animals. After she became well known, admirers from all over the world sent her haunches of beef and mutton to dissect. At a time when it was unusual for a woman to own property, she bought a château on the edge of the woods of Fontainebleau.

Along with Bonheur's financial success came official recognition from the governments of Mexico, Belgium, Spain, and Portugal. She was awarded the Cross of the French Legion of Honor in 1865 and made an Officer in 1894, the first woman artist to receive these honors.

M.L.W.

Anna Elizabeth Klumpke (American, 1856–1942). *Rosa Bonheur*. 1898. Oil on canvas, 46⅛ × 38⅝". The Metropolitan Museum of Art. Gift of the artist in memory of Rosa Bonheur, 1922

OPPOSITE:
Rosa Bonheur. *Sheep by the Sea*. 1869. Oil on cradled panel, 12¾ × 18". The Holladay Collection

BERTHE MORISOT

FRENCH | 1841–1895

Edouard Manet (French, 1832–1883). *Repose: Portrait of Berthe Morisot.* 1870. Oil on canvas, 58¼ × 43¾". Museum of Art, Rhode Island School of Design. Bequest of Mrs. Edith Stuyvesant Vanderbilt Gerry

OPPOSITE:
Berthe Morisot. *The Cage.* 1885. Oil on canvas, 19⅞ × 15". The Holladay Collection

BERTHE MORISOT was a prominent member of the Impressionists, the avant-garde French artists who first came to public attention in a series of controversial shows held between 1874 and 1896. For the first time, artists banded together and held an exhibition independent of the government and traditional Academic institutions and without the inequity of a politically appointed jury. Morisot was one of the organizers of the Société Anonyme Cooperative d'Artistes-Peintres, Sculpteurs, etc., the official sponsor of the 1874 exhibition, to which she contributed nine works. She was, after Camille Pissarro, the most faithful artist of the group, submitting works to seven of eight exhibitions.

Morisot was born on January 14, 1841, at Bourges. The third daughter of a wealthy family, she was provided with art lessons as part of the standard education given to young ladies of her class. Her talent soon became apparent, and she began formal study with the painter Joseph Guichard. She also spent many hours in the Louvre, copying the works of the old masters. In 1860 Morisot entered the studio of the well-known landscape painter Camille Corot. Her first work was accepted at the yearly Salon four years later.

By the latter half of the 1860s Morisot had become part of the circle of young artists that would later become known as the Impressionists. She adopted a brighter palette and employed a broader application of paint, and reflecting the interests of the group, she began to paint scenes from contemporary life. She submitted to the Salon for the last time in 1873, preferring thereafter to show with the Impressionists.

In 1874 Berthe Morisot married Eugène Manet, Edouard Manet's younger brother, and gave birth to a daughter in 1878. Thereafter she combined a career as an artist with that of a wife and a mother and died in March of 1895.

Morisot's career showed a clear development from her early Impressionist interests in the notation of light to broader artistic concerns and looser brushwork in her later years. She is recognized as one of the significant painters of the late nineteenth century; major museums throughout the world contain her scenes of everyday life and her striking portraits. *The Cage*, reproduced here, is typical of Morisot's paintings of the 1880s; the bird cage appears in several of her works from this period. Although painterly brushwork and bright pastel colors derive from her earlier Impressionistic style, no longer does she record the subtle nuances of light. Instead, Morisot has concentrated on the surface values and formal elements of the composition, as can be seen in her treatment of the cage, the birds within, and the bowl of flowers in the background. In addition to *The Cage*, the National Museum of Women in the Arts owns a watercolor by Morisot entitled *Lake at the Bois de Boulogne* (see page 218).

E.D.

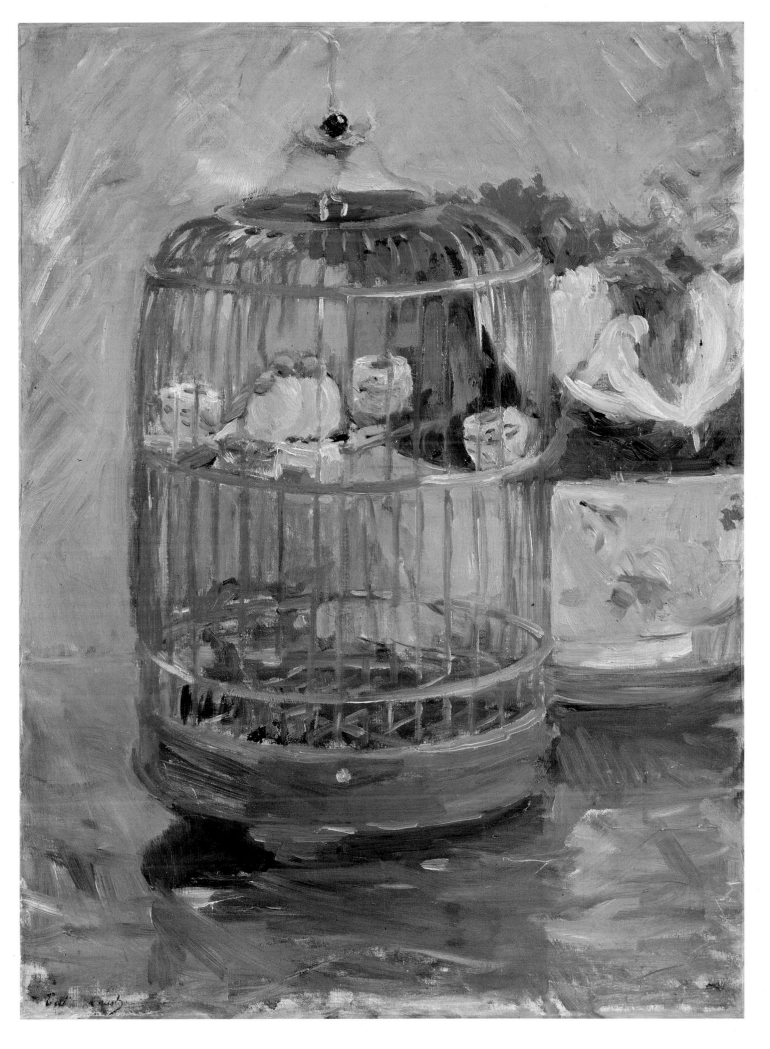

CAMILLE CLAUDEL

FRENCH | 1864–1943

THE LIFE and artistic production of the French sculptor Camille Claudel were influenced by her association with Auguste Rodin (1840–1917), one of the founders of modern sculpture. The extent of Rodin's power over Claudel's work, and of her importance in the development of his oeuvre, is difficult to ascertain in view of the emotions aroused by the story of her life and the lack of documentary evidence concerning their relationship.

Claudel was born in the Champagne region of France and moved to Paris with her mother and siblings when she was seventeen, expressly to have more opportunity to study sculpture. Since women were not yet allowed admission to the Ecole des Beaux-Arts, she studied at the private Académie Colarossi. She also rented a studio with several Englishwomen, where the sculptor Alfred Boucher (1850–1934) came regularly to review their work. Her early sculptures already exhibited a force and a naturalism that linked them with the new conception of sculpture being explored by Rodin, although Claudel at the time had never heard of him.

In 1883 Boucher had to be absent from Paris for some time and asked Rodin to take his place at Claudel's studio. The ensuing meeting between Rodin, then forty-three, and Claudel, nineteen, led to a fifteen-year-long relationship, during which she was his model and collaborator; he was her mentor and teacher. In 1888 Rodin rented a town house, which he and Claudel shared as a studio. At the same time, Rodin continued to live with his mistress of twenty years, Rose Beuret. Rodin's refusal to marry Claudel and her perception that she was still regarded as his student—never as his equal or collaborator—caused her to break off the relationship in search of more professional and personal freedom. By 1898, she had terminated their connection.

The first ten years of their association were particularly productive ones professionally for both Rodin and Claudel. He was working on the *Burghers of Calais* and had started the *Gates of Hell*, on both of which Claudel is known to have collaborated. The extent of their interdependency is illustrated by Claudel's sculpture *Young Girl with a Sheaf of Wheat*, shown here, which is often compared with Rodin's *Galatea*. The Museum's piece, the eighth of twelve castings in bronze, depicts a seated young woman leaning against a sheaf of wheat. The leftward twist of the head, the upward fold of the left arm, and the curious crouching stance are all replicated in Rodin's statue. While Rodin conceived his nude as emerging from the unfinished marble that surrounds his subject on two sides, Claudel preferred to provide her figure with a more realistic background—a monumental sheaf of wheat. Both conceptions furnish the opportunity to contrast a maiden's smoothly modeled skin with a rough background and provide a foil against which the complex composition is designed. Given the facts that Rodin and Claudel worked so closely together during this period and that there are few signed and dated pieces by Claudel, the extent of her influence upon him in this and other works cannot be exactly determined.

After 1898, when the relationship was over, Claudel continued to sculpt. In an effort to declare her independence from Rodin, she chose to portray subject matter that was significantly different from her past work and alien to his production. Her sculptures depicting groups of small figures in everyday scenes date from this period. Although she achieved some measure of critical acclaim, without Rodin's support Claudel had a difficult time financially. Not only were materials expensive, but lucrative commissions at this time were to be found only with the state. Private galleries, of which there were few, dealt exclusively with painting. Claudel became suspicious of Rodin and of his presumed efforts to steal her work and sell it as his own. As these feelings of paranoia grew stronger, she became more and more reclusive until, in 1913, when she was forty-nine, her family committed her to an asylum, where she remained until her death in 1943.

M. L. W.

Photograph of Camille Claudel in 1903.
Private collection

OPPOSITE:
Camille Claudel. *Young Girl with a Sheaf of Wheat.* 1882. Bronze, 14¼ × 8¼ × 8¼". The Holladay Collection

SUZANNE VALADON

FRENCH | 1865–1938

Suzanne Valadon. *Self-Portrait*. 1915. Oil on canvas, 18⅛ × 15″. Collection Paul Pétridès, Paris

OPPOSITE:
Suzanne Valadon. *The Abandoned Doll*. 1921. Oil on canvas, 51 × 32″. The Holladay Collection

Suzanne Valadon was born in the French provinces in 1865 and, by the age of ten or twelve, was surviving on her own in the bohemian underworld of Paris. During her late teens she worked as an artist's model, posing for, among others, Pierre Puvis de Chavannes, Henri de Toulouse-Lautrec, and Auguste Renoir. In 1883, the same year her son Maurice Utrillo was born, she began to use pastels and to draw, imitating the styles of the men artists for whom she was modeling. During this early period of her life, she became a friend of Edgar Degas's, who took a great interest in her work and considered her "one of us" artists and a genius.

Valadon's earliest paintings date from 1892–93, and from the outset she painted nudes, portraits, and still lifes. She began to print in Degas's studio in 1895 and continued a prolific production along with drawing, which she believed to be the basis of good art. The works in the Holladay Collection survey several themes and periods of Valadon's work, including the 1910 drypoint *Bathing the Children in the Garden* (see page 238), the 1920 still life *Bouquet of Flowers in an Empire Vase* (see page 238), and the 1930 *Girl on a Small Wall* (see page 238), which possesses the intimacy of a portrait.

In 1911, Valadon had her first solo exhibition and in 1912 was included in a group show of French artists in Munich. From 1921 until her death in 1938, she enjoyed critical acclaim and financial success—continuing to exhibit regularly and having retrospectives in 1927, 1929, 1931, and 1932. From 1933 until 1938 she participated in the Salon of Modern Women Artists.

Valadon's prints and drawings, as well as her paintings, reveal a continuing fascination with, and exploration of, the female body in many poses, activities, and states of mind. Two works in the Holladay Collection, *Nude Doing Her Hair* (see page 239) and *The Abandoned Doll*, reproduced here, illustrate this aspect of her work. Having been an artist's model herself, Valadon may have retained a special interest in the subject for which she previously served as model.

In her painting *The Abandoned Doll* of 1921 she examines the theme of a young woman on the threshold of adolescence and self-knowledge. Valadon's typical combination of firm compositional structure with decorative surface details and patterning is, in this painting, intensified by a compelling psychological drama. The young woman's body is partly exposed to the viewer, with the shoulders and torso twisted in the contorted pose so favored by Valadon in all her work. The subject turns away from both the older woman seated beside her and the viewer to study her own reflection in a mirror. At the bottom edge of the painting lies the abandoned doll of the title, wearing a blue dress and a large pink hair ribbon that is identical to the one that is the young woman's only garment. This identity of the young woman and the doll expresses the metaphor of the title and returns speculation and attention to the pubescent nude body that is the focus of this intensely colored, yet somber interior. The expressive distortions of the figures and the stern outline and rich color modulations of the body powerfully evoke a young woman's confrontation with the mystery of physical and psychological self-awareness.

M.B.M.

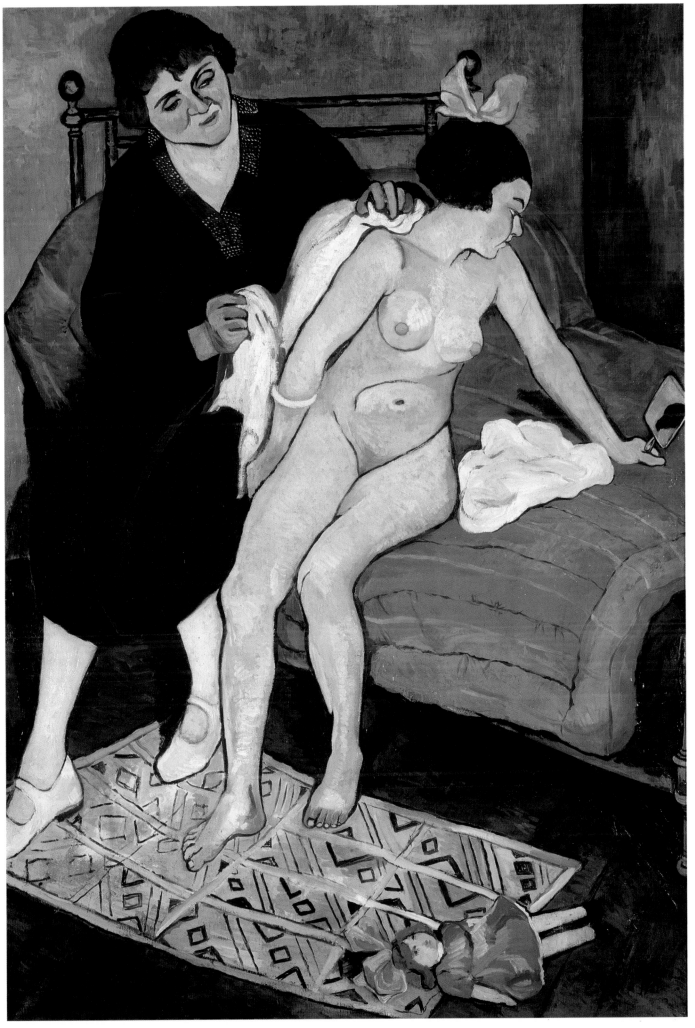

MARIE LAURENCIN

FRENCH | 1885–1956

Marie Laurencin. *Group of Artists.* 1908. Oil on canvas, 25½ × 31⅞". The Baltimore Museum of Art. The Cone Collection, formed by Dr. Claribel Cone and Miss Etta Cone of Baltimore, Maryland

OPPOSITE:

Marie Laurencin. *Portrait of a Girl in a Hat (Self-Portrait).* c. 1920. Oil on canvas board, 14½ × 11". The Holladay Collection

THE NAME of Marie Laurencin is frequently linked with those of Picasso, Apollinaire, and other members of the Cubist circle. This association has been immortalized in her 1908 painting *Group of Artists*, reproduced on this page, which shows (from left to right) Picasso and his dog Frika; Laurencin herself standing next to her lover, the poet Apollinaire; and Fernande Olivier, Picasso's mistress. Although executed early in her career, the portrait already demonstrates Laurencin's distinctive style. The ovals of the women's faces, the languid arabesque of Fernande Olivier's arm supporting her chin, and the image of the vase of flowers above her head are forms that recur in Laurencin's later work.

Laurencin's turbulent relationship with Apollinaire finally ended in 1913; a year later, she married a German art student, Otto von Waetjen. The outbreak of World War I forced them to flee to Spain, where she lived for five years, returning to Paris in 1920 after a year spent in Germany to obtain a divorce. The next seventeen years mark the most productive period of Laurencin's life.

Self-Portrait, also titled *Portrait of a Girl in a Hat*, dates from the beginning of this time. Even though labeled as a self-portrait, it is almost indistinguishable from her many portraits of this period. The dainty, upturned nose, demure mouth, and almond-shaped eyes are all prominent features of her other female portraits. She has, however, depicted her own hair quite realistically as kinky tendrils wisping around the face and neck. The color scheme is typical of her paintings, with flat planes of pink, blue, and white predominating. Her profile is delicately drawn against the mottled gray background and becomes a refined two-dimensional portrayal of Laurencin's conception of "Woman."

Laurencin's style was well suited to the decorative, lighthearted themes in fashion and decor prevailing in the 1920s, when some of her most characteristic work was executed. In addition to painting, she illustrated more than twenty books, including a deluxe edition of *Alice in Wonderland*. She designed the sets and costumes for the 1924 presentation of *Les Biches* by Ballets Russes, produced by Serge Diaghilev with music by Francis Poulenc. The production was a tremendous success, and her designs for both costumes and scenery had an immediate effect upon the fashions of the time. (When the ballet was revived in 1964 at Covent Garden, using her same designs, it met with instant success.) She also designed wallpaper and textile patterns for the Art Deco designer André Groult and worked on dress designs with the leading couturier Paul Poiret, Groult's brother-in-law.

Although Laurencin's distinctive artistic personality developed during the years when her tumultuous relationship with Apollinaire involved her in Picasso's circle, she did not become a mere imitator of the Cubists. Rather, she developed her own decorative interpretation of the style, thus contributing a unique aspect to the imagery of the time.

M.L.W.

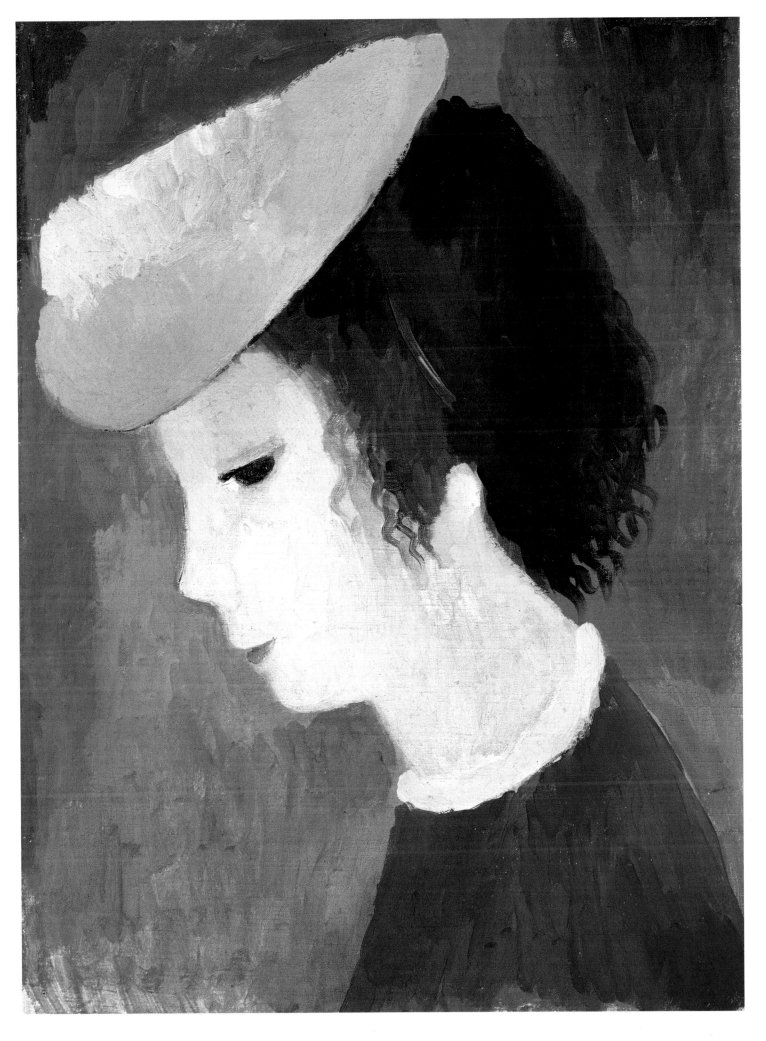

71

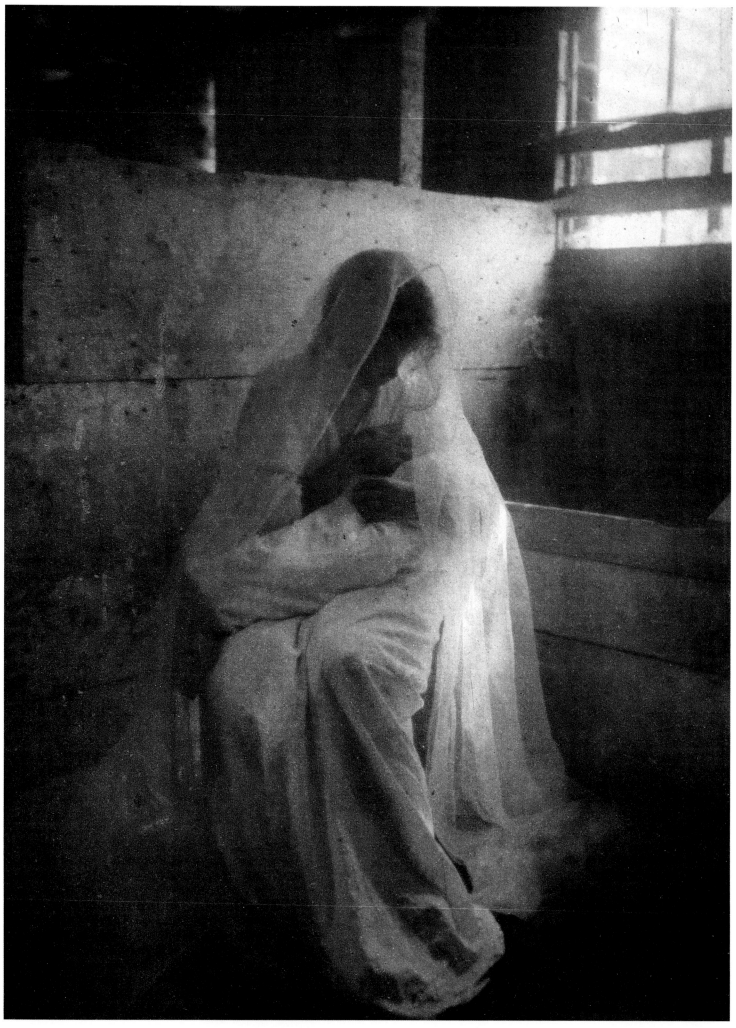

GERTRUDE KASEBIER
AMERICAN | 1852–1934

I N 1898 Alfred Stieglitz, writing in *Camera Notes*, described Gertrude Käsebier as "beyond dispute, the leading portrait photographer in the country." Käsebier, a forty-six-year-old mother of three, had just opened her first portrait studio the year before, beginning her meteoric rise in the world of photography. In 1902 she became one of the founding members of the Photo-Secession, and the next year the first issue of *Camera Work* was devoted entirely to her photographs. In 1906 she was featured in a one-woman exhibition at the Little Galleries of the Photo-Secession and was the first woman elected to the Linked Ring Society, a prestigious English group devoted to pictorial photography.

Gertrude Käsebier's career in photography began after a life as wife and mother that had given little expression to her artistic talent. She grew up on the American frontier and came east to help her mother run a boardinghouse in New York after her father died. Here, in 1874, she met and married Edward Käsebier, a German importer of shellac. While raising her three children, she applied—and was refused admission—to Cooper Union, the leading art school in New York at the time. In 1888, she entered the newly opened Pratt Institute to study portrait painting. It was not until a trip to France in 1893 that, quite by accident, she discovered her talent for photography. Before opening her own studio, she apprenticed herself to a German scientist to study the chemical basis of photography and to an American portrait photographer to learn the business aspects of running a studio.

The Manger, illustrated here, dates from around 1899, two years after her studio opened. Its selling price of one hundred dollars, the highest price commanded by an art photograph up to that time, indicates the extent of her early success. The photograph was executed in the Pictorial style, of which Käsebier was a leading exponent. Members of this movement, which began in England in the 1890s, saw photography as the equal of the other visual arts. They achieved painterly effects in their photographs by blurring many details, by wrapping the subjects in gauzy, free-flowing garments, and by suffusing the entire picture with a soft, ethereal light. Pictorialists also used titles as intrinsic parts of their artworks to explain the narrative subject matter of the photograph to the viewer. The title of the Holladay photograph makes a reference to the Nativity itself and also to the special relationship existing between mother and child.

Käsebier was equally well known to her contemporaries as a portrait photographer. Again, her fees indicate her popular success: a sitting with Gertrude Käsebier cost twenty-five dollars, with five dollars for each print, while most other portraitists charged twelve dollars, which included the sitting and twelve prints. She created likenesses that were biographical sketches of her sitters, producing memorable photographs of such major artistic and cultural figures of the day as Arthur B. Davies, John Sloan, Mark Twain, and Booker T. Washington. She also executed an invaluable series of photographs of her friend the artist Rodin in his studio and another featuring the American Indians in Buffalo Bill's Wild West Troupe.

Popular tastes changed after 1910, and the soft, hazy images of the Pictorialists gave way to sharp, hard photographs emphasizing details and bold images. In response to this new trend, Gertrude Käsebier founded Pictorial Photographers of America in 1916 with her friends Alvin Langdon Coburn and Clarence H. White.

M.L.W.

Photograph of Gertrude Käsebier

OPPOSITE:
Gertrude Käsebier. *The Manger*. c. 1899. Platinum print, 7⅝ × 5½". The Holladay Collection

LOUISE DAHL-WOLFE

AMERICAN | 1895–

Photograph of Louise Dahl-Wolfe in her New York studio, 1938

OPPOSITE:
Louise Dahl-Wolfe. *Colette.* 1951. Silver gelatin print, 10⅜₆ × 13⅟₁₆". Gift of Mrs. Helen Ziegler, 8/83

I N THE 1940s and '50s, the look of America was changing from the sophisticated, flawless style influenced by European fashion designers to the carefree, wholesome, tousled "girl-next-door" look. Louise Dahl-Wolfe, the premier fashion photographer of *Harper's Bazaar* from 1936 to 1958, helped to create and promote that style.

Encouraged by *Harper's* editors Carmel Snow and Diana Vreeland, Dahl-Wolfe transformed fashion photography in both content and technique. She shot scenes all over the world, taking models on location instead of using elaborate studio props. She made overt use of models' personalities, often furthering their careers by her innovation. For example, Lauren Bacall's Hollywood career began after she appeared on a 1943 Dahl-Wolfe cover of *Harper's Bazaar.* Dahl-Wolfe's most lasting contribution to the field was her implementation of color photography. She used Kodachrome film extensively after it was introduced in 1935 and was the first photographer to use color on location outdoors.

Dahl-Wolfe preferred photographing still lifes and personalities. Her photographs were of the great and famous of the era: fashion designers, such as Coco Chanel and Christian Dior; cinema stars such as Mae West, Spencer Tracy, and Ethel Merman; political figures, including John F. Kennedy and Jacqueline Kennedy Onassis; and literary luminaries such as Colette, the subject of the photograph in the National Museum of Women in the Arts. Dahl-Wolfe visited Colette at her home in Paris in 1951, the last year of her life. The resulting photograph, reproduced here, is both an excellent example of her portrait style and a tribute to Colette's indomitable vitality. As in her fashion photography, Dahl-Wolfe preferred casual, unposed shots—here catching the author with pen poised above her manuscript in the act of creating. She does not flatter the ill woman but instead emphasizes her character and her spirit.

M.L.W.

THE PHOTOGRAPHS of Berenice Abbott span six decades and two continents and illustrate a unique view of the twentieth century. Born and reared in Ohio, Abbott went to New York in 1918 to study journalism but found the atmosphere at Columbia University stifling and turned instead to sculpture. Since she could "be poor as easily in Europe as in America," she bought a one-way ticket to Paris in early 1921. Two years of study improved her sculpting abilities but brought no financial success, so she took a job as darkroom assistant to Man Ray, qualifying for the position because she knew nothing about photography and posed no threat to the master.

Within two years she had become a faultless technician and an enthusiastic photographer. In 1925 Abbott set up her own studio on the Left Bank, where she photographed figures from the world of fashion, luminaries of the Parisian social scene, and literary and artistic notables. These photographs have become important records of the life and culture of Paris immediately preceding the Depression. The seven examples of her work in the Holladay Collection, including *Edna St. Vincent Millay*, reproduced here, all date from this period and illustrate her talent for executing remarkable, spontaneous character studies of her sitters. Abbott's ability to portray the essence of a personality through a telling gesture, a characteristic pose, or a revealing detail of costume or accessory is apparent in these photographs (see pages 148–49). She continued to achieve this quality in her work in later years, whatever the subject—person, city street, or scientific experiment.

During this time, Abbott became interested in the work of Eugène Atget, who photographed the city of Paris from the 1890s to the 1920s. After his death, she bought his collection of ten thousand glass plates and prints and launched a campaign to preserve his work, eventually publishing *The World of Atget* in 1964.

Inspired by Atget's visual record of Paris, Abbott decided that her next project would be an attempt to document the city of New York on film. She returned home just before the Depression and worked for the next ten years recording the changes occurring in the city as nineteenth-century buildings were demolished to allow for twentieth-century expansion. In 1935, she finally obtained funding to finance her work for the next four years through the Federal Art Project and in 1939 published *Changing New York*.

With the completion of this monumental project, Berenice Abbott turned to scientific photography. Her contributions to this field are best illustrated in *Physics*, published in 1960 by the Physical Science Committee of Educational Services, Inc., and intended to revolutionize the study of high school physics.

Berenice Abbott taught at the New School for Social Research in New York for twenty-five years, training a generation of professional photographers. She wrote the best-selling popular manual *A Guide to Better Photography*, published in 1941 and reissued in 1953. She also succeeded in developing and marketing her own inventions of photographic equipment, another field in which she excelled.

M.L.W.

Photograph of Berenice Abbott, 1986.
© Arnold Newman

OPPOSITE:
Berenice Abbott. *Edna St. Vincent Millay.*
c. 1927. Vintage silver print, 14½ × 11½". The Holladay Collection

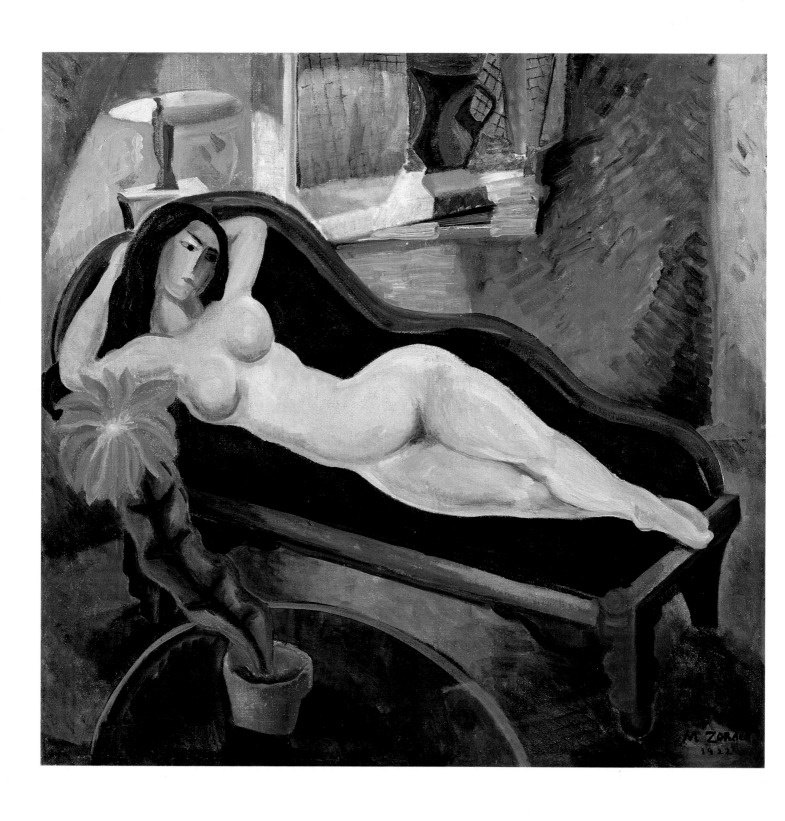

MARGUERITE THOMPSON ZORACH
AMERICAN | 1887–1968

W HEN Marguerite Thompson arrived in Paris in the fall of 1908, she faced a
very different world from her native Fresno, California. Her first day in the
city she attended the Salon d'Automne, where Henri Matisse and André Derain,
among others, were exhibiting. These so-called Fauves, or "Wild Beasts," were scan-
dalizing the Paris art world with their radical use of bold, flat colors. Thompson, who
had received a traditional artistic training in America, was immediately influenced by
these revolutionary ideas.

Her studies at the progressive school La Palette encouraged her to develop a dis-
tinctive style based on the color and rhythms of the Fauves and the early Blaue Reiter
artists, whose work she probably saw in Germany in 1910. Thompson was thus in the
first generation of American modernists to understand and to wholeheartedly espouse
the revolutionary color theories of the Fauves.

In March 1911, Thompson met William Zorach (1887–1966), a Lithuanian-born
lithographer from Cleveland, who was also studying at La Palette. They both returned
to the United States at the end of that year and were married in New York in December
1912. Their marriage proved to be a close personal and professional relationship,
especially during the first eight years, when they were both still working in the medi-
um of oil. The years, 1908–1920, when Zorach was experimenting with the theories of
Fauvism and Cubism and actively promoting the works of these artists in America,
were her most productive and creative period.

Nude Reclining, signed and dated 1922, is a radical departure from the landscape
studies in which she had specialized in Paris. The Fauvist influence can be seen in the
sharp contrast of the nude's body against the dark sofa and in the bright colors of the
orange flower in the foreground and blue jug in the background. While the sinuous
line of the nude probably derives from the conception of Matisse in his *Blue Nude* of
1907, some elements of the painting reveal other sources of influence. The flesh of the
nude is slightly modeled, and the background is composed of strokes of reds, blues,
and yellows—a departure from the pure, bright patches of colors found in paintings of
the true Fauve tradition. Radical Cubist theories concerning space can be seen in the
treatment of the room, in which space is simultaneously defined and denied. While
the overlapping forms and raised viewpoint serve to create space, the depth is denied
by the flattening of the forms and the ambiguous rendering of the window frame.

The importance of Zorach's work as a modern American artist was not fully recog-
nized until 1970, two years after her death, when some of her early canvases, painted
in 1911 and 1912, were discovered. Zorach had destroyed most of these early works,
some in 1912 and others in the 1920s, retaining a few, which she gave to her family at
her death. These works illustrate her understanding of the Fauve revolution in color
and help place her later paintings in perspective.

In the years following the birth of her second child in 1917, Zorach began to use
brilliantly colored wools, rather than paints, to execute her bold experiments in design
and color. Her needleworks, particularly the large-scale tapestries, were creative
endeavors that explored the range of color possible with woolen yarns and the varied
effects of texture and design attainable with the juxtaposition of different stitches.

Zorach and her husband both took part in the International Exhibition of Modern
Art, better known as the Armory Show, of 1913. She was one of seventeen artists
selected to exhibit at The Forum Exhibition of Modern American Painters in 1916,
another significant event in the annals of modern art in America. As Director of the
Society of Independent Artists and as the first President of the New York Society of
Women Artists, she also worked to promote modern art.

M.L.W.

Photograph of Marguerite Thompson Zorach,
c. 1960

OPPOSITE:
Marguerite Thompson Zorach. *Nude Reclining*.
1922. Oil on canvas, 29⅛ × 30¼". The Holladay
Collection

GEORGIA O'KEEFFE

AMERICAN | 1887–1986

Photograph of Georgia O'Keeffe, 1956. © 1956
Yousuf Karsh

OPPOSITE:
Georgia O'Keeffe. *Alligator Pears in a Basket.*
1923. Charcoal drawing, 24⅞ × 18⅞". The
Holladay Collection

ONE OF THE most prominent and successful American artists of the twentieth century, Georgia O'Keeffe produced a monumental body of work including paintings, watercolors, and drawings. Even before her death she had been the subject of books and films, and in 1977, had received the highest civilian award of her government, the United States Medal of Freedom. From the time of her first solo exhibition in 1917, her work had received positive critical attention, and within a decade after her first retrospective, her reputation and financial security were assured.

Born in 1887 near Sun Prairie, Wisconsin, O'Keeffe studied in Chicago in 1905–6 at the Art Institute and then in New York, first at the Art Students League with William Merritt Chase and later at Teachers College, Columbia University, with Arthur Wesley Dow. She worked as a commercial artist in Chicago and taught art in the Amarillo, Texas, public schools; at the University of Virginia; and at Columbia College, Columbia, South Carolina.

In 1916, O'Keeffe destroyed all the work she had produced in the preceding ten years, resolving thereafter to paint only what she herself wanted to paint. The works she then produced, small abstract watercolors and drawings, came to the attention of New York dealer Alfred Stieglitz, who gave O'Keeffe her first show in 1917. Through contact with Stieglitz, whom she married in 1924, O'Keeffe became part of the most progressive and innovative circle of American artists of the first part of the twentieth century.

O'Keeffe's earliest preserved works were abstractions, or extremely abstracted landscapes and still lifes, in which the image and the technique create a firm tension that constantly moves the viewer's eye and mind between the work of art itself and the subject it depicts. The 1923 charcoal drawing *Alligator Pears in a Basket* dates from this early period of O'Keeffe's work, when that tension was most rigorously maintained. The deliberate ambiguity of the composition forces careful exploration of the image itself, its subtle shadings of gray and black, and the way the rich grays of the fruit seem almost to appear as colors. O'Keeffe was fond of creating an unexpected viewpoint or focus in a work to surprise the viewer into a new confrontation with a familiar object. In this drawing, the pears are ringed by two thick charcoal lines, so that the fruit is seen from two vantage points. The work also reflects O'Keeffe's interest in images from the natural world, for which she developed a fluid, organic manner of drawing and painting.

O'Keeffe became best known for her paintings of flowers, often enormously enlarged or fragmented, and of bones set in the desolate landscape of the American Southwest. She first visited New Mexico in 1917 and, from 1929 onward, began to travel there regularly to paint; she settled there permanently in 1949. The colors and forms of the desert characterized her paintings for many years until later in her life, when new motifs from trips abroad also began to appear in her works. Throughout her life, O'Keeffe explored the near terrain on either side of abstraction, leaving a strong legacy of a life of hard work and single-minded devotion to art.

M.B.M.

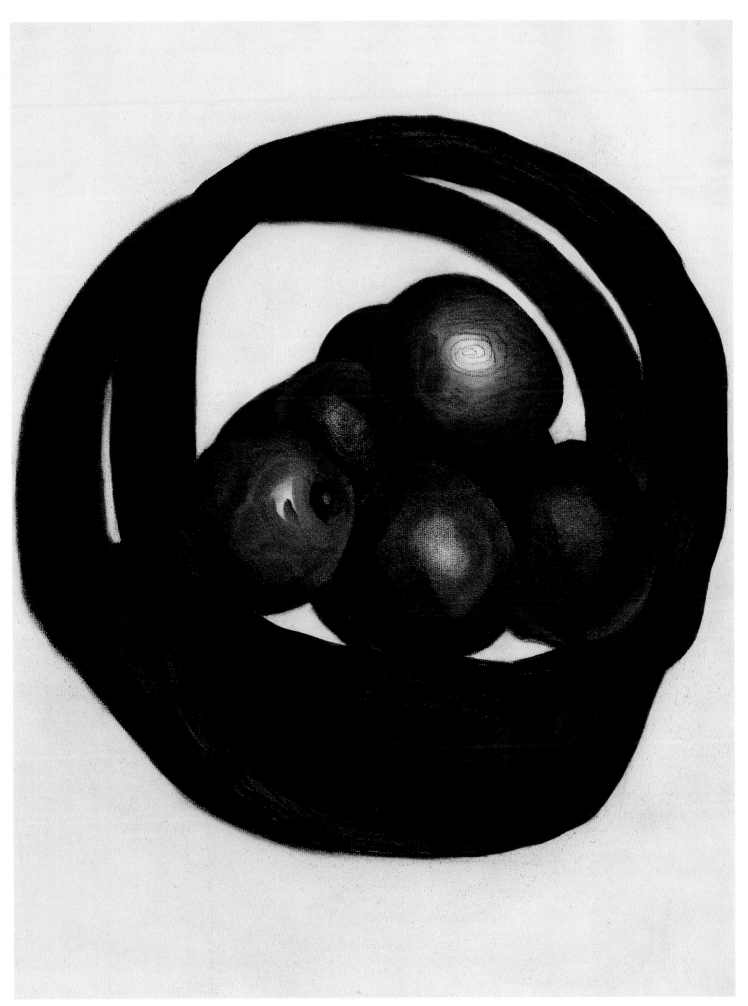

BEATRICE WHITNEY VAN NESS
AMERICAN | 1888–1981

BEATRICE WHITNEY VAN NESS was a painter of national repute and an art educator of international renown, a significant combination in twentieth-century America, which has pioneered art education for the masses.

Van Ness's own artistic education was at the Boston Museum of Fine Arts School of Drawing and Painting, where she studied from 1905 to 1913 with the painters Frank Benson, Edmund Tarbell, and Philip Hale. In 1914 she was awarded the Julia A. Shaw prize at the National Academy of Design for the best painting by a woman who had not previously been awarded the prize. The following year she received a silver medal at the Panama-Pacific International Exposition in San Francisco.

As she was becoming established as a professional painter, Van Ness became involved in art education, teaching classes at the Museum of Fine Arts, Boston. In 1921 she was offered a position at the Beaver Country Day School, where she created the art department. This project enabled her to give concrete form to many of her theories about art education for young people. As head of the department from 1921 to 1949, Van Ness developed and implemented programs that supported her strongly held belief that the arts were an integral part of everyone's life, well-being, and intellectual maturation. Her curricula were used as national models when art began to be integrated into the public school systems as an important and essential discipline. She received international recognition for these achievements and served on commissions sponsored by the Carnegie, Rockefeller, and Guggenheim foundations.

Because of her heavy teaching schedule, Van Ness painted during the summers, when she and her family went to Maine. There the sun-drenched environment and brilliant light inspired her to produce both figure studies and landscapes. *Summer's Sunlight*, which features her daughter, nephew, and neighbor, is a spontaneous evocation of the artist's love of light and color in which she uses warm colors to communicate a summer's atmosphere of heat and intense light. The composition invites the viewer into the scene, to stand under the orange umbrella that cuts across the upper half of the canvas and gaze out at the brilliant landscape. Van Ness tended to sketch the canvases out-of-doors during the months in Maine and then ship them to her Brookline studio for further work. Some she completed there, others she took back to Maine and reworked until she felt that she had captured the atmosphere and tonality she desired.

In Van Ness's early work, from the sensuously modeled single figures to the citrus-hued family groups of the 1920s and '30s, her exploration of light and shade was a recurring theme. Her later work was a constant search for new materials and an exploration of the special properties of light. Many of her oils and watercolors have been scraped, sanded, and reworked to allow the canvas or watercolor paper to shimmer through the tones of the pigment.

Because of her major contributions to art education in the United States, Beatrice Whitney Van Ness's career left a double legacy to the history of art: In addition to her own accomplishments as a painter, she made it possible for thousands of others to share in the creative process of art.

M.L.W.

Photograph of Beatrice Whitney Van Ness, c. 1940

OPPOSITE:
Beatrice Whitney Van Ness. *Summer's Sunlight*. c. 1932–34. Oil on canvas, 40 × 50″. The Holladay Collection

ALMA THOMAS
AMERICAN | 1891–1978

Portrait of Alma Woodsey Thomas, 1891–1978.
1976. National Museum of American Art,
Smithsonian Institution

OPPOSITE:
Alma Thomas. *Iris, Tulips, Jonquils and Crocuses.*
1969. Acrylic on canvas, 60 × 50″. The Holladay
Collection

ALMA THOMAS, whose name and reputation are often associated with the Washington Color Painters of the 1970s, was the first black woman to have a solo exhibition at the Whitney Museum of American Art. The show, held in 1972, was a tribute both to Thomas's tenacity and to her talent and came only slightly more than a decade after the artist had completed one career as a teacher and turned her full attention to painting. The dimension of Thomas's accomplishments took the art world somewhat by surprise, and she was hailed by one major critic as bringing "joy to the painting of the '70s."

Born in Georgia in 1891, Thomas moved in 1907 with her family to Washington, D.C.; she lived there, except for six years that she taught in Wilmington, Delaware, for the remainder of her long and productive life. In high school she had dreamed of becoming an architect and of building bridges but instead prepared for a career as a teacher, first at the Miner Teachers Normal School and later at Howard University, where in 1924 she became the first graduate of its Fine Arts Department. Later she earned an M.F.A. at Columbia Teachers College. In 1925 she embarked upon a teaching career at Shaw Junior High School, from which she retired in 1960.

During her years of teaching, Thomas was an important and dynamic force in the Washington arts scene. She organized clubs and art lectures for her students, established art galleries in the public schools, and was active in the founding of the Barnett-Aden Gallery in 1943, one of the first commercial art galleries in Washington devoted to modern art.

Although Washington was not a major art center during her lifetime, Thomas was nevertheless aware of the dilemma presented to modern painters by the development of abstraction. Even before her retirement in 1960, Thomas began to open up her compositions to more expressive brushwork and abstract structure. By 1959 her canvases had become totally nonrepresentational yet still rooted in the artist's visions of and feelings for the natural world. By 1964 she had discovered a way to construct an image almost entirely through small dabs of paint laid edge to edge across the painting surface, the technique she used in *Iris, Tulips, Jonquils and Crocuses*, illustrated here, painted in 1969, and in *Orion* of 1973 (see page 235). While the tight net of color on the canvas confronts the viewer, the spaces between the colors create the illusion of a space beyond. Thomas never adopted the stain technique favored by many Color-Field Painters, but her orderly rows of brushstrokes accomplish a similar tension between surface presence and depth beyond the surface. In *Iris, Tulips, Jonquils and Crocuses*, the pictorial drama is many-layered, with color bands moving both horizontally and vertically, engaging all the painting's edges. At the same time, it presents a vivid pictorial equivalent of a breeze moving over a sunlit spring garden.

M.B.M.

CHARMION VON WIEGAND
AMERICAN | 1900–1983

Photograph of Charmion von Wiegand in her New York studio, c. 1975

OPPOSITE:
Charmion von Wiegand. *Advancing Magic Squares.* 1957–58. Oil on canvas, 12⅛ × 22½″. The Holladay Collection

C HARMION VON WIEGAND was a self-taught artist who abandoned a successful journalism career to devote herself to painting and promoting mid-century Geometric Abstract painting.

Her father, Karl, was a veteran American correspondent in Europe when she was born in Chicago in 1900. She attended Barnard College and the Columbia School of Journalism and worked as a newspaper reporter in New York City. In 1926 she began to paint and to meet the various members of the artistic avant-garde, with whom she increasingly associated. From 1929 to 1932 she was the correspondent for the Hearst newspapers in Moscow. After she returned to New York, she gave up her journalism career and devoted her full attention to painting and to writing about art for such publications as *Art Front*, *Partisan Review*, and *The New Masses*, a magazine co-founded by her husband, the novelist Joseph Freeman.

In 1941 von Wiegand met the expatriate Dutch artist Piet Mondrian, and the two developed a close friendship that lasted until Mondrian's death in 1944. Von Wiegand worked with Mondrian on his essays explaining the principles of the abstract Neo-Plastic art that he espoused, and she wrote the first American article on his painting for the *Journal of Aesthetics and Art Criticism*. During this same period, von Wiegand joined the American Abstract Artists (A.A.A.), a group which had been founded in 1936 to protest Social Realism and the representational art then receiving official acclaim. The group had continued to advocate an art based on the pictorial expression of intellectual processes and images. Von Wiegand served as president of the A.A.A. from 1950 to 1953.

Von Wiegand exhibited regularly in solo and group exhibitions from 1948 until her death in 1983. Her work has also been included in the numerous surveys of Constructivist and Geometric Abstract art organized by American and European museums since the early 1950s.

After 1960 von Wiegand moved away from the stern geometric rigor of the Neo-Plastic style, incorporating into her later works a greater, "full prism" range of color and correspondingly richer emotional expression growing out of her studies of Tibetan Buddhism and Asian culture. The painting *Advancing Magic Squares* (1957–58), however, falling at the end of her Neo-Plastic period, presents her idiosyncratic version of that style. The grid of colored squares gives the painting its basic structure; within it von Wiegand communicates a sensation of movement by using shifts in color and tone and by only partially completing the diamond form at left. Consequently, the painting is both stable and dynamic, creating an impression of energy at odds with its elementary forms. Construction of such active images by the simplest means available to painting was the perennial goal of Neo-Plastic painters. In *Advancing Magic Squares* von Wiegand displays the rich possibilities of such art.

M.B.M.

ALICE NEEL
AMERICAN | 1900–1984

Photograph of Alice Neel, 1970

OPPOSITE:
Alice Neel. *T. B., Harlem.* 1940. Oil on canvas,
30 × 30″. The Holladay Collection

ALICE NEEL'S portraits construct a record of modern urban society, revealing its anxieties, ambitions, and cruelty, and the look of the human condition during the middle decades of the twentieth century. Although she also executed landscapes and still lifes, Neel is primarily known for the expressive portraits she began to paint shortly after moving to New York City in 1927.

Neel was born in 1900 in Merion Square, Pennsylvania, and grew up in Colwyn before attending the Philadelphia College of Art and Design (now Moore College of Art) from 1921 to 1925. Neel settled in New York and in 1932 began to work at the frantic pace she maintained to the end of her life.

During the 1930s and '40s Neel painted the city and its residents, using her friends, family, and neighbors as subjects, especially after she moved in 1938 to Spanish Harlem. She worked for the Federal Art Project of the WPA from 1933 to 1943, developing her interest in radical politics and culture. In later years she made distinctive portraits of such major cultural and social figures as Virgil Thompson, Andy Warhol, Stewart Mott, and Linus Pauling.

Neel's art developed independently of the numerous styles and groups that succeeded one another in artistic fashion from 1930 until 1980. She remained committed to a representationalism that allowed her to incorporate into her portraits the marks on faces and bodies that she saw as the price the world exacts for survival. She noted that the scars left by the psychological and emotional battles her sitters had endured revealed themselves to her as she painted the portraits. Her refusal, indeed incapacity, to flatter her subjects, combined with her insistence on recording the complete personality as she encountered it in painting, produced a body of portraiture remorseless in its honesty. Neel's sitters rarely purchased the finished portraits, possibly a testimony to their accuracy.

Neel's painting *T.B., Harlem* of 1940 is one of her masterpieces and a major social document of its time. This chronicle of tuberculosis, a disease frequently found in the lightless and airless tenements of the urban ghetto, is unflinching in its depiction of a mangled and pain-wracked body. There is no sentimentality or false pathos, just the bare torso exposing a bandage that barely covers the wound where eleven ribs had been removed. The patient lifts his hand to his bandage, a Christ-like gesture Neel later acknowledged was deliberate. She meant the painting to resemble a traditional crucifixion and, through her somber palette and the figure's gesture, invoked that archetypal image of acceptance and suffering.

T.B., Harlem in many ways comprehends Neel's accomplishments as a portrait painter. Although the human condition studied here is an extreme example, she reveals in all her works the same expressive mixture of beauty and torment that is experienced and made visible in every life.

M.B.M.

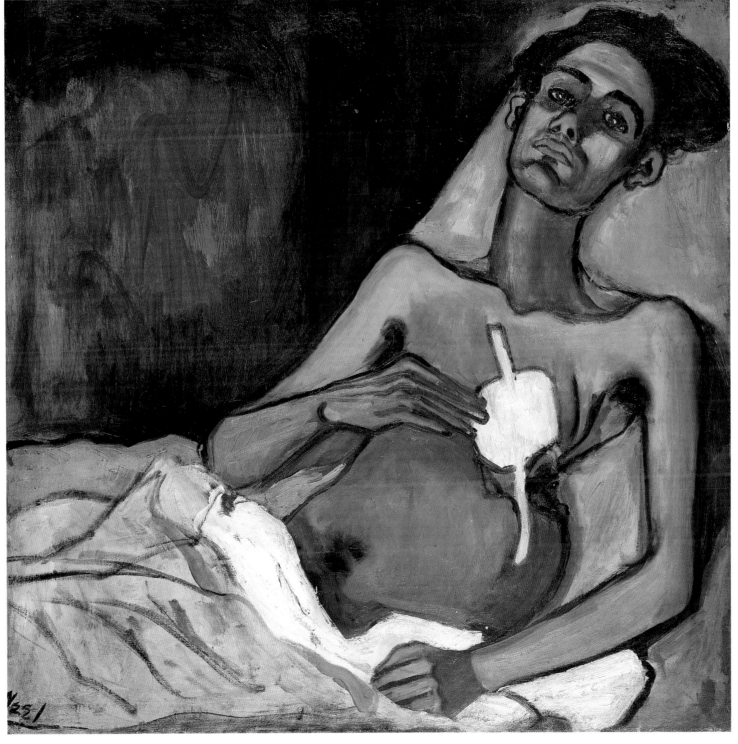

ISABEL BISHOP

AMERICAN | 1902–

Photograph of Isabel Bishop. Peter A. Juley and Son Collection. National Museum of American Art, Smithsonian Institution

OPPOSITE:
Isabel Bishop. *Men and Girls Walking.* 1969. Aquatint, 13⅛ × 17⅝". Gift of Mr. and Mrs. Edward P. Levy, 7/1/85

ISABEL BISHOP is an American painter and printmaker who has devoted her career to the careful study and rendering of the human figure. Since the 1920s, she has explored in aquatint and oil the varied activities of the inhabitants of lower Manhattan. Bishop has always recorded the ordinary aspects of urban life: men rushing for the subway, women sitting and reading, a child eating in the park with a friend or feeding the pigeons. Nothing has been too commonplace to have escaped her attentive eye. The artist invests her subjects, despite the unremarkable character of their action, with integrity and monumentality that derive from the strength of her draftsmanship. In fact, her diligent concentration on subtle nuances of form and attitude has yielded works that have been justly compared with the art of the old masters.

Bishop was born in Cincinnati in 1902. Her youth was spent in Detroit, but following high school she moved to New York to study illustration. In the early 1920s she decided to become a painter and enrolled at the Art Students League of New York, where she studied with Kenneth Hayes Miller and Guy Pène du Bois. Miller's teaching stressed the importance of fine draftsmanship and the primacy of the human figure in design and composition. He also emphasized the depiction of contemporary urban life, a theme that Bishop readily embraced. Pène du Bois rendered scenes of daily life as well, but his instruction focused on capturing temperament and personality; Bishop's inherent sensitivity to character and disposition was reinforced by their long friendship.

In 1925 Bishop began to etch; she started with nude studies but soon was depicting small vignettes of everyday life. In 1926 she moved into her first studio, on Fourteenth Street at Union Square. For more than half a century, the square provided her with a rich encyclopedia of human activity and an appropriate artistic environment. Bishop soon became associated with other artists who depicted urban life in Greenwich Village, including Miller, Reginald Marsh, and the Soyer brothers. Miller, Marsh, and Bishop were particularly close and traveled to Europe together in 1931 to study the great masters of the Renaissance and the Baroque.

Isabel Bishop is usually associated with the period of the 1930s, when her work first received widespread critical acclaim. Her classic early prints often show only one or two carefully drawn subjects in a fairly minimal setting. Although she was inspired by the activity in Greenwich Village, she tended to make sketches there and later pose models in her studio in the attitudes she had witnessed previously. The strength of her early etchings is the apparent simplicity of her subjects and their poses, which belie the difficulty and complexity of her compositions.

Bishop has continued to produce vigorous works in varied media; her later prints are still organized around the human figure but with a new regard for space and background. The aquatint *Men and Girls Walking* (1969) is typical of her renewed interest in creating a deeper space while still emphasizing the vitality of the subjects. The use of multiple figures, high contrast of light and shadow, and increased energy and movement are also hallmarks of Bishop's continued artistic development.

E.D.

12/65 Diehl Berlin

LEE KRASNER was a major figure in the first generation of American artists to develop a new mode of abstract painting in the late 1940s and early 1950s. As the wife of Jackson Pollock (1912–1956), the acknowledged leader of the Abstract Expressionist group, Krasner participated in the crucial experiments that led to the evolution of the new style, but, until shortly before her death, her painting and reputation were obscured to a large extent by the brilliance of Pollock's accomplishments.

By education and temperament Krasner was prepared to be an artistic innovator. Born in 1908 into a strongly matriarchal Russian Jewish family in Brooklyn, New York, Krasner was introduced in her home environment to languages, literature, and art. She studied in the 1920s at the Women's Art School at Cooper Union and then at the Art Students League and the National Academy of Design. From 1934 until 1943, she worked as a mural painter for the Federal Art Project of the WPA and became involved with radical art and politics. She entered Hans Hofmann's studio in 1937 and began to exhibit with the American Abstract Artists, a group founded in 1936 to protest the prevailing style of Social Realism.

By the early 1940s, Krasner was familiar with the modern art developing in Europe—the works of Picasso and Matisse, the Surrealists, and the School of Paris—and her own work had been included in an important exhibition of American and French art at the McMillan Gallery in New York in 1942. Krasner, like the other artists of the emerging Abstract Expressionist group, was struggling to break away from the restrictions of traditional representationalism and to find new ways to express spiritual and emotional insights of her own. Soon after she began to work with Pollock in 1942, she found that his experiments with gesture and movement provided her with new freedom. And Krasner, who possessed the most sophisticated understanding of contemporary European modernism in New York at the time, contributed to Pollock's evolution during that pivotal moment in his development of the new style.

In *The Springs* (1964), reproduced here, Krasner used three shades of green, three browns, and white to examine the varieties of marks in a painting and the way they make nets of color that occupy a painting's space. In *The Springs*, painted from right to left, as are most of Krasner's works, thin strokes mingle with broad, thick ones. Curves, lines, and dots are also dabbed straight from the paint tube. The three colors vie for the front plane of the painting, their energy reflecting the artist's work in creating the painting. As in the best Abstract Expressionist works, of which *The Springs* is an example, the artist's experience in making the painting is a metaphor for life itself. Because of their abstraction, such paintings invite emotional and intuitive responses, which explains the intensity of the popular response they provoke and their powerful influence on subsequent styles.

M.B.M.

Photograph of Lee Krasner, c. 1982

OPPOSITE:
Lee Krasner. *The Springs*. 1964. Oil on canvas, 43 × 66″. The Holladay Collection

DOROTHEA TANNING

AMERICAN | 1910–

WOMEN and women artists occupied an anomalous position in the Surrealist movement that emerged in France in the 1920s. Surrealist theory exalted the instinctive and irrational qualities traditionally attributed to women; in practice, however, Surrealism, in the hands of men artists, often appeared as an obsessive fascination with, and violence against, the bodies of women. Starting in the 1930s, a number of women artists made significant contributions to the Surrealist genre, at the same time establishing a foundation for exploring women's lives and minds that would be important for artists in the 1970s and '80s.

Dorothea Tanning began exhibiting Surrealist works in the 1940s, contributing from the outset an explicitly female vision to the movement's imagery of eroticism and terror. Her paintings and later prints examine the fear and menace of adolescent sexuality, often presented simultaneously with visual metaphors for exploration of the unconscious and the irrational.

Tanning was born in Galesburg, Illinois, in 1910. After attending Knox College in her hometown from 1928 to 1930, she traveled for several years before settling in 1940 in New York City. There she quickly became a member of the Surrealist group, exhibiting in 1944 at the major Surrealist gallery of Julian Levy. In 1942 she met Max Ernst, whom she married in 1948.

From the time of her first exhibition, she has shown almost annually in either Europe or New York. From 1946 to 1953, she also produced stage and costume designs for the Ballets Russes de Monte Carlo and the New York City Ballet.

The aquatint *To Max Ernst* (c. 1970) contains a number of Tanning's characteristic images. The work is structured by representations of books with opening pages resting on a crumpled blue-green cloth that sits on a field of red. Two of the book covers resemble doors, and keyhole designs metamorphosing into heads and tassels appear on the right. In the center of the composition a bundle of hair lies on a bed, above which hangs a clock with its hands set at five after five. At the far left, a yellowish gown turning to flames or hair at the top runs into the fold of a book whose cover is a door. Another doorway opening to book pages stands above and behind these foreground images.

The running figure with hair and gown dissolving in flame, the bundles of hair, and the opening doorway are motifs that recur in Tanning's work from the 1940s. They are usually placed, as they are in this work, in ambiguous but erotically provocative settings, where the feelings of menace and torment contrast with intrigue and sensuous beauty. Even the fragmented text written beneath the bed, "A mon b . . . Max Ernst, le pl . . . du monde, le ra . . . plumes, qui me . . . ," tantalizes with its hint of intimacy and only partial revelation. This capacity to delineate the specific terrain of nightmare and desire is a major contribution of Surrealism to twentieth-century art. Dorothea Tanning's work gives such descriptions a distinctive and significant form.

OPPOSITE:
Dorothea Tanning. *To Max Ernst.* c. 1970.
Aquatint, 15¼ × 17¼". The Holladay Collection

M.B.M.

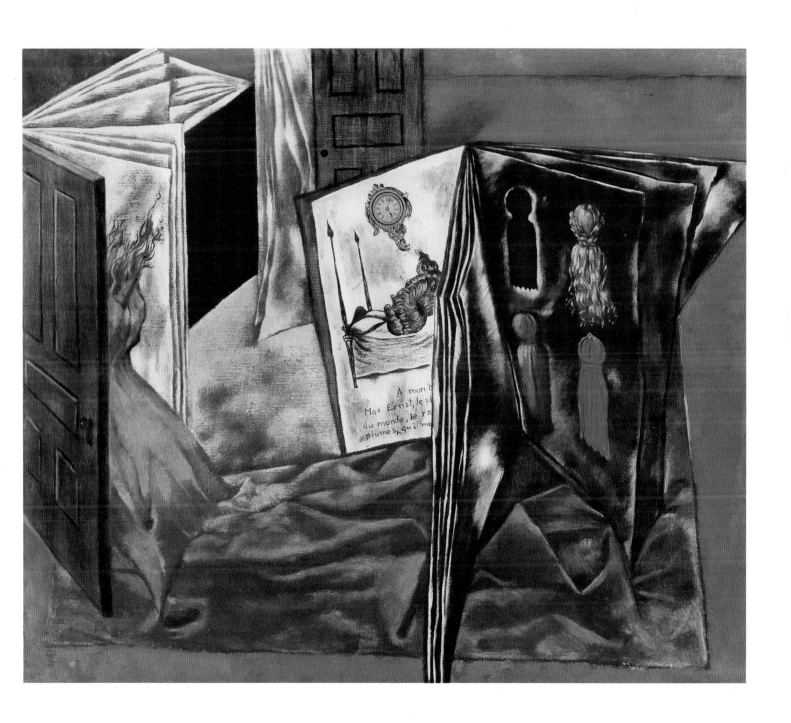

A mon b
Max Ernst, le
du monde, le ra
plumes, qui me

ELAINE FRIED DE KOONING
AMERICAN | 1920–

ELAINE FRIED DE KOONING was born and grew up in Brooklyn, New York, and spent her childhood studying the lives of artists and visiting the museums and galleries of New York City. After high school she attended the American Artists School and the Leonardo da Vinci School and was swept up in the cultural excitement in New York of the late 1930s and early '40s.

In 1938, the artist met painter Willem de Kooning (1904–), who was a member of the group of artists soon to emerge as the first generation of Abstract Expressionists. She became his student and model, and in 1943 they were married.

Elaine de Kooning never completely abandoned representation, as have many of her contemporaries. Indeed, a substantial portion of her career has been devoted to portraiture, for which she was particularly known in the 1950s and '60s. Her most famous portrait commission was of President John F. Kennedy, which she was struggling to complete at the time of his assassination.

Other aspects of de Kooning's work show a divergence from the Abstract Expressionist model as well. During most of her career she has drawn and painted the male figure. She began with studies and paintings of basketball and baseball players in typical and expressive poses, which she used to explore movement and expression in painting. She also painted a series of bullfights and a series of landscapes before embarking, in 1976, on the Bacchus paintings, which she continued to work on into the 1980s.

The Bacchus paintings are a splendid summation of de Kooning's career to date. They were inspired by a nineteenth-century bronze statue by the French sculptor Jules Dalou in the Luxembourg Gardens in Paris. This sculpture shows the god Bacchus astride a horse, surrounded by an entourage of bacchantes who reach up to help him keep his seat. When the image of this sculpture is transferred to de Kooning's canvas, it disintegrates into fragments of pattern and color as the dashes of greens, lavenders, and yellows re-create the experience of sky, sculpture, and forest dissolving in the fracturing sunlight.

De Kooning tends to work on her series for long periods and to work on many canvases within a series simultaneously. *Bacchus #3* of 1978, illustrated here, relates to a number of contemporaneous variants, all of which examine the process and elements of painting through the structure provided by the Dalou sculpture. Only the looming figure of Bacchus and one bacchante to the left can be identified within the mass of color patterns and lines. Just as the viewer looks up at the sprawling figure of Bacchus, the paint and the charcoal lines on top of the pigment seem to move up from the chaos in the lower section of the composition, constructing the image before our eyes. The baroque exuberance of the fountain becomes a symbol for the creative energy of painting—the work becomes a record of the act of looking and of the act of its making, thus fusing the viewer's and artist's experiences in the reality of the painting itself.

M.B.M.

Photograph of Elaine de Kooning, 1986

OPPOSITE:
Elaine de Kooning. *Bacchus #3*. 1978. Acrylic on canvas, 78 × 50″. The Holladay Collection

JOAN MITCHELL
AMERICAN | 1926–

Photograph of Joan Mitchell, 1981

OPPOSITE:
Joan Mitchell. *Dirty Snow*. 1980. Oil on canvas,
86½ × 70⅞″. The Holladay Collection

Joan Mitchell is a leading figure in the second generation of American painters who adopted abstract painting in the 1950s. Her work continues the concerns of the preceding generation and synthesizes many of its characteristic stylistic elements.

Mitchell was born in Chicago in 1926 into a wealthy family. She began to paint as a child, then attended Smith College from 1942 to 1944, before transferring to the Chicago Art Institute, from which she received a B.F.A. in 1948 and an M.F.A. in 1950.

After a year in France (1948–49), Mitchell settled in New York City, where she began to modify her work under the influence of Abstract Expressionism, the emotional and energetic painting that was soon to dominate the New York art world. Mitchell was particularly impressed by the work of Willem de Kooning and Franz Kline and adopted their aggressive brushwork and intense color. Her work impressed the more established artists, who included her in the important "Ninth Street Show," a survey of vanguard art organized in 1951 by major figures of Abstract Expressionism's first generation. That same year, Mitchell had her first solo New York exhibition and continued to exhibit regularly into the next decade, even after she moved to Paris in 1955.

During the 1960s, other styles superseded Abstract Expressionism, but renewed interest in her work of the 1970s has returned Mitchell to critical and popular attention.

Many of Mitchell's paintings derive from the experience of landscape: sometimes the wooded countryside near Vetheuil, France, where she moved in 1968; at others, winter scenes remembered from her Chicago childhood. The painting shown here, *Dirty Snow* (1980), may combine the memory of snow and cold, to which the artist frequently alludes, with her continuing exploration of pictorial problems of structure, gesture, and color. Although, in typical Abstract Expressionist manner, the painting appears to be spontaneous and its marks almost accidental, its surface is actually carefully constructed of thick layers of color: pale grays, cobalt blue, and lavender. In the top half of the painting these colors blend to read as white and snow and cold. The lower portion is densely painted with broad strokes of dark blues, purples, green, and black, which become the landscape under the snow. But the tension in *Dirty Snow* is not merely between areas of light and dark, upper and lower areas, or areas of color contrast; it pervades the entire work in the agitated pattern and rhythm of the brush marks. In this way Mitchell links the appearance of the painting to the activity by which it was made and resolves all tensions in the balance of the whole.

M.B.M.

GEORGIA MILLS JESSUP
AMERICAN | 1926–

GEORGIA MILLS JESSUP was born in 1926 in Washington, D.C., into an artistically active and talented family, the thirteenth of eighteen children. Both parents were artists (although they made their living in other ways), as were brothers, children, and in-laws. By the mid-1980s, twenty-nine members of Jessup's family supported themselves through art or photography.

Jessup's early enthusiasm for art led her as a child to the studio of WPA artist Herman L. Walker. In 1939, two of her paintings were exhibited at the World's Fair in New York, and she embarked on a career of exhibiting, teaching, and organizing for art. She received a B.F.A. degree from Howard University in 1959 and an M.F.A. from the Catholic University of America in 1969 and has pursued postgraduate studies at American University and District of Columbia Teachers College.

In addition to producing her own work, Jessup has been a dynamic force for art education in the Washington, D.C., public schools. She worked for years as both teacher and administrator and retired from the post of Art Supervisor of the system. While with the D.C. schools she founded the program "The World Is Your Museum," which was the foundation of the Capitol Children's Museum. She has exhibited regularly in group, family, and solo shows; pushed for greater exposure for black artists; and from 1968 to 1970 served as artist-in-residence in the Anacostia Neighborhood Museum.

Jessup works in a variety of media—painting, collage, sculpture, and ceramics—and has been an active muralist as well. In the painting *Downtown* (1967) Jessup presents a fragmented and reassembled vision of Washington, D.C., nightlife. Constructed largely through dark, linear patterns that contrast with bright orange, yellow, and pink pools of color, the painting vividly conveys the impression of a night street in a busy city. Two figures in silhouette look into the scene from the lower right; before them orbs of light, building façades, and neon signs dissolve into an almost liquid blur of pattern and light. Jessup's rich blacks blend smoothly into the areas of thicker pigment of orange and yellow globes, while the contrast of lights and darks approximates the disorientation of the city night, in which known vistas become unintelligible and must be reconstructed by memory. The signs "St. H NW," "Translux," "Casino," "Beauty," and "Park" identify a particular location and can also serve as universal symbols for the American urban scene.

M.B.M.

Photograph of Georgia Jessup, 1981

OPPOSITE:
Georgia Jessup. *Downtown*. 1967. Oil on canvas, 44 × 48″. Gift of Savannah Clark, 3/28/86

HELEN FRANKENTHALER

AMERICAN | 1928–

Photograph of Helen Frankenthaler, spring 1981

OPPOSITE:
Helen Frankenthaler. *Spiritualist*. 1973. Acrylic on canvas, 6 × 5′. The Holladay Collection

Helen Frankenthaler began her painting career at the moment when Abstract Expressionism was beginning to dominate American art. Having completed her education at Bennington College and studies with Hans Hofmann, she emerged as a Modernist painter around 1950, just as Jackson Pollock and Willem de Kooning were creating and showing some of the great masterworks of the Abstract Expressionist style. Impressed by the ambition, scale and color, lyrical power, and intensity of these works, Frankenthaler began to develop those elements in her own work and, in 1952, produced a painting whose implications were to reverberate in the art world for over twenty years.

Frankenthaler's 1952 painting *Mountains and Sea* is an openly abstract interpretation of landscape. Its major novelty lay in its technique: Rather than painting on top of an already sealed canvas, Frankenthaler poured paint over an unprimed surface that allowed the color to soak into the canvas support. This process of staining the canvas with paint rather than making marks on its surface became the hallmark of Frankenthaler's style, and a whole generation of painters, following her lead, began to practice what has come to be known as stain, or Color-Field, painting.

Nature and the modern landscape tradition are major inspirations for Frankenthaler's work. To them she joins a formal concern for the processes and materials of painting, using her paintings themselves as areas for the exploration of color and gesture. Pouring paint onto and over the canvas and allowing the flowing pigment to create its own shapes and edges become a metaphor for experiences of, and objects in, nature. As a consequence, Color-Field Painting has powerful allusive qualities, such as the impression of infinite space in *Spiritualist* (1973), reproduced here. The pink and blue ground, because it is actually stained *into* the canvas rather than painted *on* it, seems to be everywhere rather than suspended at a particular point in space before the eyes. This identity of color, paint, and surface, so important in Modernist painting, focuses on the materials and processes of painting yet allows the imagination to engage transcendent and wide-ranging ideas. Combined with the extreme emotional effects of color, this process results in paintings of intense and often mystical impact.

Frankenthaler's paintings reveal an exquisite coloristic sensibility balanced by a firm feeling for pictorial structure. In *Spiritualist*, the almost aggressive contrast of these particular pinks, blues, and yellow gives the painting a provocative and forceful visual edge, a superb example of the way Color-Field Painting, in the hands of its founder and major practitioner, can both please and provoke, both trouble and reassure.

M.B.M.

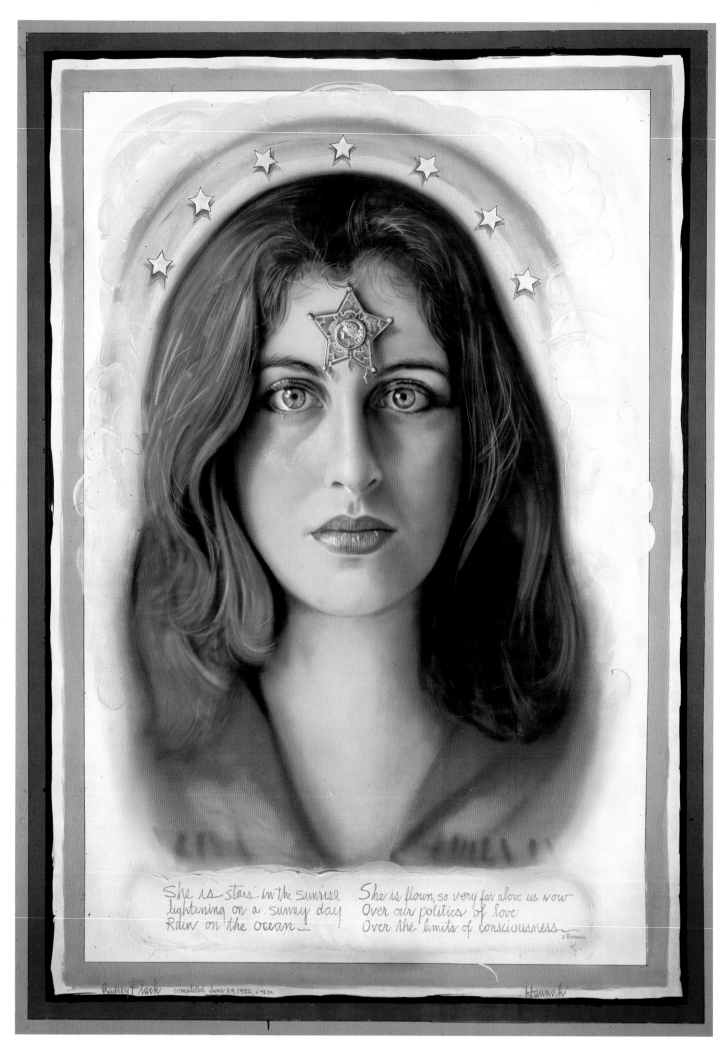

She is stars in the sunrise
lightening on a sunny day
Rain on the ocean

She is flown, so very far above us now
Over our politics of love
Over the limits of consciousness

Audrey Flack completed June 29, 1982, 6.48 pm Hannah

Photorealist painter Audrey Flack has made major contributions to the revitalization of still-life painting in the 1970s and '80s. Her experiments with photographic images and technique, her analysis of color perception, and her introduction of popular imagery as high art subject matter have made her an important innovator in contemporary American art.

Flack began working in a representational mode during her student years, when Abstract Expressionism was still the predominant art style. Born in 1931, she graduated from Cooper Union in 1951 and received a B.F.A. degree from Yale in 1952, emerging from school determined to pursue her own way as a representational artist. Feeling that her training in drawing was weak, she went to study anatomy at the Art Students League and began to forge her own figural style out of a training that had been heavily based on Abstract Expressionist models. In the late 1950s she exhibited a few Realist works, which were often the only representational paintings in group shows.

In the early 1960s, Flack began to copy photographs, first using black-and-white photos and snapshots. Her painting *Kennedy Motorcade* (1964) was the first for which she used a color photograph as a source. By 1970, she had begun projecting color slides onto her canvases to achieve the scale necessary for her large paintings. As Flack studied the way light fragmented and reassembled as color on her canvas, she began to produce the vivid and intensely sensuous paintings for which she is best known. Her complex still lifes examining the iconography of the gambling and the dressing table and of fruits, flowers, and popular religious symbols have brought new subjects and, more important, new ways of treating those subjects to the repertoire of contemporary art. The enormous scale of her paintings, which are rarely smaller than six feet on any side, the exquisite and precise rendering of color gradations with airbrush, and the "popular" cultural sources of much of her imagery have made Flack's work frequently shocking, as well as widely admired.

The work reproduced here, *Who She Is* (1982), is somewhat atypical of Flack. The devices of painting are more evident, particularly around the edges of the image and in certain passages in the figure's hair and face. It is a portrait of Flack's daughter, Hannah, depicted as the goddess-heroine of a Joe Pintauro poem, lines from which are included at the bottom of the painting. The gypsy star on the figure's forehead was worn by Flack herself in her 1980 self-portrait and in numerous photographs of the artist (see photograph on this page). In *Who She Is* the face seems to hover in space and dissolve as the paint fades into thin color areas of blue, magenta, and yellow. The image possesses the focused intensity of a talismanic design, contradicted by its enormous size.

M.B.M.

Photograph of Audrey Flack wearing her gypsy star, c. 1981–82

OPPOSITE:
Audrey Flack. *Who She Is*. 1982. Oil over acrylic on canvas, 7 × 5'. On permanent loan

EVA HESSE

AMERICAN, BORN GERMANY | 1936–1970

Photograph of Eva Hesse, c. 1969

OPPOSITE:
Eva Hesse. *Accession.* 1967. Gouache drawing,
15⅜ × 11³⁄₁₆″. The Holladay Collection

During the 1960s many contemporary artists began to question the materials of—in fact, the very nature of—painting and sculpture. Among those whose work explored these issues was Eva Hesse, who, in a short but brilliant career, contributed a significant new vocabulary of materials, forms, and methods to contemporary American art.

Hesse was born in Hamburg, Germany, in 1936 and moved to New York at the age of three. She attended Pratt Institute, the Art Students League, Cooper Union, and Yale University, from which she graduated in 1959. Soon after her graduation she settled in New York City, began to show and sell her work, and had her first solo exhibition in 1963. She spent the next year in Germany, where she began to work increasingly in sculpture, abandoning painting completely after her return to New York. During the last five years of her life, she pursued her experiments with nontraditional materials and idiosyncratic forms so vigorously that by the time of her death from a brain tumor at the age of thirty-four, she was acknowledged as a major innovator of contemporary art.

The aesthetic vocabulary evolved in Hesse's work grew out of tendencies in the work of Minimalist artists, whose cool, geometric, and reductive style was a reaction to the intensity and passion of the Abstract Expressionist artists of the 1940s and '50s. Hesse was attracted by Minimalism's deceptively simple forms, its interest in serialization and repetition, and its intellectual rigor. However, she rejected Minimalism's emotional detachment, preferring a more expressive and personal, yet still abstract, mode. Her work focused on the circle, the square, the rectangle, and the grid, which she explored with an obsessive tenacity and in a radically new range of materials.

In order to achieve complex emotional and psychological effects with such simple forms, Hesse turned to materials rarely, if ever, used in art before: rope, wood, steel, papier-mâché, latex, fiberglass, cheesecloth, wire mesh, twine, and plaster. These she layered, wrapped, glued, molded, and punctured, creating powerfully sensuous and tactile works. The contrast between underlying geometrical and intellectual logic and chaotic, often absurd manifestations in these baffling materials made Hesse's sculptures among the most mysterious and compelling works of their time.

Both works by Hesse in the National Museum of Women in the Arts collection reveal characteristic aspects of her work. The gouache drawing *Accession*, reproduced here, and the *Study for Sculpture* (see page 194), both of 1967, exhibit serial procedures, repetition, and analysis of fundamental forms. The sculpture study, constructed of Sculpmetal, cord, Liquitex, and Elmer's Glue, is typical in its use of unusual materials. The *Accession* drawing is one of a number of studies made by the artist in relation to a series of 1967–68 sculptures of the same title. The drawn cube's pale, mottled surface makes the same tactile appeal as Hesse's sculptures, while the subtle deviations from strict geometry in the lines and edges accomplish her favored juxtaposition of such extremes as control and abandon, geometric and organic, and the known and the threatening.

M.B.M.

Accession 1967

Eva Hesse

DOTTY ATTIE
AMERICAN | 1938–

DOTTY ATTIE has evolved her distinctive narrative visual technique by juxtaposing fragments from paintings and drawings of the past and interrelating them with refined euphemistic language. This deceptively simple strategy opens a vast and complicated realm between the words and images, which describe, verbally and visually, bizarre and impossible episodes that are, nevertheless, haunted by emotional truth.

Attie, born in Pennsauken, New Jersey, in 1938, trained as a Realist painter at the Philadelphia College of Art and the Brooklyn Museum School. She painted for over a decade and then decided in 1973 to concentrate on drawing. She began to copy images from books and from small sections of famous paintings and to explore the possibilities of juxtaposition. She selected details of body parts, gestures, drapery, landscapes, and interiors, which, when displayed in a new context, acquired erotic and violent implications. Drawing on her own fantasy life, Attie created new narrative situations for the appropriated images to communicate the eloquent sensuality and menace she had responded to in selecting the fragments.

An Adventure at Sea of 1977 recounts the story of a favorite Attie character, Pierre, as he acquires and experiments with a mysterious and unnamed object during the course of a sea voyage. Just enough text is provided to identify the characters and their activities but not enough to define the viewer's imaginative, emotional response. Consequently, it is always the viewer, not the artist, who decides exactly what form the story is taking. The artist manipulates the storytelling by controlled shifts from close-up drawings of drapery, facial expression, or partially draped body parts to distant views of a sailing ship or an ambiguous interior labeled only "a secluded cabin." Forced to interpret a hand on the edge of a door, a figure leaning over a rolled sail, or the partially revealed handle and shaft of a tool, the viewer creeps deeper into the imagination to be stunned by the monstrous and unnameable passions that lurk behind and between these beautiful façades.

The story is told through a series of thirty-three squares, some of which contain the images and others the narrative text. Both text and images are physically suspended within slightly larger squares, setting up a spatial ambiguity that contributes to the uneasiness provoked by the story. The works must be examined closely, drawing the viewer into a physical intimacy that reflects the emotional intimacy exposed within the work.

Attie was an early member of the first women's co-op, the A.I.R. Gallery in New York, and associates her freedom as a feminist with the freedom she discovered in abandoning painting and devoting herself to drawing and her idiosyncratic narrative style. Attie has said, "There is no one thing you can say is feminist, except that it means supporting other women and it means freedom."

M.B.M.

Photograph of Dotty Attie working on the print
Mothers Kisses, c. 1982

OPPOSITE:
Dotty Attie. *An Adventure at Sea*. 1977. Pencil on paper, 67¾ × 20½"; each individual element, 5¼ × 5¼". The Holladay Collection

NANCY GRAVES

AMERICAN | 1940–

Photograph of Nancy Graves, 1983

OPPOSITE:
Nancy Graves. *Rheo*. 1975. Acrylic, oil, gold leaf on canvas, 64 × 64″. The Holladay Collection

PAINTER, sculptor, and filmmaker Nancy Graves explores modern systems of knowledge. She uses the history and techniques of painting, sculpture, and film to investigate anthropology, paleontology, oceanography, computer mapping, psychology, and semiology, the science of signs. Consequently her paintings are extremely focused examinations of methods for transmitting information.

Born in 1940 in Pittsfield, Massachusetts, Graves received an undergraduate degree from Vassar College in 1961 and an M.F.A. from Yale in 1964. She lived and painted in Paris on a Fulbright-Hays grant, then moved to Florence for a year before returning to New York, where she had her first exhibition, in 1968, at the Graham Gallery and a year later a solo show at the Whitney Museum of American Art. Since then she has exhibited annually in the United States and in Europe.

From 1965 to 1971, Graves produced no paintings, concentrating instead on sculptures and films of camels. She chose the camel for her subject because she wanted to explore issues of structure and meaning through a form that has no history in the Western cultural tradition. Her representations of the camel, either reconstructions of the whole figure, groups of bonelike fragments, or sculptural armatures themselves, forced new ways of examining historic sculptural issues. They also inserted into contemporary art a rich and complex iconography of paradoxical and recondite forms.

In the early 1970s, Graves transferred her preoccupations with signs and meanings to painting and produced several series based on theories of scientific perception and mapping techniques. One was derived from the camouflage strategies of fish, another from bathymetric and topographic maps of the ocean floor. Then came a series based on lunar and Martian mapping and one inspired by satellite weather photographs. A number of her concerns from those series are at work in the painting *Rheo* (1975) from the Aza Series. In it small, maplike images seem to float on top of a larger, yellow maplike area painted on a ground of gold leaf. The colors of the smaller images allude to those used in computer maps and infrared aerial photography. The use of gold leaf relates to medieval altarpiece techniques, and the unfinished edge to the right—in a stratagem of contemporary art—points to the painting's contingency. Brushstrokes on the yellow area refer both to informational marks of mapping and to themselves as the fundamental elements of painting. This layering tactic modulates from distant images mediated by electronics, machines, and cameras to the immediate presence of the entire painting as an information system of its own.

In the late 1970s Graves's paintings became more abstract and she returned to making sculpture, now in bronze. Her art in the 1980s has been increasingly colorful and exuberant yet continues to be informed by the systematic analysis that produced her earlier work.

M.B.M.

THE GREAT GOD PAN
FROM THE SERIES ENTITLED
"THE MACHINE THAT MAKES
THE WORLD"

— A PRELIMINARY PROPOSAL
FOR THE SEAGRAM'S PLAZA

— A MACHINE WITH MOVING PARTS
FLUORESCENT TUBES & HOT COILS
IMMERSED IN WATER OF
A HANGING PAN SUSPENDED
FROM A SHEET OF GLASS
SCALE 1:1/2"

MONG THE artists whose works established in the 1970s a new terrain within the traditional domains of architecture, sculpture, poetry, and drama is the sculptor Alice Aycock. Her innovations in site work and her elaborate and mysterious machinelike sculptures have forced critical reevaluations of conventional artistic categories and provided a way for contemporary art to examine science and technology in the modern world.

Aycock had her first solo New York exhibition in 1974, only three years after she received her master's degree from Hunter College. Her work touched a sympathetic chord in other artists who were seeking ways for art to explore the implications of history in the modern world and current social conditions in nontraditional locations and materials and with the indirect, metaphorical allusiveness of poetry. Aycock's early structures, set in rural landscapes, art parks, or galleries, seemed mysteriously complex, apparently incomplete, and often deliberately terrifying. Spectators were able to move through or into these buildinglike constructions, experiencing them in a very personal and intense way.

By the end of the 1970s, Aycock had shifted her focus from history and architecture to the modern industrial world. She began designing and building her own machines, confounding the austere vocabulary of science with the power of poetry, irony, fantasy, and absurdity. Aycock's strategies are evident in the drawing shown here, *The Great God Pan* (1980), part of the series *The Machine That Makes the World* and derived from an earlier series entitled *How to Catch and Manufacture Ghosts*. The proposal includes fluorescent tubes and hot coils immersed in water and a hanging pan suspended from a sheet of glass. It calls also for a ringed concave antenna that will receive information from space. The design derives from a nuclear linear accelerator, batteries, and electric circuits. It plays word games in its title and accompanying text and confronts the claimed logic of science with the obvious illogic of what science has already and still proposes to accomplish. Designed for the Seagram's Plaza in New York, the sculpture was constructed in 1984 at Salisbury State College in Salisbury, Maryland.

Like the works of other artists, such as Francis Picabia, Marcel Duchamp, and Jean Tinguely, who have used the machine as a central metaphor, Aycock's constructions call into question the paradoxes implicit in such devices and the world they have created. She draws on our aesthetic fascination with the visually and conceptually complex and contrasts it with the machine's dehumanizing absurdity and its capacity for active menace. In *The Great God Pan* Aycock conflates the ancient mythical domain of dream and magic with the horror of the modern myths of science. In doing so, Aycock proposes a way for contemporary art to expose and question these myths by combining the visual eloquence of the machine itself with the real and potential absurdity of its applications.

M.B.M.

Photograph of Alice Aycock

OPPOSITE:
Alice Aycock. *The Great God Pan*. 1980. Graphite on nylon, 42½ × 52½". The Holladay Collection

NATIVE AMERICAN CERAMICS
OF THE TWENTIETH CENTURY

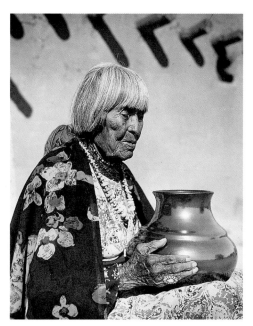

Photograph of Maria Martinez, 1975

Photograph of Lucy Lewis, 1984

FOR CENTURIES pottery making has been an essential communal and creative activity in the Pueblo Indian cultures of the American Southwest. Due to the pressures of tourism, however, and the influx of manufactured goods, pottery and other native arts fell into decline by the late nineteenth century. In the twentieth century, Lucy Lewis, Maria Martinez, and Margaret Tafoya were leaders of a pottery-making revival and combined techniques, materials, and decorative patterns of the past with their own innovations to provide an artistic and economic legacy for their communities. In the process they transformed Southwest Pueblo earthenware from utilitarian and ceremonial vessels into works of modern art.

MARIA MONTOYA MARTINEZ | c.1887–1980

Maria Martinez, as rediscoverer, with her husband, Julian, of the ancient San Ildefonso blackware technique, became a legendary figure within her lifetime. She learned pottery making as a child and became a pottery demonstrator at the Museum of New Mexico in Santa Fe. At the request of an archaeologist, Martinez in 1909 used an excavated shard as a guide to reconstruct a pot by techniques that had not been practiced for seven hundred years. Her husband discovered the reduction, or "smothering," firing process necessary to produce the distinctive black color. Around 1919 the couple invented the matte black on shiny black decorative process, which after 1920 they shared with other Pueblo potters. The *Collings Pot*, an example from 1939 illustrated here, shows Maria's elegantly balanced form and Julian's typical zigzag and feather decoration. By the end of her life in 1980 she had established an international reputation, having exhibited and received awards in America and abroad, provided a secure economic livelihood for her community, and created a new audience and appreciation for native American art.

LUCY LEWIS | 1897–

By studying ancient Mimbres culture pottery shards found on the ground of her native Acoma Pueblo, Lucy Lewis, born in 1897, enriched the native pottery tradition she had learned as a child from an aunt. She combined bird and flower decorations derived from Spanish-influenced ceramics with abstract, geometrical, and zigzag designs painted on, and incised into, the kaolin clay slip with which she covered her earthenware pots. Known for the bold optical-illusion designs such as the one displayed on this *Star Vase* (1983), Lewis also "traded" designs with contemporary Hopi and Zia potters, an example of the way these living pottery traditions are preserved and extended.

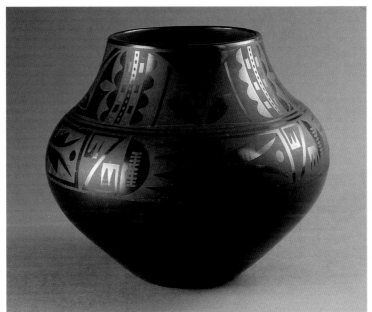

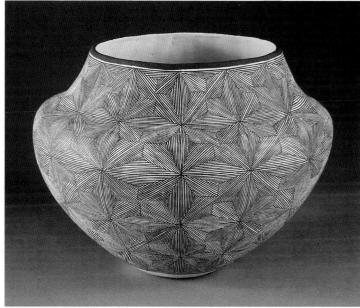

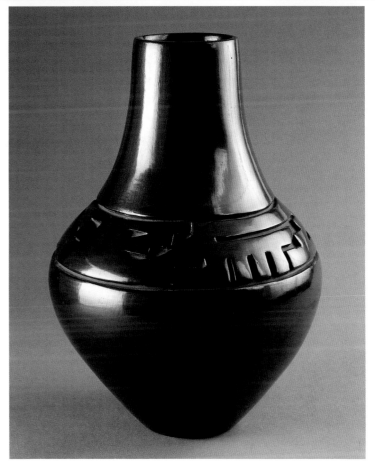

MARGARET TAFOYA | 1904–

Like Maria Martinez, Margaret Tafoya of the Santa Clara Pueblo preserved and modi-
fied traditional forms while contributing new decorative effects of her own. She
learned pottery making from her mother, who was known for making unusually large
pots, a tradition Tafoya continued. Out of the experimentation encouraged by the
ceramics revival of the 1920s in the Pueblo, she developed a method of intaglio
molding and carving that is now a hallmark of much Santa Clara pottery. The black
pottery water jar reproduced here bears on its shoulder an incised design, a variation
on an ancient water-serpent pattern. Tafoya is credited with preserving the water
vessel as a modern art form after a well drilled on the Pueblo in 1916 made it obsolete
as a practical utensil.

M.B.M.

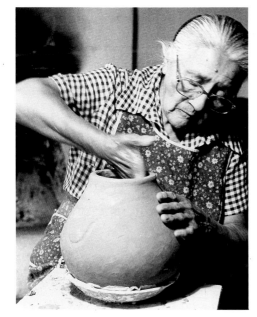

GWENDOLEN JOHN

BRITISH | 1876–1939

Augustus John (British, 1878–1961). *Portrait of the Artist's Sister Gwen.* c. 1905. Pencil on paper, 14¹/₁₆ × 8⅜". Collection of Roy and Cecily Langdale Davis

OPPOSITE:
Gwen John. *Seated Woman.* c. 1923–24. Watercolor and pencil, 8½ × 8". The Holladay Collection

THE LIFE AND ART of Gwendolen (Gwen) John remain an enigma. The shy young woman who developed into a recluse was an elusive figure whose passionate devotion to various men and women in her early life was matched by her intense religious faith in the last twenty-six years of her life.

Born in Wales and educated at the Slade School in London with her brother Augustus, John lived most of her life in Paris. She worked slowly and methodically, finding it difficult to part with a work once she had finished it. She had only one show during her lifetime, in 1926. She was supported by one patron, John Quinn, a wealthy American lawyer. Throughout her life, little personal acclaim was hers yet Gwen John's solitary lifestyle, especially of her later years, enabled her to produce a body of work at once rare, meditative, and intensely personal.

John preferred the act of drawing, with its rapidity and spontaneity, to that of painting, which she found frustrating; she considered her finished drawings to be as important as her paintings. Today over one thousand drawings and watercolors exist in collections around the world. By contrast there are about two hundred oils.

The largest and most cohesive group of John's finished drawings is made up of studies of women churchgoers, nuns, and children at Meudon, outside Paris, where she lived, and dates from her conversion to Catholicism in 1913 and on into the 1920s. The example reproduced here, *Seated Woman*, represents a solitary woman seen from behind, seated on a plain, straight-backed chair, a motif used repeatedly in this sequence of works. John has depicted the woman in three-quarter length, in a quiet, self-contained pose, an attitude she favored throughout her career in her oil paintings as well as in watercolors and drawings. In these works of her later years, John tended to simplify the forms of her figures, defining them with just a few lines and with thin washes of color. The subdued colors, concentrated in browns and blacks, achieve subtle transitions within their restricted palette.

John's religious conversion was a turning point in her life and is illustrated in the artistic production of these years. The simplified forms, cool tonalities, and faceless sitters are painstakingly conceived expressions of the intensity with which she approached her life and her religion. Her reduction of the compositions to simple, monumental forms was an attempt to express the depth of her religious feeling. As Gwen John herself said, "My religion is my art; for me, it is everything in life."

M.L.W.

BARBARA HEPWORTH

BRITISH | 1903–1975

Photograph of Barbara Hepworth in the late 1960s

OPPOSITE:
Barbara Hepworth. *Figure (Merryn)*. 1962.
Alabaster with wood base, 13 × 11½ × 8¼". The
Holladay Collection

BRITISH sculptor Barbara Hepworth participated in the creation of a revolutionary new sculptural vocabulary that developed both on the Continent and in England during the first three decades of the twentieth century. Hepworth's bold sculptures, first carved in stone and wood and later cast in bronze, proposed a modern idiom of organic and abstracted form in works possessing the dignity and grandeur of antique sculpture.

Born in 1903 in Yorkshire into a family that encouraged the talents of, and provided an education for, its daughters, Hepworth attended the Leeds School of Art in 1920, leaving after a year to attend the Sculpture School of the Royal College of Art in London. In 1924 she won a traveling scholarship, which she used to study painting and sculpture in Siena, Florence, and Rome. She married sculptor John Skeaping in Italy in 1925, and later divorced him to marry the painter Ben Nicholson, her husband until 1951.

During the 1930s Hepworth and Nicholson visited Paris twice, discovering Picasso, Braque, Brancusi, Arp, and Mondrian and feeling an important affinity with the abstract work of Mondrian and Brancusi. She joined the Association Abstraction-Création before leaving Paris in 1933, becoming, with Nicholson, an important link between the international Abstract movement and England.

At the outbreak of World War II, Hepworth moved her family to Cornwall for safety and ran a nursery school; she produced very little art until after the end of the war. After 1950 she began to achieve financial and critical success, exhibiting work at the Venice Biennale in 1950, receiving a retrospective in 1954, and winning the Grand Prix at the São Paulo Bienal in 1959. She began to receive public commissions, and in 1956 she discovered a way to maintain the effect of her worked surfaces in a bronze casting process. She was made a Dame Commander of the British Empire in 1965 and had become a major figure in the international art world by the time of her death from a studio fire in 1975.

From the early 1930s, Hepworth's sculpture developed steadily toward organic and abstracted shapes that, nevertheless, retained a powerful sense of presence. The curving, leaning silhouette of *Figure (Merryn)* of 1962, shown here, is an example in which the form seems to move and reach as if impelled from within. The hole penetrating the center of the work was one of Hepworth's characteristic formal gestures and one of her major contributions to modern sculpture. This arbitrary penetration of the stone radically alters its mass and balance. A feature first used by Hepworth in 1931, the hole destroys the mystery of the interior while creating a new ambiguity between inside and outside, front and back, edge and center, space and solid. These rich allusions are contained by the outline and weight of the sculpture, to fuse, as always in Hepworth's best work, in rhythmically balanced simplicity.

M.B.M.

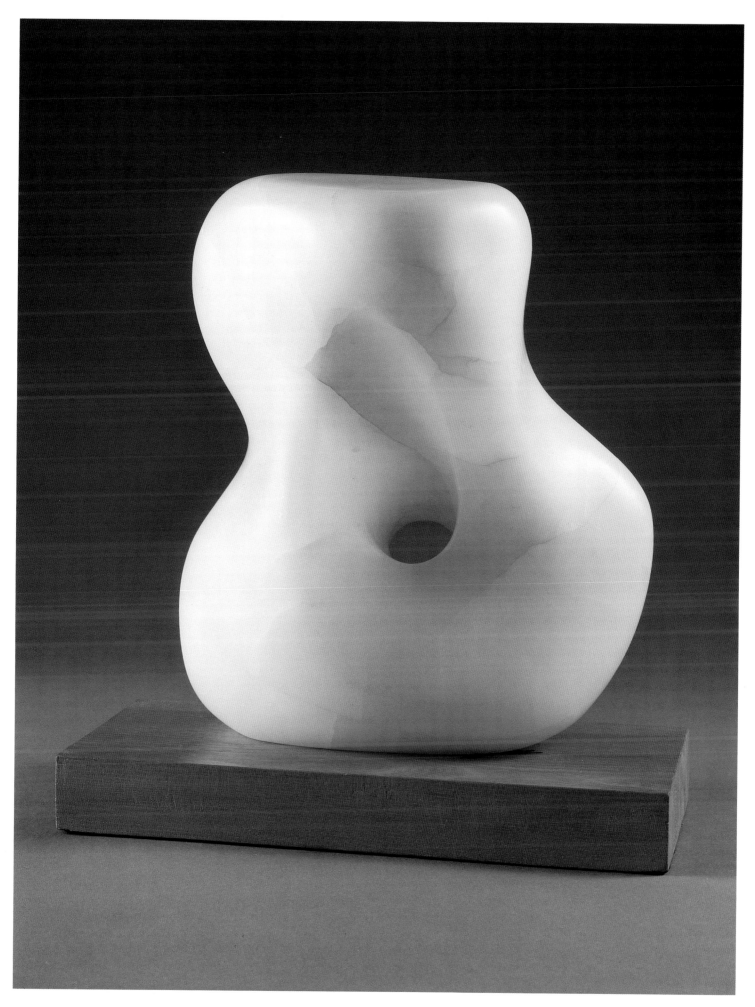

LEONORA CARRINGTON

BRITISH | 1917–

Photograph of Leonora Carrington, 1986

OPPOSITE:
Leonora Carrington. *The Magic Witch*. 1975.
Gouache on vellum, 47¾ × 32⅜″. The Holladay
Collection

Leonora Carrington is one of the major figures in the second generation of Surrealists. Born in 1917 in Lancashire, England, she rebelled from childhood against what she felt was the narrow provinciality of bourgeois society represented by family, church, and school. After expulsion from several English schools, she went to Florence and there began her first study of the art of the past. In 1936, she enrolled at the Amedee Ozenfant Academy in London and was impressed by the First International Surrealist Exhibition, held that year at the Burlington Galleries. The next year she met Max Ernst, who was lecturing in England, and returned with him to France, where they lived and worked together for the next three years, eventually settling in the South to avoid the social conflicts within the Surrealist circle in Paris. In 1940 Carrington fled to Spain to escape the Nazis, making her way by 1942 to Mexico, where she has lived ever since.

Carrington's work has always reflected a strong personal vision of a hallucinatory world in which myth, nightmare, and the occult merge with the history of art to create a visual symbolic language of considerable power. Carrington, like other Surrealists, sought pictorial avenues to gain access to the unconscious, the irrational, and the instinctual. Her particular vocabulary included plant and animal imagery—with many fantastic or metamorphosing hybrids—and perplexing, often bizarre, narrative settings in which the creatures act out ancient rituals or disturbing modern ones.

Carrington's *Magic Witch* (1975), shown here, contains many of these symbolic and mystical references. They include the garlic-headed figures holding branches hung with mirror-written cartouches, the camel with a face on its saddle, the tortoise and snake configurations at the top of the image, and the figure in the central medallion. These images, along with many others in her oeuvre, derive from her continuing exploration, in both writing and painting, of satanic rituals and beliefs, rites of symbolic purification, and the alchemical search for transformative substances. The figure in the blue central medallion is representative, with its multifaced, garlic-shaped head, snake arm, and three legs: one ending in a broken egg, one in horses' hooves, and a third in an indescribable appendage perhaps resembling an imagined alchemical device.

There are many layers of meaning in Carrington's work, beginning, in *The Magic Witch*, with the shape and material of the vellum support itself. Retaining the sheepskin shape not only structures the work on a formal level but also provides an organic reference that conditions the symbols painted upon it. In this way Carrington connects the material to the visionary and establishes a specific location for revelations of magic, myths, and dreams.

M.B.M.

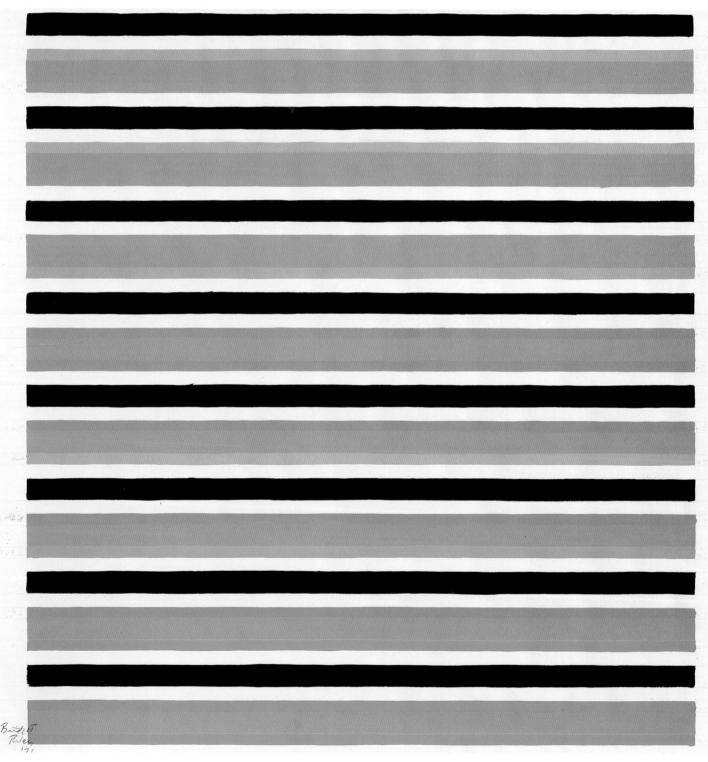

Bridget
Riley
'71

122

BRIDGET RILEY

BRITISH | 1931–

BRITISH painter Bridget Riley was a founder of Op Art painting in the 1960s. She is one of the few painters to continue the style's perceptual and experiential studies through her work in succeeding decades.

Riley was born in London in 1931, received a sporadic wartime education in Cornwall, and concluded her secondary studies from 1946 to 1948 at Cheltenham Ladies College, where she was allowed to pursue exclusively her interest in art. From 1949 to 1952, she studied drawing at Goldsmith's College of Art in London and from 1952 to 1955 attended the Painting School at the Royal College of Art. In the late 1950s she worked briefly in advertising, returning to it from 1961 to 1964, taught art to children, and began to exhibit paintings in group exhibitions.

In 1959 and 1960 Riley visited the Continent and, on returning, conducted her first experiments with optical painting. In 1962, she had her first solo exhibition at London's Gallery One, and a second followed a year later. In 1964 she was included in shows not only in London but all over the world—in Pittsburgh, Los Angeles, Buffalo, and Cincinnati in the United States and also in France, Germany, and Japan. The following year, 1965, two of her paintings were included in New York's Museum of Modern Art show "The Responsive Eye," and she had her first solo show in the United States. The response to her work in the New York exhibitions firmly established her international reputation. In 1968 Riley became one of the few British artists and the first British woman artist to win the International Prize for Painting at the Venice Biennale.

Riley's paintings are experiments in perceptual illusions and immediate neural-retinal experiences of seeing. For years she worked only in black-and-white and with a limited number of forms: the circle, the oval, the square, the rectangle, the triangle, and vertical, horizontal, and curving lines. Her reputation rests partly on the wide range of emotional and psychological response she can produce by subtle adjustments in size and position of forms or alterations in their patterns. And although it is often assumed to have a complex mathematical substructure, Riley's work is, in fact, based on simple arithmetic calculations combined with an artist's intuition for balance, placement, and color.

In the late 1960s, Riley gradually began to add color to her work. In this example, *Red, Turquoise, Grey and Black Bands* (1970), the black lines establish a rhythmic, repetitive structure within which the color bands are placed. As the color lines shift in relation to the black-and-white ones, the image becomes a nearly physical sensation in the eye of the viewer.

Riley's work expresses her belief that repetition and restraint lead an artist to greater freedom and creativity. When she subjects color and form to such focused scrutiny, she frees them from descriptive or functional roles and allows them to act as intense experiences of feeling and seeing.

M.B.M.

Photograph of Bridget Riley in her studio, early 1980s

OPPOSITE:
Bridget Riley. *Red, Turquoise, Grey and Black Bands*. 1970. Gouache, 27½ × 27½". The Holladay Collection

DOROTHEA ROCKBURNE
CANADIAN | 1934–

THE CANADIAN-BORN artist Dorothea Rockburne creates drawings and paintings based on the most rigorous geometric and procedural analyses. Her work often literally folds inward on itself but expands awareness of form, structure, and meaning by such introspection.

Rockburne was born in Montreal, where she attended the Ecole des Beaux-Arts after surviving an invalid childhood from which she remembers solitude, reading, and music. Once her health improved she took up swimming and, in winter, skiing and has related her later passion for drawing to the experience of skiing on new snow. She came to the United States to attend Black Mountain College in 1951, receiving a B.F.A. degree in 1956. At Black Mountain, Rockburne studied with Philip Guston, Esteban Vicente, and Jack Tworkhov and became friends with Cy Twombly, Franz Kline, and Robert Rauschenberg. She also studied dance with Merce Cunningham.

From Black Mountain, Rockburne moved to New York City, where she began to paint and, in the mid-'60s, to participate in dance events at the Judson Theater with Carolee Schneeman, Yvonne Rainer, Trisha Brown, Robert Morris, and others and to take part in then fashionable Happenings. The dance experience, Rockburne later explained, was the inspiration for the folded work she began to make in the late 1960s. Dancing made her more conscious of the grid pattern through which dancers move and, consequently, of surface. Even more important for Rockburne was the folding of bodies and arms in dance; these physical actions led her to explore other kinds of folding as a way to release emotion in art.

By the early 1970s Rockburne was producing paintings based on the golden section, using folded linen or paper with surfaces marked by lines of blue chalk or blue pencil. The golden section is a rectangle whose proportions are believed to be perfectly satisfying to the eye. Rockburne's works were inspired by the techniques and subject matter of fifteenth-century Italian frescoes and panel paintings whose painters had also studied and frequently used the golden section. Like the Italian painters Rockburne devised a number of methods for deriving the golden section from a given square, and that process becomes a subject of her work. An example is *Copal #7* (1976), in which the measurements of the square extending from either end of the central parallelogram determine all other dimensions of the image.

Rockburne had her first solo New York show in 1970 and has exhibited annually ever since. In 1980 she produced a series of white paintings inspired by Egyptian wall reliefs, of which *Sheba* (see page 227) is a part. This multiple ensemble of linen, glue, and pencil is both complex and subtle in its structure, not only exploiting the texture and shape of the material itself but incorporating its own shadows as part of the finished work.

M.B.M.

Photograph of Dorothea Rockburne, early 1980s

OPPOSITE:
Dorothea Rockburne. *Copal #7.* 1976. Kraft paper, varnish, blue pencil, 29⅛ × 39⅛". The Holladay Collection

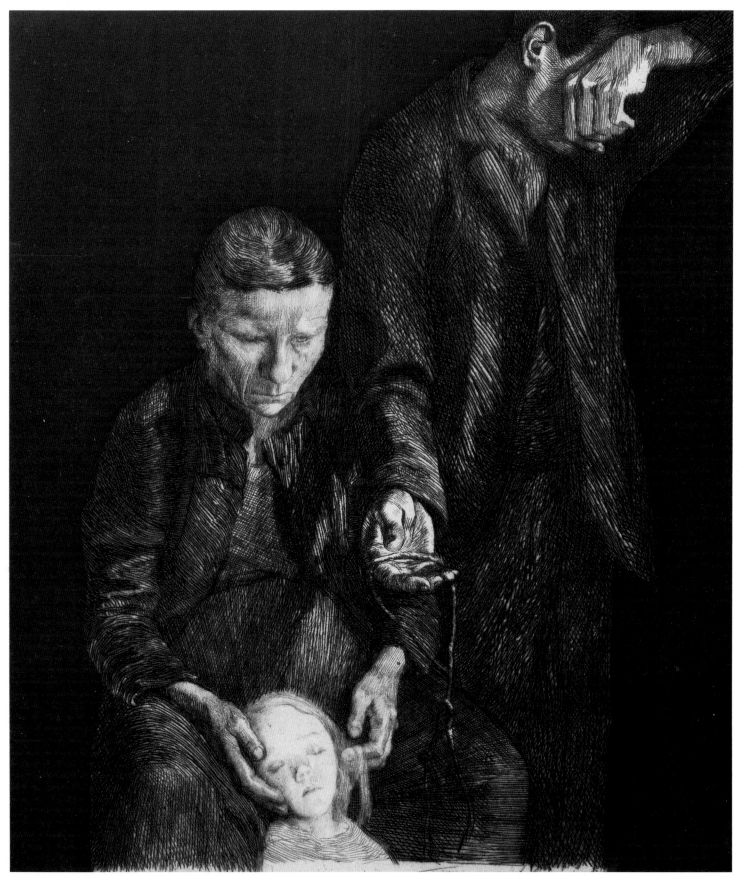

126

KATHE KOLLWITZ
GERMAN | 1867–1945

KÄTHE KOLLWITZ was one of the most famous and influential German print-makers of the early twentieth century. Her powerfully stark imagery describes the plight of the poor and denounces the atrocities of war. Working at a time when many artists used their art to investigate formal problems, Kollwitz devoted her art to describing the human condition. In both her sculpture and her graphics she expressed profound dismay at social injustice and outrage at indifference to suffering.

Käthe Kollwitz was born in 1867 in Königsberg, Prussia, and began studying in 1881 with Rudolf Mauer, a local printmaker. At seventeen Kollwitz enrolled in the School for Women Artists in Berlin. Her early studies, which reveal a developing social consciousness, depicted workers engaged in manual labor. In 1885 she became engaged to a medical student, Karl Kollwitz, who was also a member of the Social Democratic Party. Over the next fifty years, her husband's practice exposed her to an even wider range of suffering and tragedy.

Käthe Kollwitz first studied etching in 1889–90 in Munich, the artistic center of nineteenth-century Germany. At that time Max Klinger's imaginative etchings captivated Kollwitz, especially his cycles that illustrated difficult passages of human existence: infidelity, murder, death. Kollwitz was inspired by Klinger's imagery but even more affected by his writings and theory of art. He wrote that some themes, particularly those that dealt with evil, weakness, and the darker side of life, were best expressed by the graphic arts. Kollwitz adopted Klinger's themes and stopped painting at this time.

Kollwitz executed her first significant cycle of prints, *A Weaver's Rebellion*, between 1893 and 1898. She was inspired by Gerhart Hauptmann's play *The Weavers*, which related the brutal suppression of a worker's revolt in Silesia in 1844. Her series included three etchings and three lithographs based on Hauptmann's narrative. Unlike the play's author, however, Kollwitz removed all specific references to German history to create a more universal expression of tyranny. The simple titles of the prints, such as *Poverty*, *Death*, and *Conspiracy*, support this direction in her art.

The Downtrodden, illustrated here, was originally conceived as part of a symbolic etching that would have concluded the *Weaver's Rebellion* series. However, Kollwitz eliminated this etching from the series because its allegorical imagery was inappropriate amidst the stark realism of the rest of the set. In 1900 she revised the design of the more realistic left-hand section to create *The Downtrodden*. Kollwitz's characteristically harsh contrasts emphasize the agonizing gestures and poignant expressions of the figures, which are illuminated within a shroud of darkness. The anguished father covers his face with his hand as his grief-stricken wife gently caresses a lock of their slain child's hair. Kollwitz has powerfully evoked the immense horror and fear of violence and death with these few poignant details. Throughout the remainder of her long career Kollwitz would continue to express these universal themes in printmaking and in sculpture.

Other works by Kollwitz in the collection of the National Museum of Women in the Arts (see page 207) include *End*, an etching and aquatint from the *Weaver's* series, a bronze relief, *Rest in His Hands* (1935–36), and a 1940 bronze sculpture, *The Farewell*.

E.D.

Käthe Kollwitz. *Self-Portrait of Käthe Kollwitz.* 1891–92. Pen and ink with brush and white gouache, 15¾ × 12⅝″. Gift of Mr. and Mrs. Alan Press. © The Art Institute of Chicago. All Rights Reserved

OPPOSITE:
Käthe Kollwitz. *The Downtrodden.* 1900. Etching, 12⅛ × 9¾″. The Holladay Collection

PAULA MODERSOHN-BECKER

GERMAN | 1876–1907

Paula Modersohn-Becker. *Self-Portrait with
Camellia Branch*. 1907. Oil on canvas, 24½ × 12″.
Folkwang Museum, Essen

OPPOSITE:
Paula Modersohn-Becker. *Sitting Female Nude*.
Charcoal on white paper, 20⅖ × 15⁷⁄₁₀″. The
Holladay Collection

THE FIRST German painter to integrate French Post-Impressionist influences in
her art, Paula Modersohn-Becker was a major figure in the evolution of modern
art in Germany. In her short career, Modersohn-Becker quickly passed from an early
Academic style of realistic and sentimental painting to a reductive, analytical, and
symbolic manner that allowed for more direct presentation of subject matter and tech-
nical experimentation. Although most of her paintings are small, nearly all possess a
monumentality and grandeur.

Modersohn-Becker was born in 1876 in Dresden and began taking drawing lessons
at sixteen when her family moved to Bremen. She completed a two-year teacher-
training course to prepare for the possibility of a teaching career before attending,
from 1896 to 1898, the Berlin School for Women Artists. She then settled in the
artists' colony at Worpswede.

The Worpswede artists were known for their rejection of urban centers and their
embrace of the simple values of rural life. Modersohn-Becker studied with the one
figure painter in this colony and learned graphic techniques from an illustrator and
designer there. She soon began to feel the colony's limitations, however, and in 1900
she left for Paris to broaden her studies of modern art.

It was to be the first of four trips to Paris. In 1900 and 1903 she attended the
independent Académie Colarossi, and in 1905 she enrolled at the Académie Julian.
During her Paris visits she frequented museums and galleries, attended special exhi-
bitions, and began to meet other young artists working in the French capital. She had
married Otto Modersohn in 1901 on a return trip to Worpswede but was torn by the
conflict between domestic duties and artistic creativity and eventually left Modersohn
in 1906 to move to Paris for an extended stay. Her husband followed her there and in
1907 persuaded her to return to Worpswede, where she died a month after giving birth
to a daughter in November of that year.

Modersohn-Becker's short artistic career was marked by an impressive productiv-
ity, including some four hundred paintings and studies and one thousand drawings.
She had recorded in her journals and letters premonitions of an early death, which
may have spurred her on to greater activity. She herself began to express satisfaction
with her work in 1902 in Paris as she was beginning to assimilate the influences of
Cézanne, Gauguin, and Van Gogh. These Modersohn-Becker drawings of women, the
nude reproduced here and the *Seated Old Woman* (see page 218), are undated, but
reflect the artist's lifelong interest in the female figure and personality. Women mod-
els were always more available to women artists, and while Modersohn-Becker lived at
Worpswede, the residents of the local poorhouse and peasant women were the only
sitters available to her. In *Sitting Female Nude*, the semireclining figure is drawn in an
Academic pose, but Modersohn-Becker has not treated her model with Academic
impersonality. Striving for simplicity and fluidity of line, the artist communicates
the vulnerability, humanity, and dignity of the sitter with a directness rare in early-
twentieth-century depictions of the female nude. This blend of rigorous formal analy-
sis and compassion appears in all of Modersohn-Becker's work.

M.B.M.

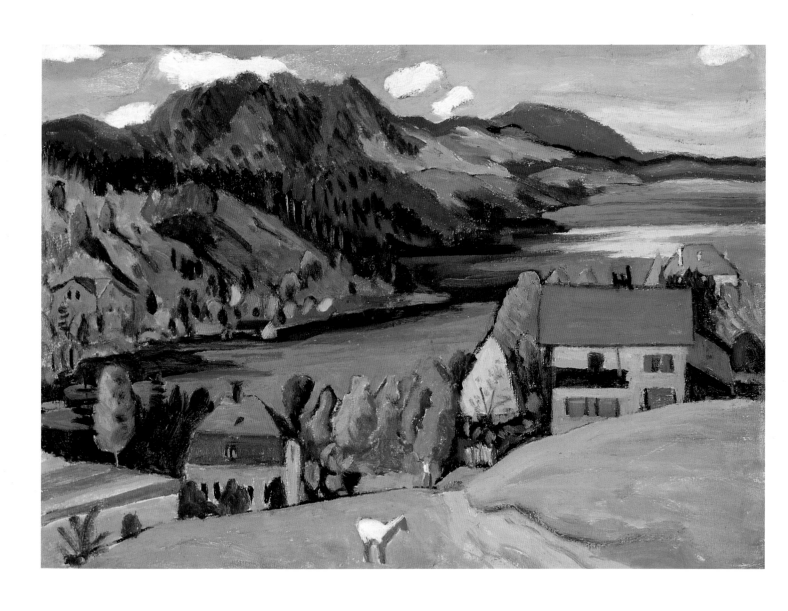

GABRIELE MUNTER
GERMAN | 1877–1962

As one of the founders of German Expressionism in the first decade of the twentieth century, Gabriele Münter contributed to the formation of modern German art at a crucial point in its development.

Münter was born in 1877 in Berlin and began her art studies in 1897 at Düsseldorf in the Ladies Art School because women students were not then admitted to the established art academies. From 1898 to 1901, she traveled in the United States then resumed her studies in Germany in 1901, in Munich. She soon became dissatisfied with traditional teaching and enrolled as one of the first students at Kandinsky's Phalanx School. From the time of their meeting, Kandinsky was impressed by her talent, declaring that he had nothing to teach her, that she was a "natural" artist. The two traveled across Europe from 1903 to 1908, including a two-year stay in France. They lived at Sèvres, near Paris, where they were much impressed by the new style of bold color and simple forms evolving there in the work of the Fauve group. During those years, 1906 and 1907, Münter exhibited her work in Paris at both the Salon des Indépendants and the Salon d'Automne.

On their return to Germany, Münter and Kandinsky settled near Munich in the village of Murnau in the Bavarian Alps. The local influence of folk arts and crafts—especially underglass painting and wood-block designs—and the Alpine landscape combined with the artistic innovations she had encountered in Paris to produce her mature style.

Münter's painting, as well as that of the other founders of the Blaue Reiter group in 1911, Kandinsky, Von Werefkin, Klee, Marc, Jawlensky, is characterized by broad, flat areas of color; intense and expressive color contrasts; emphatic, bold, and simple compositional designs; and extreme expressionistic effects. These qualities of German Expressionism, to which the Blaue Reiter group made important contributions, continued to characterize German art for many years.

The Münter painting *Staffelsee in Autumn* (1923), reproduced here, presents a view of the Bavarian lake landscape that inspired the artist throughout her life. The regular, flat brushstrokes and the clearly separate areas of color control and structure the surface of the painting. In such a mountain landscape, Münter said she felt she moved beyond "painting from nature" to something more abstract—the painting of essences. Essences, both pictorial and natural, are superbly unified in this small masterpiece of German Expressionist painting.

Münter left Murnau in 1917 and returned a decade later; by the 1930s she was once more painting actively. She had to do so clandestinely during the Nazi era, as her work, along with most other progressive German modern art, was declared "degenerate" under the Third Reich. The 1934 painting *Breakfast of the Birds* (see page 219) represents Münter's style of this period. After World War II, she worked to promote the reputation and history of the Blaue Reiter group during its early years in Munich. She died in 1962.

M.B.M.

Wassily Kandinsky (French, b. Russia, 1866–1944). *Gabriele Münter*. 1905. Oil on canvas. Städtische Galerie im Lenbachhaus, Munich

OPPOSITE:
Gabriele Münter. *Staffelsee in Autumn*. 1923. Oil on board, 13¾ × 19¼″. The Holladay Collection

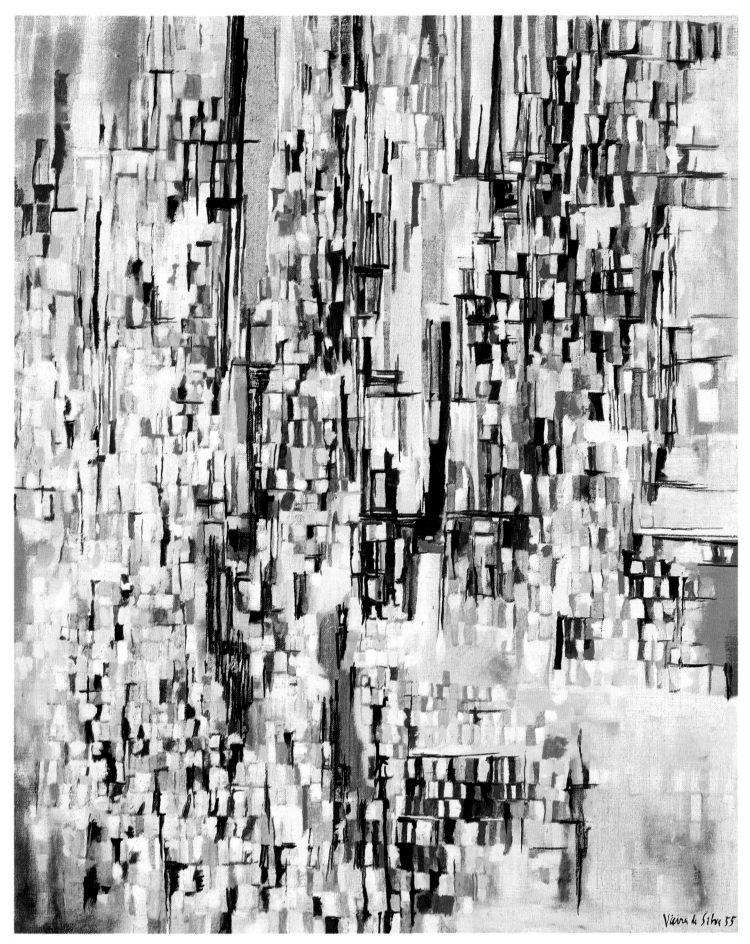

MARIA ELENA VIEIRA DA SILVA
PORTUGUESE | 1908–

BORN IN 1908 in Lisbon, Maria Elena Vieira da Silva began to paint and draw at the age of eleven and was sculpting at sixteen. She moved to Paris in 1928 to work at the Académie de la Grande Chaumière, where she studied sculpture with Bourdelle; during this period, she also studied sculpture with Despiau, painting with Léger, and graphics at Hayter's workshop. In 1930, she married the Hungarian painter Arpad Szenes.

At the outbreak of World War II, Vieira da Silva and her husband left Paris for Lisbon, eventually settling in Brazil, where they lived from 1940 to 1947. During her Brazilian exile Vieira da Silva came into contact with Uruguayan painter Joaquín Torres-García, who was living in Montevideo. Torres-García wrote a major article on Vieira da Silva's painting and discussed with her the many problems of craft. Critics have noted a greater stability and coherence in her work after her contact with Torres-García.

Before leaving Paris, Vieira da Silva had her first solo show in 1933 at the Galerie Jeanne Bucher. A second followed in 1935 in Lisbon and two more in 1937 and 1939, both in Paris. She exhibited in 1942 at the Museu Nacional de Bellas Artes in Rio de Janeiro and had her first New York show in 1946 at the Willard Gallery. After her return, she showed her work annually in Paris and in the 1950s in other European cities. By the end of the '50s her international reputation was firmly established, and her works were included in museum exhibitions in the major European art centers as well as in the United States—in New York, Washington, and Pittsburgh. In 1966 she received the Grand Prix National des Arts from the French government, an award previously given only to André Masson, Jean Bazaine, Max Ernst, Alberto Giacometti, and Hans Arp.

Many of Vieira da Silva's paintings are structured with black, and the heavily worked surfaces, whose thick paint layers attest to the struggle attending their creation, accomplish effects of somber intensity. Vieira da Silva's paintings often resemble a contest between the forces of darkness and light; in her work there is a perpetual conflict, with no intimations of resolution. In this she is a preeminently Modernist painter, seeing each painting as an arena for enacting anew the search for, and discovery of, revelation.

In the 1955 painting shown here, *The Town*, dark tones—mainly black and dark blue—structure the image and balance the subtly shifting lighter and brighter tones and hues. The painting's basic grid design vaguely alludes to city views and architecture. Some areas of the canvas, particularly those along the left and right edges, are indistinctly defined, and, as the light and dark areas build up toward the center, the image increases in clarity, as if the view is materializing out of a mirage or a dream. This effect is typical in Vieira da Silva's work. The thing depicted cannot quite be grasped by vision, but it is nevertheless felt and understood through the hallucinatory power of the painting.

M.B.M.

Photograph of Maria Elena Vieira da Silva, 1981

OPPOSITE:
Maria Elena Vieira da Silva. *The Town*. 1955. Oil on canvas, 39½ × 31¾". The Holladay Collection

NATALIA GONCHAROVA

RUSSIAN | 1881–1962

Photograph of Natalia Goncharova in Paris, 1920, in front of her work *The Spanish Women*

OPPOSITE:

Natalia Goncharova. *Cosmic Universe*. Watercolor, 12⅞ × 9¼″. The Holladay Collection

DURING the second half of the nineteenth century, women in Russia had access to higher education for the first time. Art education followed this liberalizing trend. In 1871 the Academy of Arts opened to women, and in the 1880s art schools were established in St. Petersburg, Moscow, Odessa, and Kiev and soon attracted a majority of women students. By the beginning of the twentieth century, a second generation of educated women artists emerged to take part in the social, cultural, and political upheaval in Russia during the first three decades of the twentieth century. Historians are now recovering the names and works of scores of women artists active in the Russian avant-garde. Natalia Goncharova was a distinguished leader in that group.

Goncharova was born in 1881 in central Russia, which she left in 1892 to study in Moscow. She studied history, botany, and zoology before enrolling at the Moscow School of Painting, Sculpture and Architecture, where she studied sculpture with a Rodin disciple, Pavel Trubetskoi. Completing her education in 1903 with a gold medal in sculpture, Goncharova thereafter devoted her full attention to her paintings, which she had been exhibiting since 1900. In 1906 her work was included in a show of Russian art organized by Diaghilev in Paris, and in 1907 she was part of the first avant-garde exhibition, "Stephanos," in Moscow.

During these early years of her career, Goncharova's work was influenced by developments in France, especially the work of the Impressionists and of Gauguin, Cézanne, and Matisse. However, Goncharova, along with the avant-garde painters Mikhail Larionov and David Burliuk, had broken with French Modernism to espouse an art based on native Russian arts and crafts called Russian Neo-Primitivism. Saying that she "shook the dust of the West" from her feet and was turning to the East, Goncharova and the other Neo-Primitives adopted the bright colors and intense contrasts of Russian peasant art, fabrics, furniture, and icons; the rich imagery of Russian religious art; and the lubok print, a popular wood-block form combining images and words. Their work, and that of many artists who followed and exhibited with them during the second decade of the century, led to the radically new forms and themes in modern art that developed in Russia by the end of World War I.

In 1915, Goncharova left Russia to work with Diaghilev on set designs and costumes for the Ballets Russes and settled permanently in Paris in 1917. There she continued to design for the theater, to paint, and to exhibit until the end of her life in 1962.

During her last decades Goncharova painted mostly themes of resurrection in the form of flower images and subjects inspired by the exploration of space. After the Soviet launching of *Sputnik* in 1957, she produced a series of works, on the theme of the cosmos, which was exhibited in Paris in 1958. The watercolor *Cosmic Universe* may relate to that series. Description and narrative merge in the image into a flattened abstract design. The viewer seems to look through a near window into a distant universe of speeding planets and stars. At the same time the allusion to comets, asteroids, and planets is contradicted by the tight surface pattern of brown and gray arcs punctuated by bright circles of light. As earlier in her career Goncharova called attention to pictorial structure through folk arts and popular stories, so later in her life she drew on contemporary myths as an inspiration and foundation for her work.

M.B.M.

135

RUSSIAN artists during the first decade of the twentieth century struggled to create new visual vocabularies that would challenge the traditional, realistic, and often sentimental art of the immediate past. Their new work was bold and colorful, frequently drawing on folk art styles and forms. Many women were active members of the Russian avant-garde and made important contributions to the creation of Russian and, subsequently, European modern art.

Alexandra Grigorovich Exter, born in Bielostock and raised and educated in Kiev, was one of these pioneers of Modern Abstraction and a major force in revolutionizing theater design. From the beginning of her career, she sought out poets, artists, and composers of the most radical and advanced circles of the day, exhibiting from 1907 onward with the young artists who were challenging traditional Russian painting styles.

Between 1908 and 1914, Exter traveled regularly from Moscow to Paris, becoming a transmitter of artistic ideas between the two art capitals. Her earliest work was in painting, but she soon expanded her range of media to include theater design, book illustration, collage, and constructions. When she returned to Russia at the beginning of World War I, she began the serious involvement with theater design on which her reputation as a major artist rests.

The new theater developing in Russia grew out of collaboration of audience, actors, and designers for extemporaneous, dynamic interaction. Exter carried into the theatrical context her experiments in pictorial composition, specifically her search for dynamic, disjunctive, nonnarrative forms in compositions that retain a balanced design. Beginning with the analyses of Cubism, Exter continued to investigate the problems of space and movement in painting, subsequently extending her discoveries to the stage environment and to the bodies of actors, using them for further evolution of her ideas. Broad areas of color and often abstract, geometric shapes, juxtaposed to the structure and movement of the body, characterize her designs from the 1920s onward. Her earlier work had been even more abstract and almost self-consciously modern, incorporating contemporary materials, such as celluloid and metal sheeting, to produce a mechanistic, futuristic effect.

Exter's costume design of c. 1933 for *Les Equivoques d'Amour*, illustrated here, a play by Francis de Miomandre, reflects her treatment of individual garment elements as abstract, geometric shapes. The contrasting treatment of the sleeves, one thin, dark, and marked with a lightning design and the other large and round, as if constructed of numerous sections, is typical of the contrasts she built into her costumes. Similar contrasts distinguish the collar, the elaborate belt, and the train. It is important to remember that Exter's individual designs were intended to be seen in motion, as part of the elaborate spatial context of the theater.

Exter left Russia and in 1924 settled in Paris, where she continued to paint and exhibit, also working in experimental film. She published a book of theater designs in 1930 and was active in the European cultural avant-garde until her death in 1949.

M.B.M.

Photograph of Alexandra Exter in her Paris studio in the mid-1920s. The Billy Rose Theatre Collection, The New York Public Library at Lincoln Center. Astor, Lenox and Tilden Foundations

OPPOSITE:
Alexandra Exter. Costume design for *Les Equivoques d'Amour*. c. 1933. Gouache and pencil on paper, 22⅜ × 17⅛". The Holladay Collection

SONIA TERK DELAUNAY RUSSIAN | 1885–1979

Sonia Terk Delaunay. *Study for Portugal.* 1936–37. Gouache, 14¼ × 37″. The Holladay Collection

SONIA TERK DELAUNAY, although Russian-born, acquired her artistic education largely outside of Russia and lived most of her life abroad. She was born in 1885 in the Ukraine and raised in St. Petersburg in the home of an uncle. She left Russia in 1903 for studies in Germany, then settled in Paris in 1905, where she lived until her death in 1979 except for a period of exile in Spain and Portugal from 1917 to 1920.

Delaunay's early works were inspired by the French Fauve painters, particularly Henri Matisse. Vincent Van Gogh and Paul Gauguin also were important influences during her early years in Paris. She quickly developed a personal style incorporating the Fauves' strong colors and boldly patterned areas into an abstract vocabulary fusing color, form, and movement. This evolved, after her marriage in 1910 to painter Robert Delaunay (1895–1941), into a belief in the primacy of color over form, a theory the two elaborated as the basis of their doctrine of Orphism.

Sonia Delaunay worked continually throughout her long and active life in many artistic media besides painting. From the creation of a pieced quilt for her son in 1911, in which she synthesized Russian peasant blanket design with Cubism, she moved on to collage, bookbinding, book illustration, and, eventually, to costume and theater design, fashion design, and decorative arts. In 1918 she designed some of the costumes for Diaghilev's ballet *Cléopâtre*, and in 1919 she executed the interiors for the Petit Casino in Madrid. After meeting members of the Surrealist circle, she designed costumes for Tristan Tzara's scandalous play, *Le Coeur à Gaz*, in 1923.

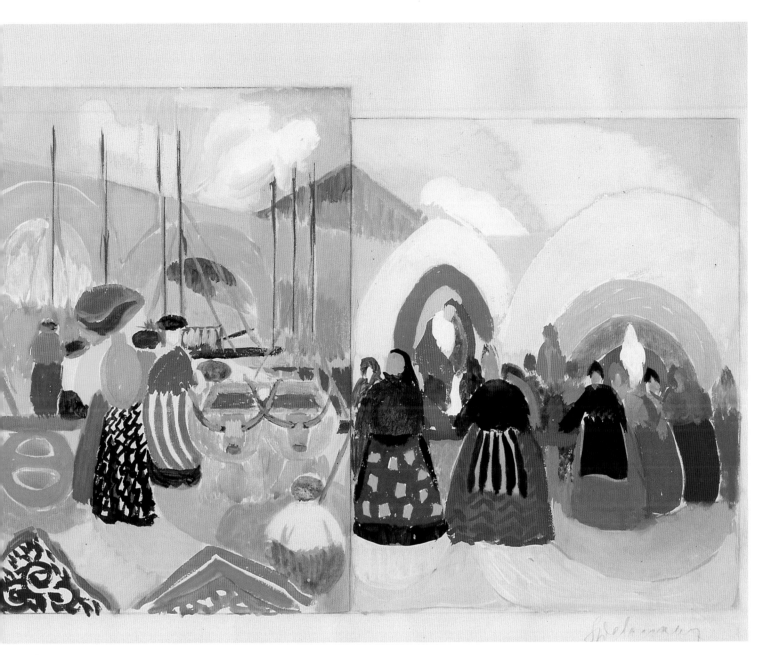

From the mid-1920s on, Delaunay became increasingly involved in textile design and fashion, eventually setting up her own studio for the creation of fabrics and garments. She collaborated with couturiers in an effort to merge the commercial and artistic worlds in order to democratize aesthetic values; she delivered lectures and published articles in support of her theories and work.

In 1936–37 the Delaunays received a commission to decorate the Air and Railroad Pavilions for the Paris Exposition of 1937. *Study for Portugal* is the artist's gouache design for that monumental public work, which is now in the Musée National d'Art Moderne, Centre Georges Pompidou, in Paris. *Study for Portugal* contains a sequence of four scenes that hover on the border between representation and abstraction. It draws from the years the Delaunays lived in Portugal and expresses the color theories developed in her work over the years. The four sections become more closely focused as the eye moves to the right, and the figures within them become larger and more specifically rendered. Arches of the railroad viaduct move across and down to the right of the four panels, dissolving in a great circle of color at the right edge, a fragmented color pattern reminiscent of both Delaunays' abstract Orphic color designs. The image is created entirely by color juxtapositions, a representative example of the color-as-form theories of Orphism.

M.B.M.

Photograph of Sonia Terk Delaunay, 1932

ANNE REDPATH

SCOTTISH | 1895–1965

THE SCOTTISH painter Anne Redpath was the daughter of a tweed designer who recognized his daughter's talent and agreed to her attending art school only on the condition that she also prepare for a "useful" career as a teacher. She attended the Edinburgh College of Art from 1913 to 1918, receiving a teaching certificate and the only postdiploma fellowship awarded the year she graduated. In 1919, she traveled through Europe and settled in France for fourteen years after her marriage in 1920 to James Michie. She exhibited there twice, in 1921 and 1928, devoting most of her time to raising and caring for a family.

After her return to Scotland in 1934 Redpath was elected a member of the Society of Scottish Artists and, as her family responsibilities lessened, she began to paint and exhibit more frequently. By the time she settled in Edinburgh in 1949, she was one of the most famous painters in Scotland. During the last two decades of her life, Redpath traveled to Spain, Corsica, the Canary Islands, Portugal, and Venice. On each trip the artist made new discoveries that produced important changes in her painting style. This technical and compositional development culminated in a series of paintings inspired by Venetian altarpieces. These works, made during the last years of the artist's life, are considered her greatest achievements.

Redpath's earlier work consisted largely of landscapes and still lifes. In the still lifes, especially, she communicated not only a formal and analytical pleasure in the configuration and balance of objects and color, but an affection for the everyday reality that familiar artifacts represent.

She continued this twofold interest in her late paintings, in which the history and ritual significance of the churches and altarpieces merged with her enthusiasm, as a painter, for the exuberance of color and light. This led Redpath to abandon increasingly direct representation, so that in these late works she found herself exploring a kind of abstraction that could give substance to her vivid sensations yet invoke the objects that inspired them as well.

The painting reproduced here, *Altar in Venice* (1961–62), is typical of Redpath's late works. The visual and atmospheric splendor of a candlelit altarpiece has been so intensely examined that the image itself nearly dissolves into brushstrokes and pigment. This intensity seems to have been the result of Redpath's attraction to extreme ways of life in the landscapes and churches that inspired these late paintings. She admitted that she struggled to transpose those extremities into her paintings, as seen here in the contrast between light and dark, between horizontal and vertical brushstrokes, and between the descriptive gesture and the constructive mark.

M.B.M.

Photograph of Anne Redpath

OPPOSITE:
Anne Redpath. *Altar in Venice*. 1961–62. Oil on paper, 23½ × 29⅝". The Holladay Collection

ALICE BAILLY

SWISS | 1872–1938

Photograph of Alice Bailly. Photograph courtesy of the artist's estate

THE SWISS artist Alice Bailly was one of many early-twentieth-century artists who left their homelands to settle, at least temporarily, in Paris, where they found a community of like-minded adventurous and innovative colleagues. Bailly had spent twelve years studying and working in Switzerland and Germany before arriving in Paris in 1904 at the age of thirty-two. There she worked for ten years, assimilating the new styles developing around her, specifically Fauvism, Cubism, and Futurism, and eventually practicing her own synthesis of all three.

Bailly was born in Geneva in 1872 and after attending the Ecole des Beaux-Arts received a scholarship to Munich, which was withdrawn after she failed to attend classes, preferring to work and study on her own. Bailly soon settled in Paris in 1904 and became friends with the avant-garde artists Dufy, Gleizes, Picabia, Laurencin, Gris, and Lewitzka. She exhibited in the Salon d'Automne every year from 1906 on and in the Salon des Tuileries and the Salon des Indépendants. Her first exhibited works were prints, but her paintings were shown at the Salon d'Automne in 1908 in company with the Fauves.

Attracted to the experiments of Cubism, Bailly had developed by 1910 her own version, which was praised by the poet and art critic Apollinaire as expressing much freshness of feeling. Her paintings reveal a mastery of Cubist brushwork and surface treatment but a stronger affirmation of the depicted object or scene than was typical of Braque or Picasso at that time. By the time she painted the *Self-Portrait* in 1917 (shown opposite), she had more thoroughly integrated spatial fragmentation and reorganization and intensified her palette as well.

In her *Self-Portrait*, Bailly's treatment of the head is particularly interesting. It appears to have undergone not so much the fragmentation typical of Cubism as an erasure. It is as if, for the artist, the act of painting—the movement of color, and thereby form, from the palette to the head—becomes a double creation. As she constructs her painting she also creates her own image and, by that act of making, also creates a self.

In 1912 Bailly's work was selected to represent Switzerland in an international exhibition that traveled to Russia, England, and Spain. By the time she returned to Switzerland at the outbreak of World War I, she had developed a manner of painting akin to that of the Futurists and the painting of Marcel Duchamp. In 1916, she began to construct "wool paintings," in which she replaced brushstrokes with strands of wool. She continued to work on these until 1922, producing twenty-seven canvases in this fashion.

Bailly made one more visit to Paris in 1921, then spent the remainder of her life in Switzerland, exhibiting paintings and trying to expand awareness of, and support for, modern art. In 1936, she executed eight large murals for the foyer of the Theater of Lausanne. The demands of this monumental project so exhausted the artist that her health failed and she died in early 1938.

M.B.M.

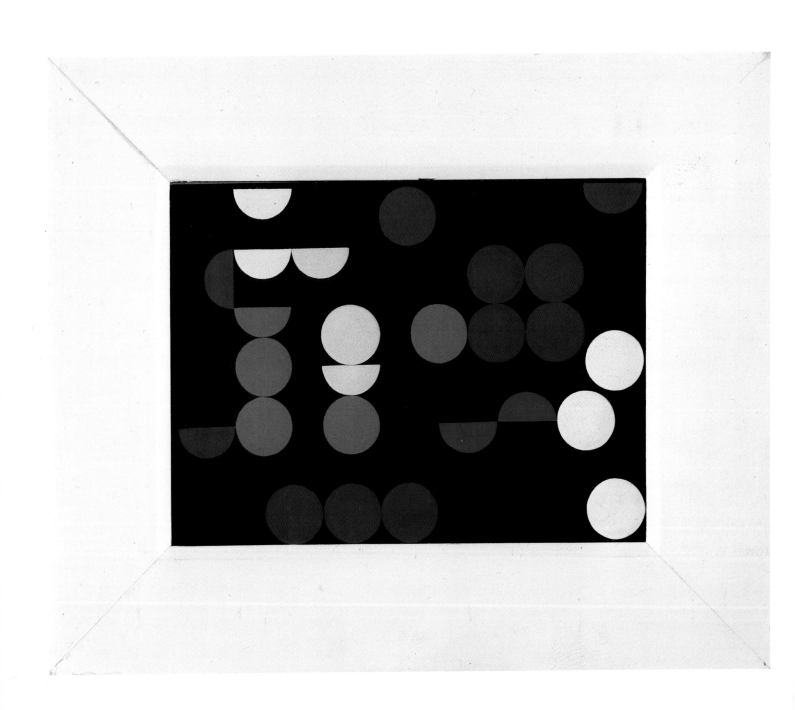

SOPHIE TAEUBER-ARP

SWISS | 1889–1943

Photograph of Sophie Taeuber-Arp in her studio, Zürich, 1918

OPPOSITE:
Sophie Taeuber-Arp. *Composition of Circles and Semicircles*. 1935. Gouache on paper, 10 × 13½". The Holladay Collection

THE SWISS artist Sophie Taeuber-Arp expressed her multifaceted artistic personality in a body of work distinguished by its clarity, discipline, and formal elegance. From the outset of her career, she found in abstraction a way to express the synthesis of art and life that was sought by many artists during the first half of the twentieth century.

Taeuber-Arp was born in Davos, Switzerland, in 1889 into an artistically oriented family and began studies in the textile section of the School of Applied Arts of St. Gallen in 1908. After two years she left for study in Munich and in 1912 became a student at the School of Arts and Crafts in Hamburg, Germany. In 1915 she became a member of the Swiss Workshop, committed to preserving the practice of traditional Swiss crafts, and in 1916 was appointed professor of textile design and techniques at Zurich's School of Applied Arts, a post she held for thirteen years. At the same time she was seriously studying dance and appeared frequently in Dada performances in Zurich in 1916–19. In 1916 she met the artist Jean Arp (1887–1966), who became her lifelong collaborator. They were married in 1922.

Taeuber-Arp's work of this period includes geometric abstractions in watercolor, oil, and gouache; Dada objects; and wool embroidery. In 1918, she designed the sets and marionettes for *Le Roi Cerf*. Taeuber-Arp's first exhibition was in Basel in 1922. She showed in Paris in 1925 at the Salon des Arts Décoratifs, in the Salon des Indépendants in 1930, in the Cercle et Carré group show of 1930, and with the Abstraction-Création group in 1933. From 1937 to 1939 she published the magazine *Plastique/Plastic*, devoted to abstract art in Europe and in the United States. From 1928 until 1940, she and Arp lived at Meudon-Val Fleury, near Paris, in a house she designed and decorated according to principles similar to those promoted by founders of the Bauhaus. She had previously worked with Arp and Theo van Doesburg on the interior decoration of the Café l'Aubette in Strasbourg, which was a center of artistic collaboration from 1928 until 1940. After the Germans occupied France, the Arps returned to Switzerland, where Taeuber-Arp died suddenly in 1943.

From the many strands of her life as designer, dancer, teacher, and painter, Taeuber-Arp produced a purely geometric art of remarkable spontaneity and freedom. Using only the most basic forms—the circle, the square, and the rectangle—she explored many possible configurations with choreographic subtlety. The number of colors in her palette was also restricted, so that the smallest variation in color would appear greater than it actually was. This process is visible in *Composition of Circles and Semicircles* (1935), in which the two half circles of red seem to shout from the more restrained chorus of blues and white. The forms—their placement surely suggesting the pattern and movement of dance—slip slightly out of alignment or off the canvas, giving the work a sense of personality and, even, humor.

M.B.M.

For ease in reference, the following black-and-white plates are arranged alphabetically by name of artist rather than chronologically or by nationality.

Louise Abbéma (French, 1858–1927). *Portrait of a Young Girl with a Blue Ribbon*. Pastel on canvas, 18 × 15″. The Holladay Collection

Berenice Abbott (American, 1898–). *Eva Le Gallienne*. c. 1927. Vintage silver print, 14¼ × 17¼″. The Holladay Collection

Berenice Abbott (American, 1898–). *Djuna Barnes*. c. 1926. Vintage silver print, 10¼ × 8¼″. The Holladay Collection

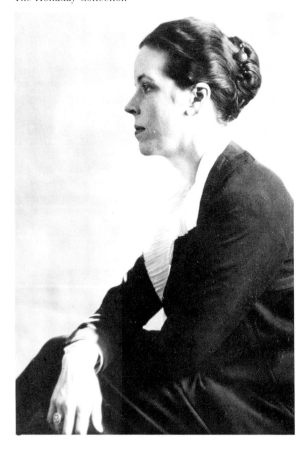

Berenice Abbott (American, 1898–). *Janet Flanner*. c. 1927. Vintage silver print, 10¼ × 8¼″. The Holladay Collection

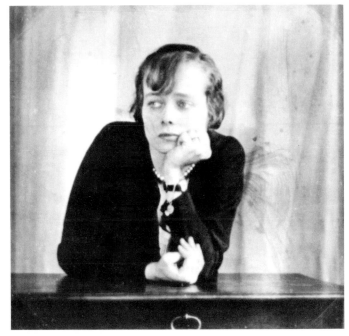

Berenice Abbott (American, 1898–). *Betty Parsons*. c. 1927. Vintage silver print, 10¼ × 8¼". The Holladay Collection

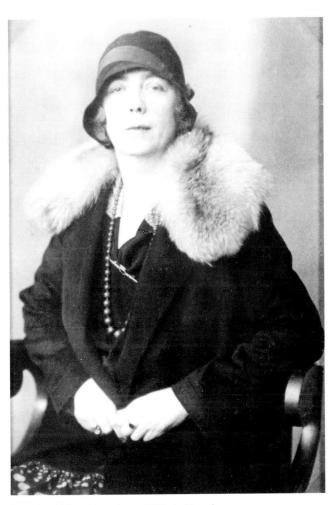

Berenice Abbott (American, 1898–). *Nora Joyce*. c. 1927. Vintage silver print, 10¼ × 8¼". The Holladay Collection

Berenice Abbott (American, 1898–). *Coco Chanel*. c. 1927. Vintage silver print, 10¼ × 8¼". The Holladay Collection

Alice Stanley Acheson (American, 1895–). *Atitlan
Village*. Watercolor on paper, 15 × 17″ (framed).
Gift of Mrs. Jefferson Patterson, 12/12/85

Anni Albers (American, 1899–). *C 31/65*. 1969. Serigraph, 24 × 22½″. The Holladay Collection

Suad Allatar (Iraqi). *Untitled*. 1981. Lithograph (68/100), 29½ × 22½″. Gift of Mr. and Mrs. Wedad Almandil, 7/83

Marie Apel (British, 1880–1970). *Grief*. 1939–40.
Bronze, 20 × 7 × 6″. Gift of the artist's daughter,
2/85

Pilar de Aristegui (Spanish). *Moors and Christians,
Alcoy.* 1984. Oil on canvas, 38½ × 42½". Gift of
the artist. 7/1/85

M. Artha (Balinese). *Untitled*. 1985. Oil on canvas, 22½ × 16½". Gift of Mr. and Mrs. Nyoman Punia

Alice Baber (American, 1928–1982). *Burning Boundary*. 1963. Oil on canvas, 24 × 19½″. Gift of Mrs. A. Grant Fordyce, 6/83

Alice Baber (American, 1928–1982). *For a Book of Kings*. Oil on canvas, 77 × 58″. Gift of the Baber Estate, 1/85

Loren Roberta Barton (American, 1893–1975).
Back Stoop (in Monterey CA.). c. 1925. Etching,
6¼ × 8¾″ (plate size). Gift of Ben and A. Jess
Shenson, 10/29/85

Lady Diana Beauclerk (British, 1734–1808). *Love
in Bondage*. c. 1795. Watercolor on paper,
16½ × 20½″. Gift of Mr. Gordon Hanes, 4/82

Friedy Becker-Wegeli (American, 1900–1984).
Roses on a Ledge. 1981. Oil on canvas,
13½ × 10½″. Gift of LaFollette Becker, 5/86

Philomene Bennett (American). *Red River to Heaven*. Acrylic on canvas, 10 × 10'. Gift of Jacqueline B. Charno and William H. Hickok, 5/85

Sylvia Bernstein (American, 1914–). *Mother and Child*. 1956–57. Ink and watercolor on paper, 25½ × 40½". Gift of Davida Goldberg

OPPOSITE:
Electra Waggoner Biggs (American). *Riding into the Sunset*. Bronze, 13 × 10⅜ × 4½". Gift of the artist, 3/3/86

Elizabeth Blackadder (Scottish, 1931–). *Still Life
with Indian Toys*. Watercolor on Japanese paper,
37½ × 49½″. The Holladay Collection

Rosa Bonheur (French, 1822–1899). *Sheep in a Mountain Landscape*. 1870. Engraving (Lionel Le Couteaux, engr.), 20 × 30¼″. The Holladay Collection

Dorr Bothwell (American, 1902–). *California Wild Mustard*. 1964. Serigraph, 25½ × 19½". Gift of Benjamin Ehrich, 1/83

Margaret Lesley Bush-Brown (American, 1857–1944). *Woman Fishing in the Canal*. 1885. Etching, 19 × 12½". The Holladay Collection

Anne Frances Byrne (British, 1775–1837).
Honeysuckle, Poppies, etc. . . Watercolor,
13 × 17½″. The Holladay Collection

Jo Ann Callis (American, 1941–). *Parrot and Sailboat*. Cibachrome print, 20 × 24″. The Holladay Collection

Mary-Helen Carlisle (American, b. South Africa, 19th c.–1925). *Lavender Gardens—Kilkenny Castle*. Pastel, 12 × 15″. The Holladay Collection

Jewel Carrera (American, 1942–). *White Hills*.
1982. Watercolor, 21½ × 14″. Gift of the artist,
4/24/86

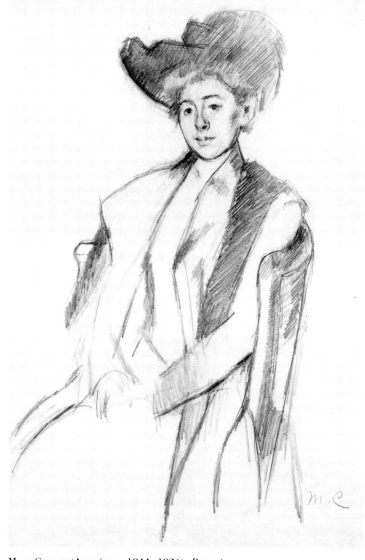

Mary Cassatt (American, 1844–1926). *Mother
Louise Nursing Her Child.* 1899. Drypoint,
15 × 11″. The Holladay Collection

Mary Cassatt (American, 1844–1926). *Portrait
Sketch of Mme. Fontveille, No. 1.* c. 1902.
Charcoal drawing, 18 × 13″. The Holladay
Collection

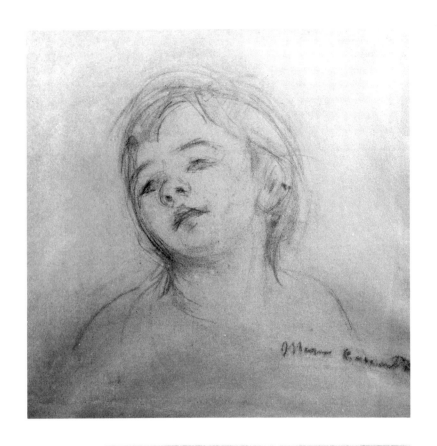

Mary Cassatt (American, 1844–1926). *Sketch of Denise's Daughter.* c. 1905. Drawing on paper, 15½ × 14″. Gift of Mrs. Kitty Taquey in memory of her father, Mr. Albert McVitty, 12/85

Mary Cassatt (American, 1844–1926). *Study of Reine: Outline of a Child's Head.* c. 1902. Pastel, 21½ × 18″. The Holladay Collection

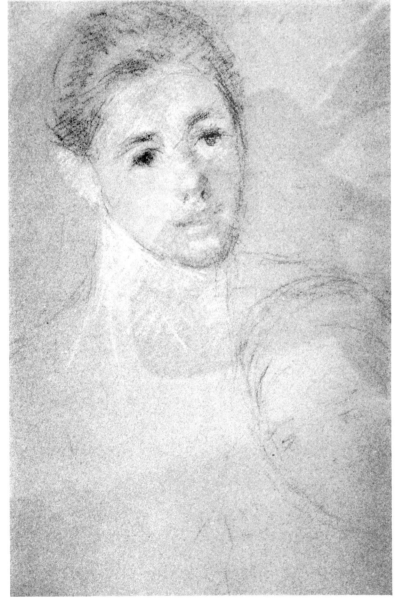

Lydia Chamberlin (American, 1923–). *Prout's Neck*. 1979. Oil on canvas, 36 × 47″. The Holladay Collection

Linda Charleston (American, 1902–). *Amazing Grace*. 1965. Acrylic on canvas. Triptych, 6′6″ × 15′10″. Gift of Mr. and Mrs. Gerald Li, 12/82

Ann Chernow (American, 1936–). *Lady of L.A.*
1984. Pencil and eraser drawing, 20¾ × 31½".
Gift of Mr. and Mrs. Edward P. Levy, 7/1/85

Marie Z. Chino (American, ?–1982). Untitled
black and white pot. 1982. 12 × 15 × 4½". The
Holladay Collection

Gabrielle de Veaux Clements (American, 1858–
1948). *Mont St. Michel.* 1885. Etching,
19¼ × 14¼". The Holladay Collection

169

Phoebe Cole (American, 1959–). *St. George and the Dragon*. 1983. Linoleum-cut print (1/15), 25 × 31″. The Holladay Collection

Susan Crowder (American, 1934–). *White Folded Pillow*. 1979. White marble, 12 × 15 × 4½″. The Holladay Collection

Louise Dahl-Wolfe
(American, 1896–).
Fashion Photograph.
Silver gelatin print,
11 × 9″. Gift of
Jeanette Montgomery,
9/85

Joan Danziger (American, 1934–). *Ozymandasis.*
1982. Wall sculpture, mixed media,
31 × 50 × 12¾". The Holladay Collection

Roselle Davenport (American, 1948–). *Genesis.*
Oil on canvas. Central panel of triptych, 64 × 51".
Gift of the artist, 7/11/85

FAR LEFT:
Wörden Day (American, 1916–1986). *Continental Divide III*. Painted wood, 60 × 30″. Gift of Edith Lawton, 11/83

LEFT:
Dorothy Dehner (American, 1908–). *Ladder II*. Bronze, with marble base, 23 × 3½ × 1½″. Gift of Mrs. Philip Wiedel, 3/86

Dorothy Dehner (American, 1908–). *Black and Brown*. 1970–71. Lithograph, 30 × 22¼″. The Holladay Collection

Elaine de Kooning (American, 1920–). *Jardin de Luxembourg VII*. 1977. Lithograph (Tam. #77–105a). 30 × 22″. Gift of Mr. and Mrs. James E. Foster. 11/84

Elizabeth Lyman Boott Duveneck (American, 1846–1888). *Newport*. January 1882. Watercolor. 10½ × 15″. Gift of Frank Duveneck, 2/83

Wendy Eisenberg (British, 1931–). *Deidre*. 1982.
Silverpoint drawing on video paper, 17¾ × 17″.
Gift of Deidre Busenburg and the artist, 6/14/85

Deborah Ellis (American, 1939–). *Sliced
Vegetables*. 1980. Watercolor, 20 × 23″. The
Holladay Collection

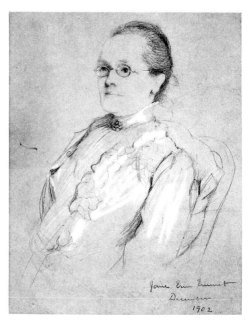

Jane Erin Emmet (American, 1841–1907). *Portrait of Mrs. B. F. Goodrich.* 1902. Drawing on brown paper with white highlights, 17 × 14½″ (framed). Gift of Mrs. Jefferson Patterson, 12/12/85

Harriet Feigenbaum (American, 1939–). *Dawn.* 1973. Charcoal on paper. One of four, 102 × 51½″. The Holladay Collection

Jackie Ferrara (American, 1929–). *M165.* 1976.
Laminated ¼-inch masonite, 9¼ × 12½ × 3″. The
Holladay Collection

Marie Ferrian (American, 1927–). *Alice–1919.*
Stoneware acrylic, height, 26¼″. The Holladay
Collection

Susan Firestone (American, 1946–). *Autumn Charm Box*. 1981. Acrylic on paper with pen and crayon, 30 × 22″. The Holladay Collection

Susan Firestone (American, 1946–). *Lipstick and Zippers*. 1981. Two-part acrylic on canvas. Each part, 12 × 9″. The Holladay Collection

Harriet Fitzgerald (American, 1904–). *Rooftops of Florence*. 1980. Oil on canvas, 27½ × 31½". Gift of C. W. Gibson, Jr.

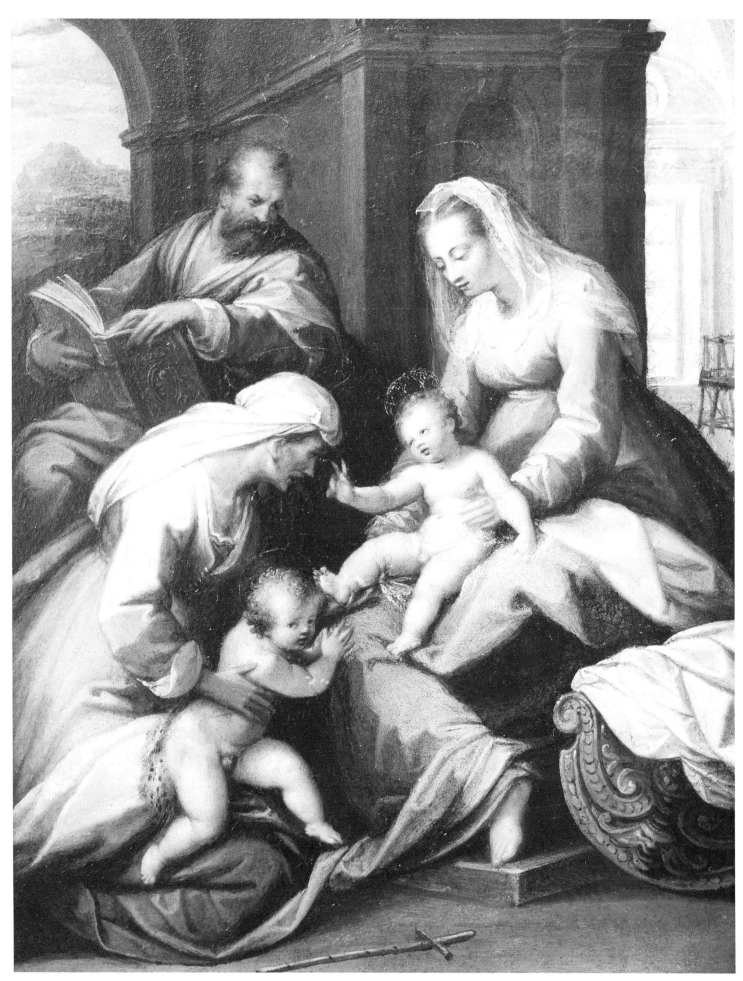

Lavinia Fontana (Italian, 1552–1614). *Holy Family with St. John*. Oil on metal, 8⁹⁄₁₀ × 7¹⁄₁₀″. The Holladay Collection

Adela Elizabeth Stanhope Forbes, A.R.W.S.
(British, 1859–1912). *Will O' the Wisp*. Oil on
canvas. Triptych, 27 × 44 × 4″. The Holladay
Collection

Patricia Tobacco Forrester (American, 1940–).
Judith's Garden. 1969. Etching (artist's proof),
9 × 12″. The Holladay Collection

Helen Frankenthaler (American, 1928–). *Ponti*.
1973. Drypoint and aquatint, 27½ × 35″. The
Holladay Collection

Elizabeth Friedman
(American, 1918–).
Monumental Grape II.
1986. Cibachrome
print, 20 × 16″.
The Holladay Collection

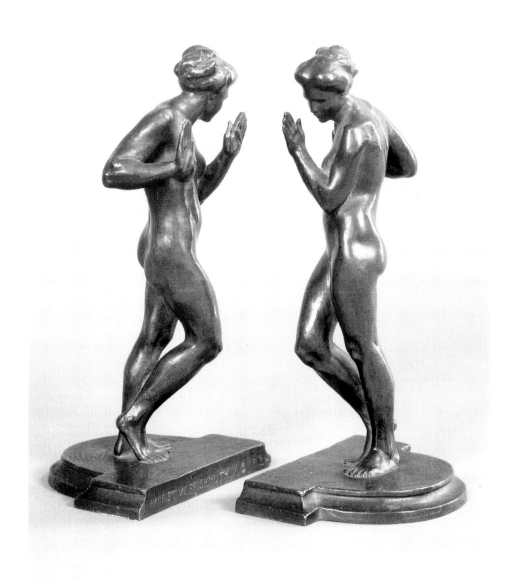

Harriet Whitney Frishmuth (American, 1880–
1979). *Pushing Nude Bookends*. 1912. Bronze,
each 10⅛ × 4½″. The Holladay Collection

Maggie Furman (American, 1941–). Pink
stoneware pot, height, c. 14″; diameter, c. 18″. The
Holladay Collection

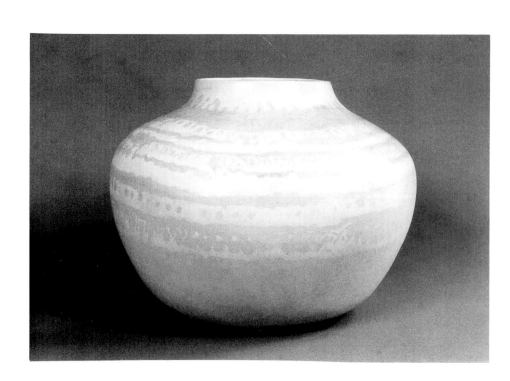

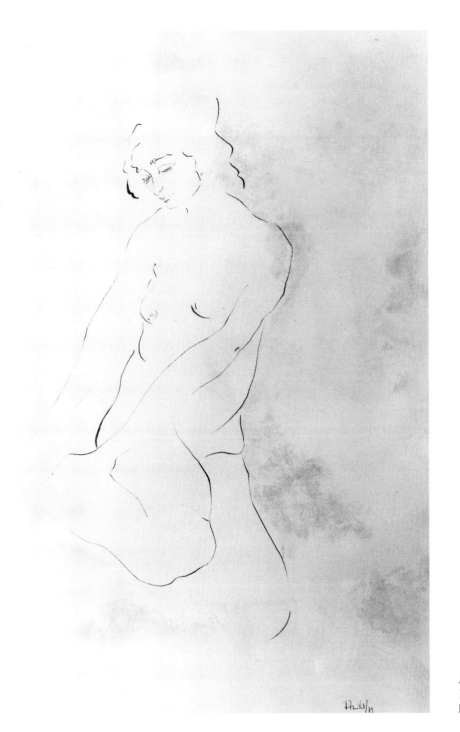

Aniko Gaal (Hungarian, 1944–). *Meditation.*
1979. Watercolor and ink, 32½ × 23⅛". The
Holladay Collection

Ada V. Gabriel (American, 1898–). *Calla Lilies*.
Lithograph, 14½ × 10¾″. Gift of Dr. Joseph Baird,
8/82

Sonia Gechtoff (American, 1926–). *Winter Rose
Interior*. 1980. Acrylic and pencil on paper,
40 × 50″. The Holladay Collection

Françoise Gilot (French, 1921–). *Air.* 1977.
Lithograph (Tam. #77–113), 15⅛×17″. Gift of
Mr. and Mrs. James E. Foster, 11/84

Lorrie Goulet (American, 1925–). *#2, Catalyst.*
1975. Ink on paper, 26×20″. Gift of Mr. and Mrs.
Kenneth Prescott, 12/30/85

Adele Greeff (American, 1911–). *Icon: In Praise of the Sea*. 1982. Oil on canvas, 20 × 24″. Gift of Adele Greeff (Mrs. Charles A. Greeff), 10/18/85

Ellen Day Hale (American, 1855–1940). *Gabrielle de Veaux Clements*. c. 1930. Oil on canvas, 36 × 30″. Gift of Mr. and Mrs. Harlan Starr, 5/83

Ellen Day Hale (American, 1855–1940). *Portrait of a Girl in a Cap*. c. 1889. Etching, 11½ × 9″. The Holladay Collection

Lee Hall (American, 1934–). *Quarry, Maine Dusk.*
Acrylic on canvas, 50×50″. Gift of Robert Maloy,
1/85

Lee Hall (American, 1934–). *Connecticut Summer.*
1978. Polymer print on paper, 7¾×6⅛″. The
Holladay Collection

Anna Marie Hancke (Norwegian, b. Yugoslavia, 1939–). *Asteroid*. 1986. Oil on paper, 22¾ × 30″. Gift of the artist, 2/86

Ann Hanson (American, 1959–). *Dancing Lizard Couple*. 1985. Celluclay sculpture on Formica base, 16½ × 20½″. The Holladay Collection

Grace Hartigan (American, 1922–). *Untitled.*
1959. Oil on canvas, 4×6′. Gift of Mrs. Richard
Salant, 7/86

Linda Hawkin-Israel (American, 1942–). *Women in Law*. 1985. Oil on canvas, 49¼ × 71¾". Gift of the Foundation for Women Judges in honor of Justice Sandra Day O'Connor, 7/8/85

Eva Hesse (American, b. Germany, 1936–1970).
Study for Sculpture. 1967. Sculpmetal, cord,
Liquitex, Elmer's Glue, varnish on masonite,
$10 \times 10 \times 1''$. The Holladay Collection

Judith Ingram (American). *Sandstone*. 1970.
Intaglio print on paper (10/30), $5\frac{7}{8} \times 6\frac{1}{4}''$. The
Holladay Collection

Sheila Isham (American, 1927–). *Lin, the Approach* (detail). 1969. Acrylic on canvas, 7'6" × 8'9½". Gift of Mrs. Townsend Hoopes, 6/82

Wako Ito (Japanese, 1945–). *Petunia Basket*.
1981. Mezzotint (9/100), 7⅜ × 11¼″. Gift of
Kappy Hendricks, 3/85

OPPOSITE:
Agnes Jacobs (American). *Oval II*. 1984. Mixed
media and aluminum on plywood, 69 × 48 × 10″.
Gift of the artist, 7/22/85

196

Virginia Jaramillo (American, 1939–). *'Visual Theorems'*. 1980. Handmade paper, 28 × 24″. Gift of John P. Mascotte, 12/17/85

Harriet Johns (American). *Untitled*. 1976. Lithograph (Tam. #76–138), 25 × 18½″. Gift of Mr. and Mrs. James E. Foster, 11/84

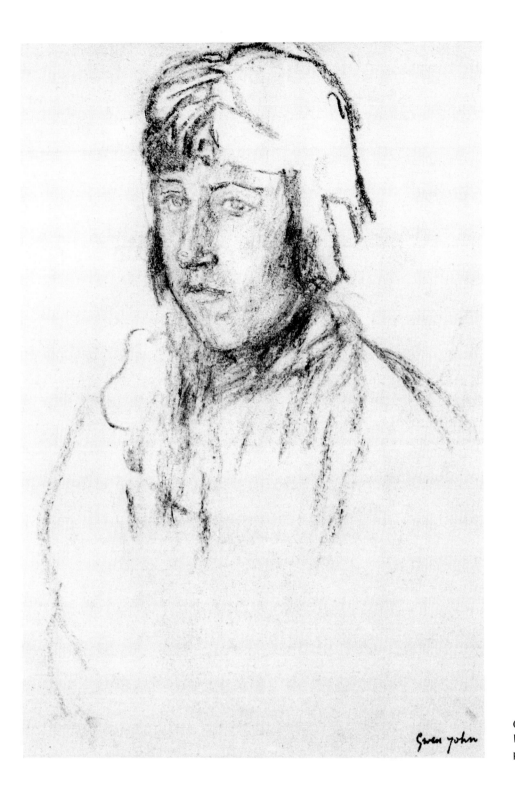

Gwen John (British, 1876–1939). *Study of a Woman in a Mulberry Dress*. 1923–24. Charcoal on paper, 16¹¹/₁₆ × 8½". The Holladay Collection

Elizabeth Jones (American, 1935–). *Feminine Snow*. 1980. Silver gelatin print, 15⅝ × 11¾″. The Holladay Collection

Elizabeth Keith (American, 1887–1956). *From the Land of the Morning Calm.* 1921. Color woodblock print, 12¾ × 8½″. Gift of Mrs. Jefferson Patterson, 12/12/85

Maurie Kerrigan (American, 1951–). *Brave Dog.* 1979. Fresco and painted wood, 25 × 40″. The Holladay Collection

Dora Khayatt (Egyptian, 1910–). *Marina*. 1974.
Mixed media on paper, 24 × 24″ (framed). Gift of
Mr. and Mrs. Jefferson Patterson, 12/12/85

Jessie Marion King (Scottish, 1875–1949).
Summer and Winter. Watercolor with pen and ink,
11½ × 9¼″. The Holladay Collection

Minnie Klavans (American, 1915–). *Within and Without*. 1977. Serigraph, 33¾ × 13″. The Holladay Collection

Georgina Klitgaard (American, 1893–). *Eaton's Neck*. Serigraph (56/200), 11 × 25¾". The Holladay Collection

Jennie Lea Knight (American, 1933–). *Tip.* 1969. Laminated pine on black Plexiglas pedestal, 17 × 12". The Holladay Collection

Ida Kohlmeyer (American, 1911–). *Symbols.*
1981. Oil, graphite, pastel on canvas, 69½ × 69″.
The Holladay Collection

Ida Kohlmeyer (American, 1911–). *Chauffeur.*
1952. Oil on masonite, 38 × 23¾″. The Holladay
Collection

Käthe Kollwitz (German, 1867–1945). *End*. 1897.
Etching and aquatint (this impression from an
edition of 50, printed in 1920), 20 × 17″. Gift of
Elizabeth Sullam, 7/83

Käthe Kollwitz (German, 1867–1945). *The
Farewell*. 1940. Bronze, height, 7″. The Holladay
Collection

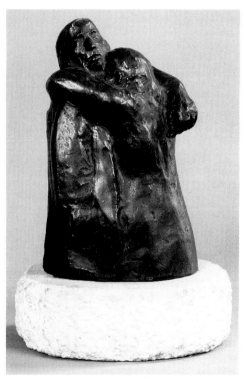

Käthe Kollwitz (German, 1867–1945). *Rest in His
Hands*. 1935–36. Bronze relief, 13¼ × 12½″. The
Holladay Collection

Constance Stuart Larrabee (American 1914–).
Witwaterstrand Gold Miner Watching Sunday Mine
Dance. Gold Mine, Yohannesberg—1946.
Photograph, 12 × 12″. Gift of the photographer,
9/86

Pat Lasch (American, 1944–). *Black Guardian
Angel I.* 1981. Paper, metal, wire mesh on board,
21 × 7 × 7″. The Holladay Collection

Elizabeth Layton (American, 1909–). *Self-Portrait, Holding Rose with Thorns.* 1985. Pastel with pencil on paper, 18 × 7″. The Holladay Collection

Doris Lee (American, 1905–1983). *Untitled.*
Serigraph, 22 × 30″. The Holladay Collection

Jeanette Leroy (French, 1928–). *Scarf on a Coat
Rack.* 1976. Pencil on paper, 22 × 15″. The
Holladay Collection

Bertha Boynton Lum (American, 1879–1954). *May Night*. 1913. Colored wood engraving, 18 × 18″ (framed). Gift of Mrs. Jefferson Patterson, 12/85

Ellen Macdonald (American, 1955–). *Dead Noise*. 1983. Lithograph, 19 × 22¾″. Gift of Washington Project for the Arts, 7/83

Arika Madeyska (Polish, 1935–). *Moon Landscape.*
1981. Oil on canvas, 12 × 16″. Gift of Krystyna
Wasserman, 7/85

Madhubani (Indian). Painting on silk, 36 × 30″.
The Holladay Collection

Phyllis Maher (American, 1945–). *Copper*. 1984.
Oil on paper, 22 × 30″ (framed). Gift of the artist,
5/10/85

Agnes Martin (American, 1912–). *The Wall II*.
1962. Oil and nail on canvas, mounted on wood,
10 × 10″. The Holladay Collection

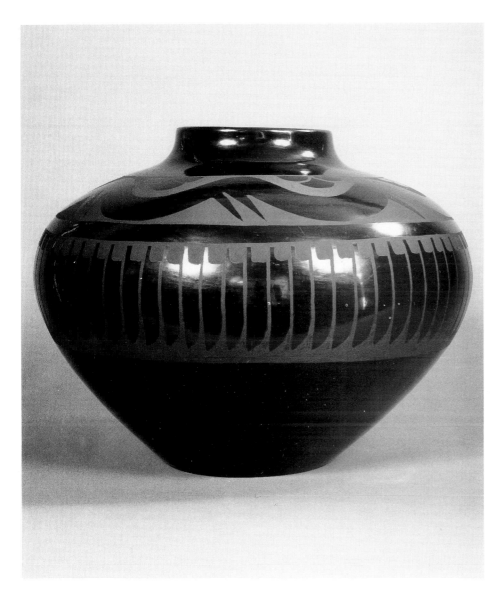

Maria Montoya Martinez (American, c. 1887–
1980). *Bowl*. c. 1950. Blackware pottery; height,
3¼"; diameter, 10¾". Gift of Clarence O.
Thompson, 3/82

Santana Martinez (American, 1909–). *Jar*. 1983.
Black-on-black pottery, height, 14". The Holladay
Collection

Norma Mascellani (Italian, 1909–). *Sanctuary of
St. Luke*. Oil on canvas, 5½ × 8½". The Holladay
Collection

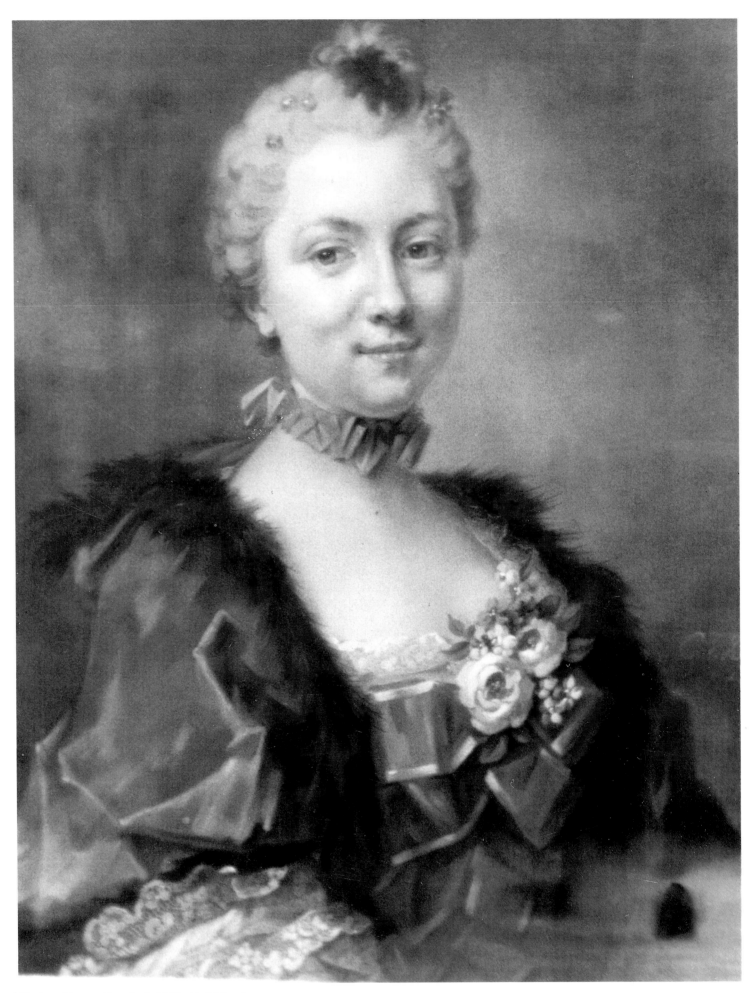

Charlotte Mercier (French, ?–1762). *Madeleine de
la Bigotiere de Perchambault.* 1757. Pastel,
23⅞ × 19¼". The Holladay Collection

Charlotte Mercier (French, ?–1762). *Oliver le
Gouidic de Troyon*. 1757. Pastel, 23⅞ × 19¼″.
The Holladay Collection

Paula Modersohn-Becker (German, 1867–1907). *Seated Old Woman*. 1898. Pencil drawing, 10¼ × 7⅛". The Holladay Collection

Berthe Morisot (French, 1841–1895). *Lake at the Bois de Boulogne*. Watercolor, 11 × 15". The Holladay Collection

Gabriele Münter (German, 1877–1962). *Breakfast of the Birds*. 1934. Oil on board, 18 × 21¾″. The Holladay Collection

Betty Parsons (American, 1900–1982). *Winged Frog*. 1978. Wood construction, painted, 27 × 20″. The Holladay Collection

Gertrude Partington (American, 1883–1959).
Eleanor. c. 1925. Oil on canvas, 32¾ × 21¼″. The
Holladay Collection

Irene Rice Pereira (American, 1907–1971).
Crystal of the Rose. 1959. Artist's book of poems
and drawings, 9½ × 5¾″. Gift of Helen Ziegler,
8/83

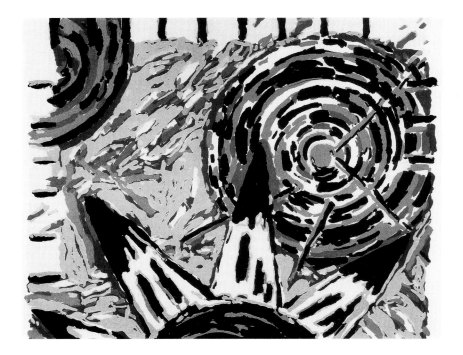

Katherine Porter (American, 1941–). *Untitled.* 1983. Serigraph, 19 × 26″. Gift of Paul Sonnabend, 12/83

Valentine Henriette Prax (Algerian, 1899–). *The Family.* Oil on canvas, 51 × 35″. Gift of Mrs. Philip Wiedel, 3/86

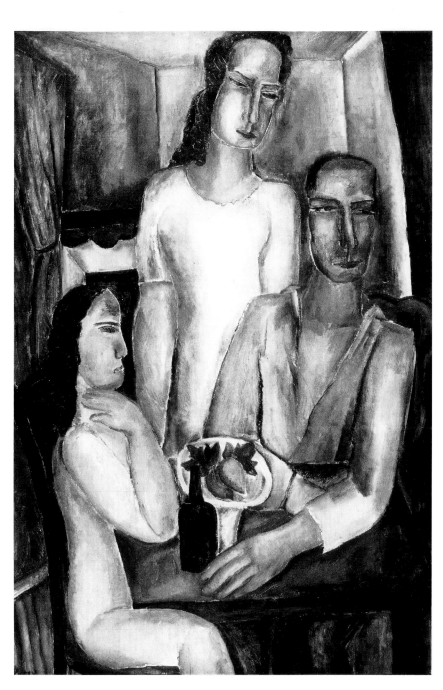

Mary Catherine Prestel (British, 1744–1794). *The Retreating Shower*. 1790. Aquatint, 22 × 27″ (platemark). The Holladay Collection

Barbara Rae (Scottish, 1943–). *Untitled*. 1984. Oil on canvas, 59 × 71″. Gift of Pamela Gould, 4/11/86

Jane Reese (American, 1869–1961). *Portrait of Jefferson Patterson*. 1928. Silver photographic emulsion on tissue, 9½ × 7½″. Gift of Mrs. Jefferson Patterson, 12/12/85

Iwami Reika (Japanese, 1927–). *Flower and Water.* 1982. Wood-block print, 21½ × 15¾″. Gift of Kappy Hendricks, 5/86

Ellen Robbins (American, 1828–1905). *Poppies.* Watercolor, 23½ × 15¾″. The Holladay Collection

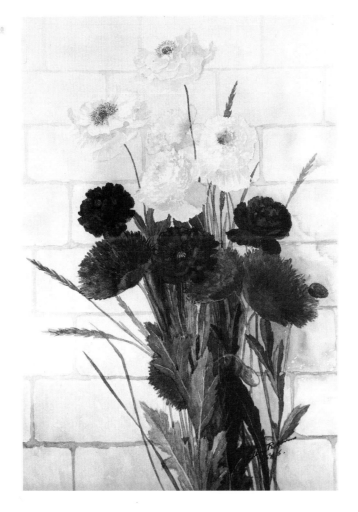

Pamela Roberson (American, 1947–). *Nevada*.
1981. Cibachrome print, 16⅞×23¾″. The
Holladay Collection

OPPOSITE:
Dorothea Rockburne (Canadian, 1934–). *Sheba*.
1980. Gesso, oil paint, blue and white conté
pencil, glue on linen, 74×59½″. The Holladay
Collection

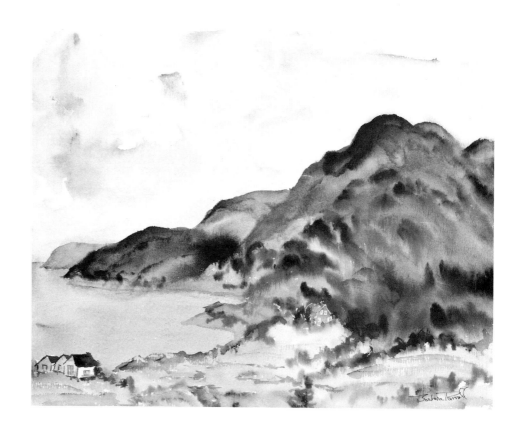

Barbara Russell (American, 1911–). *Pleasant Day*. Watercolor on paper, 20 × 25″ (framed). Gift of Mrs. Jefferson Patterson, 12/12/85

Rachel Ruysch (Dutch, 1664–1750). *Flowers in a Vase*. Oil on canvas, 18¾ × 15¾″. The Holladay Collection

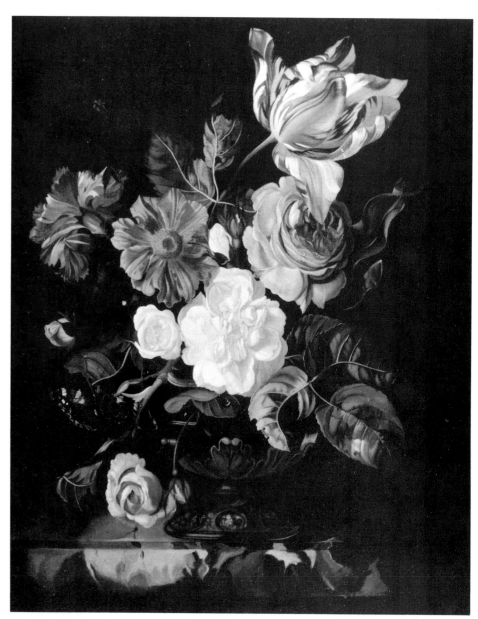

Sao (Maria Da Conceicao) (Portuguese, 1946–).
#24 from Paris Review. 1983. Silk jacket with
collage, ruffled sleeves. The Holladay Collection

Geneve Rixford Sargeant (American, 1868–1957).
Portrait of Eleanor. c. 1930. Gouache,
10¼ × 8¼″. The Holladay Collection

Lolo Sarnoff (Swiss, 1916–). *Gateway to Eden.*
1981. Plexiglas, 36 × 34″. Gift of the artist, 5/86

Fawn Shillinglaw (American, 1944–). *Morning
News.* 1984. Watercolor, 20 × 28¼″. Gift of the
artist, 12/85

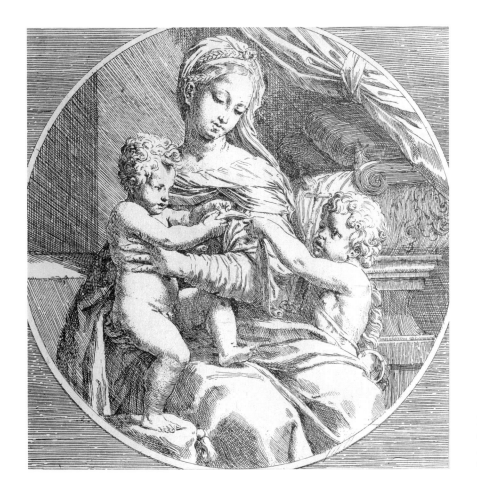

Elisabetta Sirani (Italian, 1638–1665). *Madonna and Child with St. John the Baptist*. Etching (after Raphael), 8⅛ × 9″ (mat opening). The Holladay Collection

Elisabetta Sirani (Italian, 1638–1665). *Holy Family with St. Elizabeth and St. John the Baptist*. Etching, 10½ × 8⅓″. The Holladay Collection

Louise Kidder Sparrow (American, 1884–1979).
Bust of General Sparrow as a Boy. Plaster,
24 × 6 × 6½″. Gift of General Herbert G. Sparrow,
USA, Ret.

Ellen Stavitsky (American, 1951–). *Collage 214*.
1979. Collage with book page, print on rice paper,
pencil, 15 × 11″ (framed). The Holladay Collection

Beatrice Stein (American, ?–1961). *Portrait of
Jacques Bon (Brother of Mme. Raymond Duchamp-
Villon)*. Oil and ink on canvas board, 10½ × 13¾″.
Gift of Francis Steegmuller, 4/15/85

Beatrice Stein (American, ?–1961). *Bust of
Jacques Bon (Brother of Mme. Raymond Duchamp-
Villon)*. Plaster, 10 × 15½″. Gift of Francis
Steegmuller, 4/15/85

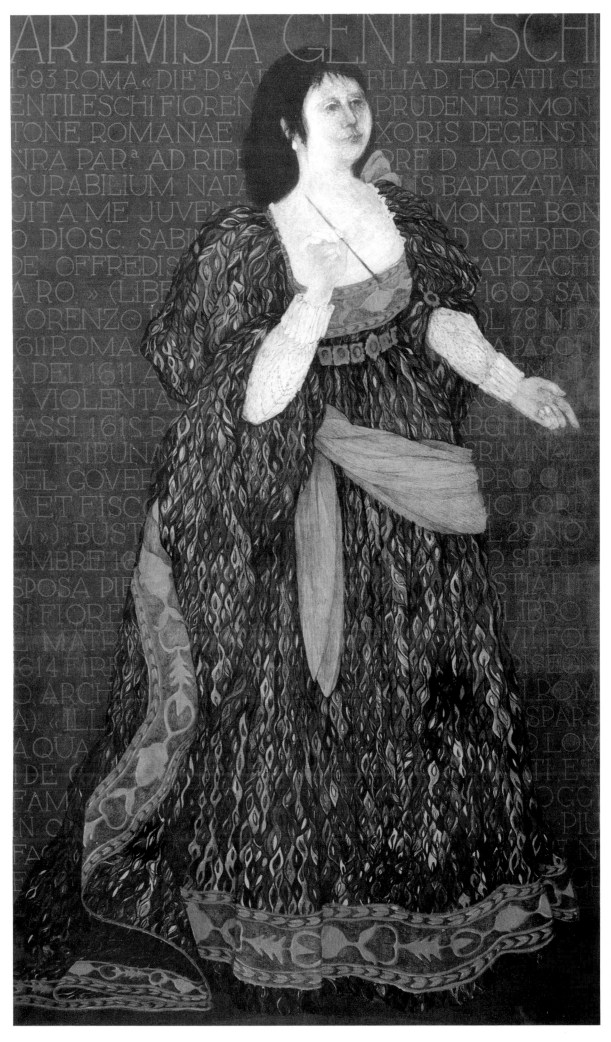

May Stevens (American, 1924–). *Artemisia Gentileschi*. 1979. Lithograph (sixth run), 41 × 29″. The Holladay Collection

Barbara Tebbetts (American). *Untitled*. 1976–77.
Acrylic and ink on canvas, 5×7′. Gift of John P.
Mascotte, 12/17/85

Joyce Tenneson (American, 1945–). *Kathy: 1985*.
1985. Silver bromide print, 22×30″. Gift of the
photographer, 10/8/86

Alma Thomas (American, 1891–1978). *Orion.*
1973. Oil on canvas, 53¾ × 64″. The Holladay
Collection

Anne Truitt (American, 1921–). *Summer Dryad.*
1971. Acrylic on wood, 76 × 13 × 8″. The Holladay
Collection

Agnese Udinotti (American, 1940–). *Totem Stele No. 8*. Welded steel structure, height, 2′. The Holladay Collection

CLOCKWISE FROM TOP LEFT:

Suzanne Valadon (French, 1865–1938). *Bouquet
of Flowers in an Empire Vase*. 1920. Oil on canvas,
28¾ × 21½". The Holladay Collection

Suzanne Valadon (French, 1865–1938). *Girl on a
Small Wall*. 1930. Oil on canvas, 36¼ × 29". The
Holladay Collection

Suzanne Valadon (French, 1865–1938). *Bathing
the Children in the Garden*. 1910. Drypoint,
14 × 16". The Holladay Collection

OPPOSITE:

Suzanne Valadon (French, 1865–1938). *Nude
Doing Her Hair*. Oil on canvas, 41¼ × 29⅝". The
Holladay Collection

Gemma Vercelli (Italian, 1912–). *The Ways of the World: A Triptych*. c. 1935. Mixed media on board; central panel, 34⅝ × 27½"; wings, 34⅝ × 17½". The Holladay Collection

Maria Vicentini (Italian, 1934–). *The Pope's Inauguration*. 1978. Oil on linen, 15 × 20½″. Gift of the artist, 5/82

Elena Vidotto (American, 1931–). *Eggs*. 1971. Oil on wood, 10 × 12″. The Holladay Collection

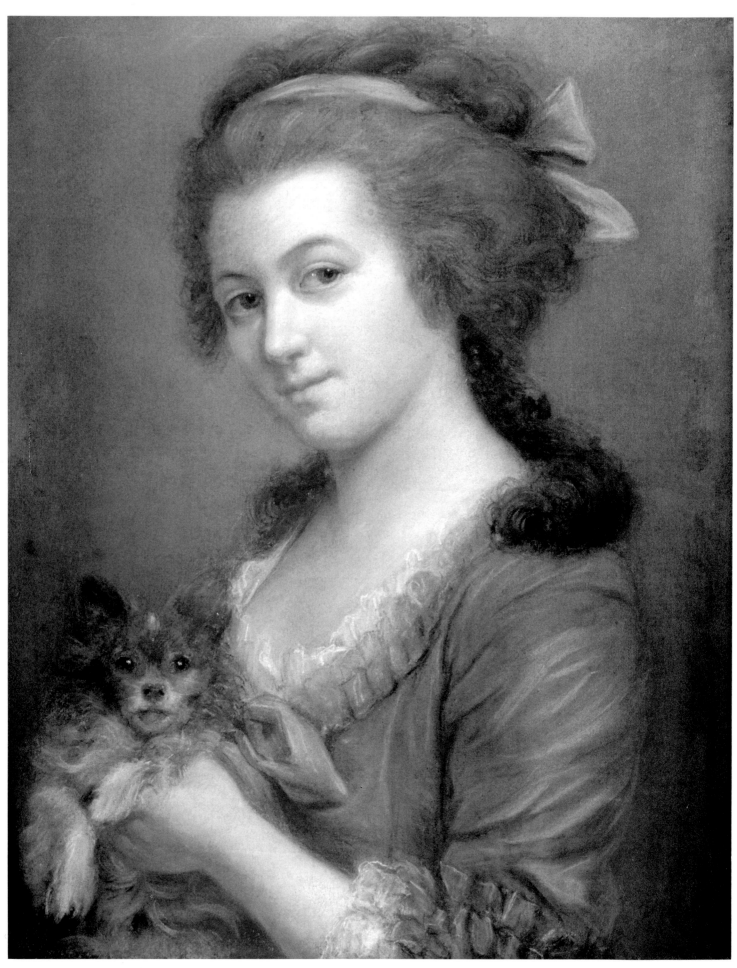

Elizabeth Vigée-Lebrun (French, 1755–1842).
Portrait of Mme. d'Espineuil. c. 1776. Pastel,
32 × 25″. Gift of Mr. Edward G. Platt, Jr., 11/85

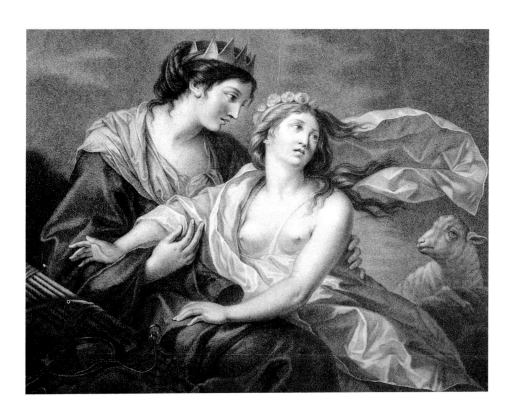

Elizabeth Vigée-Lebrun (French, 1755–1842).
Innocence Taking Refuge in the Arms of Justice.
1783. Engraving (François Bartelozzi, engr.),
15 × 17″. The Holladay Collection

BELOW, LEFT:
Elizabeth Vigée-Lebrun (French, 1755–1842).
Mlle. Anne de Visevalotsky. Illustration from a
sketchbook comprising 39 portrait drawings of
women and children of the Russian Court.
1795–1801. Graphite with red chalk, 7 × 4⅜″.
The Holladay Collection

BELOW:
Elizabeth Vigée-Lebrun (French, 1755–1842).
Study of Madame Backiloff, née Wolff. Illustration
from a sketchbook comprising 39 portrait drawings
of women and children of the Russian Court. 1795–
1801. Graphite with red chalk, 7 × 4⅜″. The
Holladay Collection

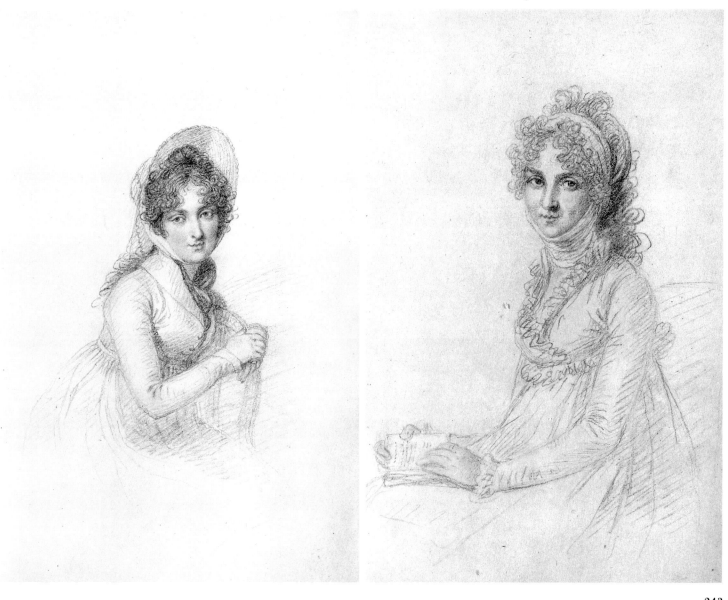

Martha Walter (American, 1875–1976). *Bathing House*. Oil on canvas, 11½ × 12½″. Gift of Miss Helen Hayes, 6/86

Eva Watson-Schutze (American, 1867–1935). *The Rose*. 1905. Gum bichromate print, 13¾ × 5″. The Holladay Collection

Katherine Ward Lane Weems (American, 1899–).
Doe and Fawn. 1927. Bronze, 11½ × 10 × 5″. The
Holladay Collection

Lee Weiss (American, 1928–). *Juniper Berries.*
1971. Watercolor, 39 × 25″. The Holladay
Collection

Irena Wiley (American). *Portrait of Mrs. Jefferson
Patterson.* Watercolor and pencil, 29 × 23″
(framed). Gift of Mrs. Jefferson Patterson, 12/12/85

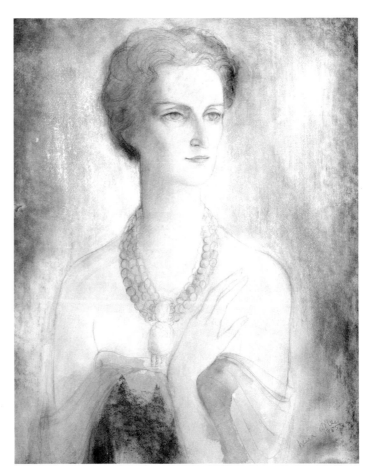

Marbet Maize Wolfson (American, 1952–). *The Transparent Table*. 1973. Etching, 11½ × 9½". The Holladay Collection

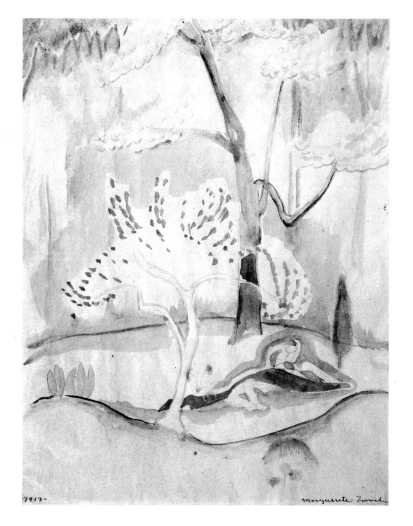

Yuriko Yamaguchi (Japanese, 1956–). *Shoot*. 1982. Watercolor on handmade paper, 9 × 12". The Holladay Collection

Marguerite Thompson Zorach (American, 1887–1968). *Central Park*. 1913. Watercolor on paper, 11 × 8½". The Holladay Collection

The following captions for works in the collection of the National Museum of Women in the Arts are not accompanied by illustrations.

Carolina Van Hook Bean (American, 1879–1980). *Portrait of Mr. Jefferson Patterson.* 1933. Pastel on paper, 23 × 16″. Gift of Mrs. Jefferson Patterson, 12/12/85

Sondra Freckelton (American, 1936–). *Celebration.* 1983. Lithograph, 28 × 23½″. The Holladay Collection

Eleanor Heller (American, 1918–). *Cassandra's Crucible.* Acrylic and additive on canvas, 32 × 32″. Gift of the artist, 5/85

Hannah Höch (German, 1899–1978). *Miniatures.* 1964. 16 linoleum-cut prints on Japan paper, each, 22 × 30″. The Holladay Collection

Grace Spaulding John (American, 1890–1972). *Thursday Night (Maid's Night Out).* 1926. Oil on canvas, 25 × 34″. Gift of Patricia John Kneightly, 4/84

Angelica Kauffman (Swiss, 1741–1807). *A Bust of a Girl, a Rose in her Hair.* 1768; *A Bust of a Girl with an Earring.* 1770. Two etchings printed on the same sheet. The Holladay Collection

Kathi Krikorian (American). *Ajanta Cave.* Wood-block print, 8½ × 12⅞″. Gift of the artist

Edith McCartney (American, 1897–1981). *Portrait of Mr. Jefferson Patterson.* Conté on paper, 30¼ × 23½″. Gift of Mrs. Jefferson Patterson, 12/12/85

Joan Y. McClure (American, 1934–). *Renewal.* 1976. Lithograph, 34 × 36″. The Holladay Collection

Anna Mary Robertson Moses (American, 1860–1961). *Calhoun.* 1955. Oil on masonite, 16 × 24″. The Holladay Collection

Roxie Munro (American, 1945–). *The Webster House.* 1979. Ink on paper, 10½ × 13½″. The Holladay Collection

Elizabeth Norton (American, 1888–1985). *On the Side Lines.* 1932. Etching, 8¾ × 7″. Gift of Elizabeth R. Strong, 12/85

Renée Sintenis (German, 1888–1965). *Faun.* Bronze, 3⅜ × 1⅜ × 1⅜″. Gift of Mary Snow, 7/31/85

Joyce Tenneson (American, 1945–). *Wilhelmina Cole Holladay.* 1983. Silver bromide print, 22 × 30″. The Holladay Collection

Elizabeth Vigée-Lebrun (attributed to) (French, 1755–1842). *Marie Antoinette (Holding a Rose).* Pastel, 31 × 25″. The Holladay Collection

School of Vigée-Lebrun (French, 1755–1842). Copy of self-portrait by Elizabeth Vigée-Lebrun. Oil on canvas, 27 × 21¾″. The Holladay Collection

Caroline Watson (British, 1761–1814). *The Honorable Mrs. Stanhope.* Engraving, 14 × 11½″. The Holladay Collection

Bachmann, Donna G., and Sherry Piland. *Women Artists: An Historical, Contemporary, and Feminist Bibliography*. Metuchen, N.J.: Scarecrow Press, 1978.

Bank, Mirra. *Anonymous Was a Woman*. New York: St. Martin's Press, 1979.

Barron, Stephanie, and Maurice Tuchman, eds. *The Avant-Garde in Russia 1910–1930: New Perspectives*. Cambridge, Mass.: MIT Press, 1980.

Broude, Norma, and Mary D. Garrard, eds. *Feminism and Art History: Questioning the Litany*. New York: Harper and Row, 1982.

Chadwick, Whitney. *Women Artists and the Surrealist Movement*. Boston: Little, Brown and Company, 1985.

Fine, Elsa Honig. *Women and Art: A History of Women Painters and Sculptors from the Renaissance to the 20th Century*. Montclair, N.J.: Allanheld & Schram/Prior, 1978.

Harris, Ann Sutherland, and Linda Nochlin. *Women Artists: 1550–1950*. New York: Alfred A. Knopf, 1976.

Hedges, Elaine, and Ingrid Wendt, comps. *In Her Own Image: Women Working in the Arts*. Old Westbury, N.Y.: Feminist Press, 1980.

Hess, Thomas B., and Elizabeth C. Baker, eds. *Art and Sexual Politics: Women's Liberation, Women Artists, and Art History*. New York: Macmillan Publishing Co., Inc., 1973.

Loeb, Judy, ed. *Feminist Collage: Educating Women in the Visual Arts*. New York: Teachers College Press, Columbia University, 1979.

Miller, Lynn F., and Sally S. Swenson. *Lives and Works: Talks with Women Artists*. Metuchen, N.J.: Scarecrow Press, 1981.

Mitchell, Margaretta. *Recollections: Ten Women of Photography*. New York: Viking Press, 1979.

Munro, Eleanor. *Originals: American Women Artists*. New York: Simon & Schuster, 1979.

Munsterberg, Hugo. *A History of Women Artists*. New York: Clarkson Potter, Inc., 1975.

Nemser, Cindy. *Art Talk: Conversations with 12 Women Artists*. New York: Charles Scribner's Sons, 1975.

Parker, Rozsika, and Griselda Pollock. *Old Mistresses: Women, Art and Ideology*. New York: Pantheon Books, 1981.

Petersen, Karen, and J. J. Wilson. *Women Artists: Recognition and Reappraisal from the Early Middle Ages to the Twentieth Century*. New York: Harper Colophon Books and New York University Press, 1976.

Roth, Moira, ed. *The Amazing Decade: Women and Performance Art in America 1970–1980*. Los Angeles: Astro Artz, 1983.

Rubinstein, Charlotte Streifer. *American Women Artists from Early Indian Times to the Present*. New York: Avon Books, 1982.

San Francisco Museum of Art. *Women of Photography: An Historical Survey*. San Francisco: Museum of Art, 1975.

Sherman, Claire R., and Adele M. Holcomb, eds. *Women as Interpreters of the Visual Arts 1820–1979*. Westport, Conn.: Greenwood Press, 1981.

Slatkin, Wendy. *Women Artists in History: From Antiquity to the Twentieth Century*. Englewood Cliffs, N.J.: Prentice-Hall, 1985.

Tuchman, Gaye, Arlene Kaplan Daniels, and James Benet, eds. *Hearth and Home, Images of Women in the Mass Media*. New York: Oxford University Press, 1978.

Tufts, Eleanor. *American Women Artists, Past and Present: A Selected Bibliographic Guide*. New York: Garland Publishing Co., 1984.

———. *Our Hidden Heritage: Five Centuries of Women Artists*. New York: Paddington Press, 1974.

Van Wagner, Judy K. Collischan. *Women Shaping Art: Profiles of Power*. New York: Praeger, 1984.

Vergine, Lea. *L'Autre Moitie de l'Avant-Garde*. Paris: Des Femmes, 1982.

Weimann, Jeanne Madeline. *The Fair Women: The Woman's Building, Chicago 1893*. Chicago: Academy Chicago Publishers, 1981.

INDEX TO ARTISTS AND WORKS

Page numbers in *italics* refer to pages on which colorplates appear.

A

Abbéma, Louise, *Portrait of a Young Girl with a Blue Ribbon*, 147

Abbott, Berenice, *Betty Parsons*, 149; *Coco Chanel*, 149; *Djuna Barnes*, 148; *Edna St. Vincent Millay*, 76; *Eva Le Gallienne*, 148; *Janet Flanner*, 148; *Nora Joyce*, 149

Acheson, Alice Stanley, *Atitlan Village*, 150

Albers, Anni, *C 31/65*, 151

Allatar, Suad, *Untitled*, 151

Allen, Marion Boyd, *Portrait of Anna Vaughn Hyatt*, 60

Apel, Marie, *Grief*, 152

Aristegui, Pilar de, *Moors and Christians, Alcoy*, 153

Artha, M., *Untitled*, 154

Attie, Dotty, *An Adventure at Sea*, 108

Aycock, Alice, *The Great God Pan*, 112

B

Baber, Alice, *Burning Boundary*, 155; *For a Book of Kings*, 155

Bailly, Alice, *Self-Portrait*, 143

Barton, Loren Roberta, *Back Stoop (in Monterey CA.)*, 156

Beauclerk, Lady Diana, *Love in Bondage*, 156

Beaux, Cecilia, *Ethel Page (Mrs. James Large)*, 56

Becker-Wegeli, Friedy, *Roses on a Ledge*, 157

Bennett, Philomene, *Red River to Heaven*, 158

Bernstein, Sylvia, *Mother and Child*, 158

Biggs, Electra Waggoner, *Riding into the Sunset*, 159

Bishop, Isabel, *Men and Girls Walking*, 91

Blackadder, Elizabeth, *Still Life with Indian Toys*, 160

Bonheur, Rosa, *Sheep by the Sea*, 62; *Sheep in a Mountain Landscape*, 161

Bothwell, Dorr, *California Wild Mustard*, 162

Bouguereau, Elizabeth Gardner, *The Shepherd David Triumphant*, 47

Brownscombe, Jennie Augusta, *Love's Young Dream*, 53

Bush-Brown, Margaret Lesley, *Ellen Day Hale*, 54; *Woman Fishing in the Canal*, 162

Byrne, Anne Frances, *Honeysuckle, Poppies, etc. . .* , 163

C

Callis, Jo Ann, *Parrot and Sailboat*, 164

Carlisle, Mary-Helen, *Lavender Gardens— Kilkenny Castle*, 164

Carrera, Jewel, *White Hills*, 165

Carrington, Leonora, *The Magic Witch*, *121*

Cassatt, Mary, *The Bath* (also called *The Tub*), 49; *Mother Louise Nursing Her Child*, 166; *Portrait Sketch of Mme. Fontveille, No. 1*, 166; *Sketch of Denise's Daughter*, 167; *Study of Reine: Outline of a Child's Head*, 167

Chamberlin, Lydia, *Prout's Neck*, 168

Charleston, Linda, *Amazing Grace*, 168

Chernow, Ann, *Lady of L.A.*, 169

Chino, Marie Z., untitled black and white pot, 169

Claudel, Camille, *Young Girl with a Sheaf of Wheat*, 66

Clements, Gabrielle de Veaux, *Mont St. Michel*, 169

Cole, Phoebe, *St. George and the Dragon*, 170

Crowder, Susan, *White Folded Pillow*, 170

D

Dahl-Wolfe, Louise, *Colette*, 75; *Fashion Photograph*, 171

Danziger, Joan, *Ozymandasis*, 172

Davenport, Roselle, *Genesis*, 172

Day, Wörden, *Continental Divide III*, 173

Degas, Edgar, *Mary Cassatt*, 48

Dehner, Dorothy, *Black and Brown*, 173; *Ladder II*, 173

De Kooning, Elaine, *Bacchus #3*, 96; *Jardin de Luxembourg VII*, 174

Delaunay, Sonia Terk, *Study for Portugal*, 138–39

Dumont, François, *Portrait of Marguerite Gérard*, 37

Duveneck, Elizabeth Lyman Boott, *Newport*, 174

E

Eisenberg, Wendy, *Deidre*, 175

Ellis, Deborah, *Sliced Vegetables*, 175

Emmet, Jane Erin, *Portrait of Mrs. B. F. Goodrich*, 176

Exter, Alexandra, costume design for *Les Equivoques d'Amour*, 136

F

Feigenbaum, Harriet, *Dawn*, 176

Ferrara, Jackie, *M165*, 177

Ferrian, Marie, *Alice–1919*, 177

Firestone, Susan, *Autumn Charm Box*, 178; *Lipstick and Zippers*, 178

Fitzgerald, Harriet, *Rooftops of Florence*, 179

Flack, Audrey, *Who She Is*, 104

Fontana, Lavinia, *Holy Family with St. John*, 180; *Portrait of a Noblewoman*, 17; *Self-Portrait*, 16

Forbes, Adela Elizabeth Stanhope, A.R.W.S., *Will O' the Wisp*, 181

Forrester, Patricia Tobacco, *Judith's Garden*, 182

Frankenthaler, Helen, *Ponti*, 182; *Spiritualist*, 103

Friedman, Elizabeth, *Monumental Grape II*, 183

Frishmuth, Harriet Whitney, *Pushing Nude Bookends*, 184

Furman, Maggie, pink stoneware pot, 184

G

Gaal, Aniko, *Meditation*, 185

Gabriel, Ada V., *Calla Lilies*, 186

Gechtoff, Sonia, *Winter Rose Interior*, 186

Gérard, Marguerite, *Prelude to a Concert*, 36

Gilot, Françoise, *Air*, 187

Goncharova, Natalia, *Cosmic Universe*, 135

Goulet, Lorrie, *#2, Catalyst*, 187

Graves, Nancy, *Rheo*, 111

Greeff, Adele, *Icon: In Praise of the Sea*, 188

H

Hale, Ellen Day, *Gabrielle de Veaux Clements*, 189; *June*, 55; *Portrait of a Girl in a Cap*, 189

Hall, Lee, *Connecticut Summer*, 190; *Quarry, Maine Dusk*, 190

Hancke, Anna Marie, *Asteroid*, 191

Hanson, Ann, *Dancing Lizard Couple*, 191

Hartigan, Grace, *Untitled*, 192

Haudebourt-Lescot, Antoinette, *Self-Portrait*, 39; *Young Woman Seated in the Shade of a Tree*, 38

Hawkin-Israel, Linda, *Women in Law*, 193

Hepworth, Barbara, *Figure (Merryn)*, 119

Hesse, Eva, *Accession*, 107; *Study for Sculpture*, 194

Hoffman, Malvina, *Anna Pavlova*, 61

Huntington, Anna Vaughn Hyatt, *Yawning Panther*, 60

I

Ingram, Judith, *Sandstone*, 194

Isham, Sheila, *Lin, the Approach*, 195

Ito, Wako, *Petunia Basket*, 196

J

Jacobs, Agnes, *Oval II*, 197

Jaramillo, Virginia, 'Visual Theorems', 198

Jessup, Georgia, *Downtown*, 100

John, Augustus, *Portrait of the Artist's Sister Gwen*, 116

John, Gwen, *Seated Women*, 117; *Study of a Woman in a Mulberry Dress*, 199

Johns, Harriet, *Untitled*, 198

Jones, Elizabeth, *Feminine Snow*, 200

K

Kandinsky, Wassily, *Gabriele Münter*, 131

Käsebier, Gertrude, *The Manger*, 72

Kauffman, Angelica, *The Family of the Earl of Gower*, 41; *Self-Portrait*, 40

Keith, Elizabeth, *From the Land of the Morning Calm*, 201

Kerrigan, Maurie, *Brave Dog*, 201

Khayatt, Dora, *Marina*, 202

King, Jessie Marion, *Summer and Winter*, 203

Klavans, Minnie, *Within and Without*, 204

Klitgaard, Georgina, *Eaton's Neck*, 205

Klumpke, Anna Elizabeth, *Rosa Bonheur*, 63

Knight, Jennie Lea, *Tip*, 205

Kohlmeyer, Ida, *Chauffeur*, 206; *Symbols*, 206

Kollwitz, Käthe, *The Downtrodden*, 126; *End*, 207; *The Farewell*, 207; *Rest in His Hands*, 207; *Self-Portrait of Käthe Kollwitz*, 127

Krasner, Lee, *The Springs*, 92

L

Labille-Guiard, Adélaïde, *Portrait of the Marquise de la Fayette (?)*, 32; *Self-Portrait with Two Pupils, Mademoiselle Marie Gabrielle Capet (1761–1818) and Mademoiselle Carreaux de Rosemond (died 1788)*, 33

Larrabee, Constance Stuart, *Witwaterstrand Gold Miner Watching Sunday Mine Dance. Gold Mine, Yohannesberg—1946*, 208

Lasch, Pat, *Black Guardian Angel I*, 209

Laurencin, Marie, *Group of Artists*, 70; *Portrait of a Girl in a Hat (Self-Portrait)*, 71

Layton, Elizabeth, *Self-Portrait, Holding Rose with Thorns*, 210

Lee, Doris, *Untitled*, 211

Leroy, Jeanette, *Scarf on a Coat Rack*, 211

Lewis, Lucy, *Star Vase*, 115

Lievens, Jan, the Elder, *Portrait of Anna Maria Van Schurman*, 23

Loir, Marie Anne, *Madame Geoffrin*, 29

Longman, Evelyn Beatrice, *Bacchante Head (or Peggy)*, 59

Lum, Bertha Boynton, *May Night*, 212

M

Macdonald, Ellen, *Dead Noise*, 212

Madeyska, Arika, *Moon Landscape*, 213

Madhubani, painting on silk, 213

Maher, Phyllis, *Copper*, 214

Manet, Edouard, *Repose: Portrait of Berthe Morisot*, 64

Martin, Agnes, *The Wall II*, 214

Martinez, Maria Montoya, *Bowl*, 215; *Collings Pot*, 115

Martinez, Santana, *Jar*, 215

Mascellani, Norma, *Sanctuary of St. Luke*, 215

Mercier, Charlotte, *Madeleine de la Bigotiere de Perchambault*, 216; *Oliver Gouidic de Troyon*, 217

Merian, Maria Sibylla, *Dissertation in Insect Generations and Metamorphosis in Surinam* (engraving from), 26

Mitchell, Joan, *Dirty Snow*, 99

Modersohn-Becker, Paula, *Old Seated Woman*, 218; *Self-Portrait with Camellia Branch*, 128; *Sitting Female Nude*, 129

Morisot, Berthe, *The Cage*, 65; *Lake at the Bois de Boulogne*, 218

Münter, Gabriele, *Breakfast of the Birds*, 219; *Staffelsee in Autumn*, 130

N

Navarre, Marie-Geneviève, *Portrait of a Young Woman*, 30

Neel, Alice, *T. B., Harlem*, 89

Netherlandish (?) Master of 1679, *Portrait of Maria Sibylla Merian*, 25

Netscher, Constantijn, *Rachel Ruysch (1664–1750) in Her Studio*, 27

O

O'Keeffe, Georgia, *Alligator Pears in a Basket*, 81

P

Parsons, Betty, *Winged Frog*, 220

Partington, Gertrude, *Eleanor*, 221

Peale, Anna Claypoole, *Nancy Aertsen*, 43

Peale, James, *Anna Claypoole Peale*, 42

Peeters, Clara, *Self-Portrait with Still Life*, 21; *Still Life of Fish and Cat*, 21

Pereira, Irene Rice, *Crystal of the Rose*, 221

Perry, Lilla Cabot, *Lady in Evening Dress*, 222; *Lady with a Bowl of Violets*, 50

Porter, Katherine, *Untitled*, 223

Prax, Valentine Henriette, *The Family*, 223

Prestel, Mary Catherine, *The Retreating Shower*, 224

R

Rae, Barbara, *Untitled*, 224

Redpath, Anne, *Altar in Venice*, 140

Reese, Jane, *Portrait of Jefferson Patterson*, 224

Reika, Iwami, *Flower and Water*, 225

Riley, Bridget, *Red, Turquoise, Grey and Black Bands*, 122

Robbins, Ellen, *Poppies*, 225

Roberson, Pamela, *Nevada*, 226

Rockburne, Dorothea, *Copal #7*, 124; *Sheba*, 227

Russell, Barbara, *Pleasant Day*, 228

Ruysch, Rachel, *Flowers in a Vase*, 228; *Roses, Convolvulus, Poppies and Other Flowers in an Urn on a Stone Ledge*, 26

S

Sao (Maria Da Conceicao), *#24 from Paris Review*, 229

Sargeant, Geneve Rixford, *Portrait of Eleanor*, 229

Sarnoff, Lolo, *Gateway to Eden*, 230

Shillinglaw, Fawn, *Morning News*, 230

Sirani, Elisabetta, *Holy Family with St. Elizabeth and St. John the Baptist*, 231; *Madonna and Child with St. John the Baptist*, 231; *Virgin and Child*, 18

Sparrow, Louise Kidder, *Bust of General Sparrow as a Boy*, 232

Spencer, Lilly Martin, *Self-Portrait*, 45; *Still Life with Watermelon, Pears, and Grapes*, 44

Stavitsky, Ellen, *Collage 214*, 232

Stein, Beatrice, *Bust of Jacques Bon (Brother of Mme. Raymond Duchamp-Villon)*, 232; *Portrait of Jacques Bon*

(Brother of Mme. Raymond Duchamp-Villon), 232

Stevens, May, *Artemisia Gentileschi*, 233

T

Taeuber-Arp, Sophie, *Composition of Circles and Semicircles*, 144

Tafoya, Margaret, *Water Jar*, 115

Tanning, Dorothea, *To Max Ernst*, 95

Tebbetts, Barbara, *Untitled*, 234

Tenneson, Joyce, *Kathy: 1985*, 234

Thomas, Alma, *Iris, Tulips, Jonquils and Crocuses*, 85; *Orion*, 235

Truitt, Anne, *Summer Dryad*, 236

U

Udinotti, Agnese, *Totem Stele No. 8*, 237

V

Valadon, Suzanne, *The Abandoned Doll*, 69; *Bathing the Children in the Garden*, 238; *Bouquet of Flowers in an Empire Vase*, 238; *Girl on a Small Wall*, 238; *Nude Doing Her Hair*, 239; *Self-Portrait*, 68

Van Ness, Beatrice Whitney, *Summer's Sunlight*, 82

Van Schurman, Anna Maria, *Self-Portrait* (drypoint), 22; *Self-Portrait* (engraving with etching), 22

Vercelli, Gemma, *The Ways of the World: A Triptych*, 240

Vicentini, Maria, *The Pope's Inauguration*, 241

Vidotto, Elena, *Eggs*, 241

Vieira da Silva, Maria Elena, *The Town*, 132

Vigée-Lebrun, Elizabeth, *Innocence Taking Refuge in the Arms of Justice*, 243; *Mlle. Anne de Visevalotsky*, 243; *Portrait of Mme. d'Espineuil*, 242; *Portrait of a Young Boy*, 35; *Self-Portrait*, 34; *Study of Madame Backiloff, née Wolff*, 243

Von Wiegand, Charmion, *Advancing Magic Squares*, 86

Vonnoh, Bessie Potter, *The Fan*, 59

W

Walter, Martha, *Bathing House*, 244

Watson-Schutze, Eva, *The Rose*, 245

Weems, Katherine Ward Lane, *Doe and Fawn*, 246

Weiss, Lee, *Juniper Berries*, 246

Wiley, Irena, *Portrait of Mrs. Jefferson Patterson*, 246

Wolfson, Marbet Maize, *The Transparent Table*, 247

Y

Yamaguchi, Yuriko, *Shoot*, 247

Z

Zorach, Marguerite Thompson, *Central Park*, 247; *Nude Reclining*, 78

PHOTOGRAPH CREDITS